GROWING MISSIONARIES BIBLICALLY

A Fresh Look at Missions in an African Context

DR. R. ZARWULUGBO LIBERTY

Foreword by Dr. Ronald Kilpatrick

iUniverse, Inc.
Bloomington

Growing Missionaries Biblically
A Fresh Look at Missions in an African Context

iUniverse books may be ordered through booksellers or by contacting:

iUniverse
1663 Liberty Drive
Bloomington, IN 47403
www.iuniverse.com
1-800-Authors (1-800-288-4677)

ISBN: 978-1-4759-3300-0 (sc)
ISBN: 978-1-4759-3301-7 (e)
ISBN: 978-1-4759-3302-4 (dj)

Library of Congress Control Number: 2012910777

Printed in the United States of America

iUniverse rev. date: 8/31/2012

Dedication

This book is written in appreciation and honor to the Lord Jesus Christ who saved me and miraculously provided for this project. Special honor goes to my beloved wife, Esther Bantoe Liberty who is patient and supportive in her prayers and unwavering love for me for many years; to our children: Robertson, Roosevelt, Roseline, Vera, Joshua, Comfort, Edwin, Samuel, Bobby, You-jay, and Baryo and to all our grandchildren. To my late father and mother (may their souls rest in perfect peace) who did everything that they could for me to be where I am today; to the citizens of Gbee & Dorwudu District, Liberia, from where the Lord raised me up to serve Him. Also, my gratitude goes to the Fahn-yah ethnic group within the Gbee clan of the District that my late father led for many years. He appointed me, among the tribal leaders, to succeed him. But prior to his death, my father stressed that, "This new leadership will be in Christ!" To members of the Church of the Believers in Liberia that the Lord founded through us; to all the pastors who are serving the Lord in our various churches; to the Board of Directors of Africa International Christian Mission; and finally, to all partners and friends who have been praying with us for our ministries in America and Africa, my deepest appreciation.

Soli Deo Gloria

Though I am free and belong to no man, I make myself a slave to everyone, to win as many as possible. To the Jews I became like a Jew, to win the Jews. To those under the law I became like one under the law (though I myself am not under the law), so as to win those under the law. To those not having the law I became like one of them (though I am not free from God's law but am under Christ's law), so as to win those not having the law. To the weak I became weak, to win the weak. I have become all things to all men so that by all possible means I might save some. I do all this for the sake of the gospel, that I may share in its blessings.

1 Cor. 9:19-23

Contents

Section Three: Anthropological Perspective of Growing Missionaries

Section Four: Operational Perspective of Growing Missionaries

Appendices

Acknowledgments

When attempting a book of this nature, one cannot begin without the encouragement, help and guidance from a variety of people. I am indebted to the following persons whose prayers and academic guidance resulted in the realization of my dream. My sincere appreciation to Dr. Ronald Kilpatrick, Adjunct Professor of Knox Theological Seminary for his scholarly advice, expertise and guidance that made the writing of this book possible. My gratitude to the late Dr. D. James Kennedy, founder of Coral Ridge Presbyterian Church and Knox Theological Seminary who had a deep passion for the Great Commission. His zeal and love for the Lord Jesus Christ resulted in the establishment of a scholarship fund at Knox Theological Seminary. Kennedy's objective for this scholarship was to train pastors for effective ministry irrespective of race. This book could not be made possible had it not been for the Scholarship Committee of Knox in both my Master of Divinity and Doctor of Ministry studies. The Victory Worship Center of Lake Worth, Florida, led by Pastor Sherry Colby, sponsored our orphanages in Liberia for one year just to enable me to focus on this writing project. My deep appreciation goes to Mr. Andrew Podray, one of my sponsors, who is residing in Boynton Beach, Florida. Besides his monthly financial support, he volunteered to perform the work that I do every Thursday morning so that the dream of writing this book would be realized; and, my deepest appreciation to Elissa Crawford and Joyce Grothamnn for helping out in editing the manuscript.

Most importantly, all the praise finally goes to God. Without Him, this work would have been impossible. He gave me good health, energy, joy, and the perseverance to come to this point. I trust that this book will contribute to the advancement of Missiology.

Foreword

An ancient Chinese proverb says, "May you live in interesting times." This is certainly an interesting time in world missions. I recently read in the *Christian Post* that two-thirds of the Christians in the world today live in countries that were receiving foreign missionaries from the West a hundred years ago.

Last year 400,000 missionaries were sent around the world: 127,000 came from the United States. Brazil has now become the second largest missionary-sending country, with 34,000 missionaries just last year; many of them went to the United States of America. Another major supplier of missionaries is South Korea.

There is a saying, "If it ain't broke don't fix it!" So why should there be another book on the recruitment and training of missionaries? One reason is that the majority of books on the subject of missions are written from the perspective of Western civilization. But the old adage still holds true: "When in Rome, do as the Romans do," i.e., a visitor should try to act as the people do who are from that place. Failure to understand and adapt to the dynamics of African (alien) life and thought patterns is a recipe for missionary frustration and puts needless barriers in the way of successful cross-cultural missions outreach.

This is a book written by a native of Liberia, Africa with biblical, theological and practical insights for prospective and seasoned missionaries and their supporters; it will successfully launch and sustain them in the course of their mission work. In education, we emphasize the need to "teach along the grain of the students' disposition." The

same holds true for effective missionary training and service. What this book proposes is a vital curriculum for missionary preparation for cross-cultural missionary service. If understood and followed it will preclude a host of problems of cross-cultural communication; and it will also make the transition to native life go more smoothly.

"Why reinvent the wheel?" Let us see how others have confronted and solved the diverse problems they have faced or will face in foreign missionaries. Because the author – who grew up in Africa - has "been there and done that" – he is in an ideal position to bring wise counsel about life and work in an alien culture. Profusely illustrated by examples from African village life, the book ushers the reader into a whole new world. Sensitivity and appropriate accommodation helps hone the message and messenger for effective ministry on the mission field.

Psalm 137:4 asks, "How shall we sing the LORD'S song in a foreign land?" Paul, the missionary *par excellence*, answers in 1 Corinthians 9:20-22, "To the Jews I became like a Jew, to win the Jews. To those under the law I became like one under the law (though I myself am not under the law), so as to win those under the law. To those not having the law I became like one not having the law (though I am not free from God's law but am under Christ's law), so as to win those not having the law. To the weak I became weak, to win the weak. I have become all things to all people so that by all possible means I might save some."

I commend this biblical and practical *tour de force* for the next wave of Christian missions. Isaiah 59:19 says: "So shall they fear the name of the LORD from the west, and his glory from the rising of the sun. When the enemy shall come in like a flood, the Spirit of the Lord shall lift up a standard against him."

Speaking of "finding our feet" in missions, Paul cites Isa. 52:7 in Romans 10:15 "And how shall they preach, except they be sent? As it is written, 'How beautiful are the feet of them that preach the Gospel of peace, and bring glad tidings of good things!'" And Jesus in John 20:21 says, "As the Father has sent me, I am sending you."

Dr. Ronald Kilpatrick

Preface

The desire to write this book stems from my background in African Traditional Religion: I am a native of Liberia, West Africa, and hailed from Nimba County from the Gbee and Dor-wudu District. My father was the leader of the Fahn-yah tribe within the Gbee Chiefdom. I was born into an animistic society, and was committed to it during my youth. Animism is a belief that natural things around us are infused with conscious life. Tribe members regard hills, valleys, waterways and rocks as spiritual beings, as are all plants and animals. As I was growing up, I remember us worshipping a creek called, Nay-wodo, in the Gbee language of Liberia with sacrifices. It was believed that every child born in that town came from Nay-wodo. Our techniques were to deal with the fear of displeasing the spirits. This was the religion of my people, yet God called me from that darkness to His glorious light in Christ.

The year I was born – 1948 – in Zarwulugbo Town, Nimba County, the Republic of Liberia, was the very year that far-away Israel was prophetically re-born as a nation. Dad was a tribal leader and a big-game hunter for the Fayn-yah ethnic group. Though he was not a Christian, Dad was a good-natured person – very generous, with a deep love for people. He had many wives. My mom, Qualie-non-nun, was his head wife. She was the only woman allowed to sleep in Dad's Fetish Hut, called Qualie-gbo, which means Bush House in the Gbee language of Liberia.

Dad wanted me to succeed him; therefore, he began to train me during my youth. I was allowed to sleep in the Fetish Hut along with

my parents. His spiritual powers were stored in this hut. It was built with mud, then thatched, and fenced in. Inside the fence was Dad's rock-throne (surrounded by tribal elders) where he usually sat to decide family matters and also to perform rituals.

Dad's vision for my education. One of the motivating factors to the writing of this book is my father's vision for my education. A major turn came in the entire ethnic group when Dad traveled to Monrovia, the capital city of Liberia and stayed for two months. When he returned home, he offered a suggestion to my mother for me to go to school. He discerned that the future of the country would be in the hands of educated people. Mom rejected this proposal on the grounds that I was next in rank to succeed my father. *How could I leave them?* But because God was working out everything for my good, she reluctantly agreed. I was sent to Glahn Town public school, then the Chiefdom headquarters. The Mid-Baptist Mission had a church in that town and worked jointly with the school. The mission's pastor, the late Joe Mein, heard about my enrollment, and he appealed to my father to let me live in the parsonage with his family, promising to do everything to make sure I attended school daily. Dad agreed.

Going to school was great, but I had a serious problem attending church services. It was boring and foreign to me. Every weekend I would come home to see my parents to sleep in the Fetish Hut, and then go back to the mission on Sundays. I reluctantly attended church services occasionally to avoid hurting Pastor Mein and suspension from the school. Pastor Mein and his members continued to pray for my salvation. In 1962 I accepted the Lord Jesus Christ.

Family crisis. But my faith in Christ resulted in a major family crisis. I avoided sleeping in the Fetish Hut, by deliberately not coming home as usual to spend time with my parents. I shared this struggle with Pastor Mein, and the congregation prayed for me.

After several weeks at school, I finally went home to see my parents. Mom was very happy to see me. But I was determined to tell my parents about my faith in Christ, and that I wouldn't sleep in the Fetish Hut anymore. I told her upfront about my new faith in Christ, and announced, "I will not sleep in the Fetish Hut anymore." She was shocked. She warned me not to tell my father this. But later when he came home from the farm, I bravely told Dad. He stood, tongue-tied,

not speaking for some time, and then demanded, "What did you say?" I repeated my declaration. "Dad, where you sent me, I met someone called Jesus Christ. He is the Savior of the world, and because He is now in my life I just cannot sleep in the idol hut anymore." Angrily he said, "Are you going out of your mind?" I held my peace when I saw his disappointment, but I was praying in my heart that he would not order me to sleep in the hut. Then he added, "I did not send you to school to dash to the ground the hope of your people for the sake of this Christ!" But at last I was given a room in one of his modern houses. Often he would talk to me about the importance of the tribal leadership, but I continually said no to it.

The Gospel preached to my ethnic group. Penetrating the Fahn-yah ethnic group with the Gospel is a story that needs global readership. In 1962, the Mission Church hosted their Annual Conference which brought together several Mid-Baptist Churches. During the last day of the conference, the moderator asked for a church that would host the next year's conference. I stood up and asked if the conference could be held in my father's town. The leadership caucused and agreed. I went home exuberantly to inform Dad about the conference. Though he didn't know what a conference was, I explained that the church people would assemble in his town for a week of Bible teaching, prayers, and worship unto God. Dad accepted this challenge and successfully hosted the conference in 1963.

Dad's blindness, salvation, and death. The salvation of my father who claimed to possess some super power motivated me to share the account of his salvation to the world. Several months after the conference, Dad was sitting on his rock-throne and suddenly he was struck blind! He heard a voice that told him not to consult any witch doctors or herbalists; he was also instructed to go to one Mother Mai-Jeane Gar-wudu in Grand Bassa County for prayer. There, according to the voice, he would be healed. In obedience to this divine guidance, the family carried him to Mother Gar-wudu for prayer. He was with her for one year. There he confessed his sins and accepted the Lord Jesus Christ – praise the Lord! The Lord restored his sight, and my father returned home rejoicing in the Lord. He indirectly abandoned his Fetish Hut too. When the tribal elders asked why he was not sleeping

in the Fetish Hut, he blamed it on his age, but in reality he could not serve two masters.

His death: Dad got sick and the entire ethnic group came together. At this time I was residing in Monrovia the capital city of Liberia. When I arrived, Dad called all the tribal elders and asked me to stand in their midst. I did, not knowing what he would do. He announced to everyone, "I am about to die, but this son of mine will take the tribal leadership's mantle. Though he is young, God has selected him to lead the Fahn-yah people to Christ." He then blessed me and said, "Son, the God you introduced to me will bless you wherever you go, and in everything you do. God will empower you and your wife, Esther, to lead the people. Just look up to God alone for everything. Don't come back to this town until after four years." He insisted that I leave the town that very day with his youngest son, Plagbo because he knew the witchcraft society had planned to kill me during his funeral. Plagbo (who is also called Robertson) and I left that very day; we did not return home until four years after Dad's death. Today, as a result of my leadership, 90 percent of the Fahn-yah people are saved. The Fetish Hut has been destroyed and a church has been built in Zarwulugbo Town planted by my wife, Esther B. Liberty.

Call to full-time ministry. The dramatic shift of my life from secular employment to full-time service for God is one of the motivating facts to publishing this book. Professionally, I am an accountant; God had blessed me to become chief accountant with a good salary and benefits for over ten years. Through my training, I was able to adequately handle the needs of my people. During those days I also served as an assistant pastor with the God of Mercy Church headed by The Reverend Joseph Kpee-you David. Things went well with me financially.

God called me to full-time ministry when I was serving as chief accountant with Liramco, a public corporation in 1980. As I sat in my office, consumed with the volumes of work on hand and the deadline for our report, I heard a voice in my inner-self, "Liberty, how old are you?' I was shocked, but I knew it was the Lord. I said, "Lord, you know I am 32 years old." Then the Lord continued, "Subtract on your calculator the years you have lived from 70 years, and multiply the balance by 365." I did. I came up with so many thousands of days

left. Then the Lord concluded, "Each day you live, subtract that day. I commission you today to be Chief Accountant for my people, for I am your God." From that very day I started witnessing to everyone working with the company. A few weeks later, instead of going to work I found myself preaching at the flea markets and doing house-to-house evangelism. Because of the strong anointing of God, I informed the manager my intention for full-time ministry. He was surprised, knowing I was the highest paid Liberian with the company. "How are you going to support your family when you resign?" I replied, "He who called me is able to provide our needs." Finally, I resigned and began full-time ministry without any means of income.

The news reached my people that I had left my job and was now preaching throughout the city. They were told that I was insane. Accordingly, my family sent Abraham K. Zarwulugbo, my eldest brother, to take me home so that herbalists could work on me. He came and insisted that the family wanted to see me. I did not refuse to go with him, but I asked him to pray for us about it. After two days, Abraham came to me early in the morning with these words, "God told me last night in my dream not to take you home." I joyfully said, "Now, God has given *you* a message to the family; go and deliver it to them." The very brother who came to get me got saved and he is now preaching Christ everywhere.

Formation of ministries. On May 20, 1982, the Lord established the Church of the Believers through me. From 1982 to 1999, my wife, Esther and I planted 19 churches, five of them through Esther's tireless prayer ministry. Also, we started the Liberty Theological Seminary to train pastors and other church workers in Africa, the Fellowship of Christian Churches of Africa, an association of Christian churches, orphanages, and a Christian high school.

Call to foreign missions. One of the key reasons for writing this book is to praise God for His faithfulness. He is fulfilling His promises about missions and my training. The book in your hands is one of the fulfillments of God's promises to me. While I was excited in training God's children for the ministry, His plan for my life was to be a missionary. This was an entirely "new thing" God did for my wife and me. Honestly, I was not thinking about leaving my country and ministry that God had entrusted to us. Usually, I traveled back

and forth between America and Africa. I hadn't actually considered residing in America.

God is faithful to His word. During our 21-day fast and prayer meeting in 1985, God revealed through one of the participants, Musa Kargbo, that He would send me to be a missionary in a foreign country. Brother Musa also said that the Lord revealed that He would train me for His work. "Let God's will be done. He who calls knows where to send me," I claimed exuberantly, and accepted the revelation. In 1998 Pastor Chea, one of our students at the Liberty Theological seminary, came to my office in tears and said that God was about to send me on the mission field out of Liberia. I appealed to him to pray for me for God's will, and told him that his revelation was the confirmation of what Musa had in 1985. Finally, in 1998, God again confirmed His Word to me and Esther the same day: I was in the bathtub on Wednesday morning preparing for our Wednesday fast and prayer meeting when God impressed on my mind in the same way He did at my accounting office, "I will send you to America as a missionary; your work in Liberia is over for now." With tears I said, "Lord, let your will be done." But like Moses who complained to God about his inability to speak, I complained about lack of funds. The truth was, leaving all that was familiar and fruitful to start afresh did not sound like an easy assignment, especially in a new culture without any means of support. On the other hand, while my wife was on her way home from the Wednesday fasting and prayer meeting at one of our churches in Paynesville, the Lord spoke to her about us leaving Liberia for mission work in America.

We met within half an hour of each other at home and shared our revelations. When we told the elders of the church, they began praying with us and encouraging us to obey. A series of miracles began to unfold – Rev. Harmon Yalartai of Faith Revival Temple and his brother Wilmot Yalartai bought my plane ticket when I told them about what God was doing. The expiration of my wife's visa was solved by a church in Naples, Florida which sent $1,000 for her ticket. Calvary Chapel Boynton Beach, Florida provided free office space for our mission base for four years. A Christian brother within the church gave me a one-room apartment free for three years; another brother, David Blackwell paid my light bill for five years. Also, Africa International

Christian Mission was established in 2000 and incorporated in the state of Florida, and it became a 501(c)(3) non-profit organization in 2003 with headquarters in Boynton Beach, Florida.

Further theological education. God's message through Musa Kargbo for my training was fulfilled through Knox Theological Seminary. It has always been my desire to be a writer. I started writing articles and other materials for the denomination that God birthed through me. But I had been praying for more education after I graduated from the Liberia Baptist Theological Seminary with a Bachelor of Theology degree. After four years of working in the United States, the desire came to continue my education. But I did not have the money. The Lord miraculously opened the door and I was accepted at Knox Seminary with 70 percent scholarship. I did my Master of Divinity for three and half years completing 107 credit hours. After my master level of training, God again opened the door and I was accepted at Knox's Doctor of Ministry program for a 50-percent scholarship. This was a major breakthrough for me! The program was slated for six years, but I did it in three years. My utmost desire has been to be a missiologist, but Knox's highest degree is the Doctor of Ministry. After completing the required courses, I appealed to the Dean for the Doctor of Ministry program to allow me do my project in Missiology. This was a tough request, but as I prayed about it, the school agreed and Dr. Ronald Kilpatrick, who then taught missions courses at the seminary, became my advisor. This book is the finished product of this effort. What I am so thankful to God for is that my father's dream for my education has come to reality. Praise the Lord that I am able to write this book that will contribute to Missiology.

Who This Book Is For

This book is my contribution to Missiology. Missiology is the study of Christian missions and their methods and purposes. Hence, the book is for missionaries, missionary-sending organizations, pastors, elders, and seminary students who are studying in the area of missions. It is also intended for Christians who are supporting missionaries overseas, and is to be used as a textbook for missions in Christian colleges, universities, and seminaries.

Having summarized the motivating factors for writing this book, I will now begin with the introduction.

R. Zarwululgbo Liberty

Section One
Introduction

God uses agricultural metaphors to teach spiritual lessons in the Old Testament and practical heavenly lessons in the New Testament.

Chapter 1
Introduction

Mission begins with God and ends with Him. God became a missionary when Adam and Eve disobeyed Him in the Garden of Eden (Gn. 3:1ff). As a result of their disobedience, our first parents were driven out of God's Paradise with a promise of restoration (Gn. 3:15). God called and sent Abraham to make His name known to all men in preparation of His restoration (Gn.12:1-3). The Lord fulfilled His promise: He became a man in the person of Jesus Christ (Jn 1:1-4; 14). God the Son gave His life on the Cross of Calvary for the redemption of mankind, mainly for those who believe in Christ as their Lord and Savior. The apostle John writes, "For God so loved the world that he gave his one and only Son, and that whoever believes in him shall not perish but have everlasting life. For God did not send his Son into the world to condemn the world, but to save the world through him" (3:16-17 NIV).

Christ commissioned the apostles and every believer to go and preach the Gospel of reconciliation (2 Cor. 5: 18-20) to every man unto the utmost part of the earth. He promised to be with us "always" (Mt.28:18-20). The message of the Great Commission is *that God is reconciling the world unto Himself through the blood of His son, Jesus Christ*. The Gospel was erroneously preached through the cultural lens of Judaism. To avoid the continuity of this error, God commissioned Paul to be an apostle to the Gentiles and Peter to the Jews (Acts 9:15; Gal. 2:8). The

perennial problem of the church historically is *its failure to differentiate one's culture from the Gospel.*

This book is aimed at solving this age-old problem. I am taking a *fresh look* at the missionary training programs for short- and long-term missions. There is a need for more effective preparation of missionaries to serve for short- and long-term missions in Africa. Honestly, the West has ignored the traditional religions and anthropological aspects of some developing countries. In spite of the advancement of missionary education, most Bible colleges, seminaries and missionary-training institutions do not offer any course in these disciplines. Africa is producing more theologians, churchmen, and missiologists in the twenty-first century. Therefore, the training procedures of the colonial and imperial missionary outreach epoch in the third-world countries are unacceptable in Africa today. In the past, the West believed that Africa was "the white man's burden." They viewed African belief systems and cultural institutions as primitive. Missiologists and missionaries, then, considered the life of Africans to be that of savages and heathen societies. Hence, they needed to be enculturated into Western civilization and Euro-American Christianity. Globally, such a cultural imperialist methodology cannot be effective any more in this modern era of the church.

Western evangelization globally, then, bore a myriad of positive fruits. But many missionaries were not cognizant of their host culture and religion. Consequently, they failed to contextualize the Gospel appropriately to the understanding of the unreached people. As a result, some African Christians were still syncretistically practicing their pagan religions within the Christian Church. Accordingly, there were always cultural conflicts between the indigenous peoples and the missionaries. Scott Martell affirms, "One problem that I am adjusting to in Ethiopia is the complexity of the culture."[1] All the missionaries who I interviewed stressed the need of learning the host country's culture and their religion for effective ministry.

Missionaries are called to imitate Christ the Eternal Son of God: He became incarnate (Jn. 1:14). They are to imitate the apostle Paul who, also, became "all things to all men" (see 1 Cor. 9:19-23) just to

[1]An Interview with Scott Martell during the Sanibel Community Church's Mission Conference in March 2010.

win some to Christ. Seeing the unreserved devotion of the Athenians to the worship of the "UNKNOWN GOD," Paul recognized their misguided commitment. He introduced them to Christ whom they had ignorantly worshiped as *unknown*. And, Paul taught them how He is to be truly worshiped (Acts 17:17:24-30). One can effectively minister to a man when he understands his culture, religion and traditions. Missionaries should be faithful to the unchanging Gospel but present it, as best they can, in a culturally sensitive way.

This book is intended to resolve the problem by taking a fresh look at cross- cultural missions. I am proposing a comprehensive training program that is biblically, cross-culturally, theologically, historically, philosophically, exegetically, cross-cultural communicationally, anthropologically, and biculturally sound. It also includes an analysis of African Traditional Religion and Philosophy, *and the* Law and Constitution of a host country. This book is also aimed at exploring and explaining the challenges facing short- and long-term missionaries serving overseas. *This approach will, however, avoid syncretism and cultural imperialism.* It will enable the Western missionaries to be cognizant to the true worship of Christ in the African context. Knowing the worldviews of the people, eventually gives birth to sound biblical contextualization in the host country. It also insures that the missionaries are law-abiding as long as it does not conflict with one's faith in Christ.

To achieve this goal, appropriate books and articles published on intercultural studies were reviewed. The review also included many books published on African Traditional Religion and Philosophy. I interviewed some mission-minded churches and reviewed their training manuals for short-term missions. The research was also supplemented by interviews with missionary-training organizations and missionaries who are currently serving on the field. Retired missionaries interviewed also provided helpful information. What is unique to this writing is my personal experience as an African native missionary and church planter. My service in the United States as missionary gave me access in contacting mission's organizations and missionaries globally.

My approach to this research was both *diachronic and synchronic*: The historical and biblical development of missionary theory and practice were traced. Cognizant of the many historical changes in mission strategy, I proposed a comprehensive Gospel presentation

for the twenty-first century. It also considered the various Gospel presentations developed by prominent pastors/scholars in this century. The analysis is biblically critical in my evaluation of mission theory and theology. Gleaning from these outcomes, a comprehensive curriculum is proposed in this book, for cross-cultural ministry training. Also, a short-term missions training program is also proposed with what I considered the biblical theology of missions.

Although, this study is limited to Africa, the principles can be applied (with some modifications) to any country. My proposed objective is to create a model for twenty-first century missionary outreach; it is Bible based, culturally sensitive, practical, and applicable for missionary training to African nations and other third-world countries. With God's blessing, this model for missions will change the world for Christ.

Bicultural Missionaries Can Happen

The concept advanced in this book regarding the need for bicultural missionary as the answer for the twenty-first —century- missions outreach is not a mere proposal, it has been tested and found to be very effective. Almost at the end of 2010 I received an e-mail from Dr. LaTonya McRae, founder and president of the Tree of Life Ministry with headquarters in New Jersey. She wanted to go to Africa on a short-term missions trip. LaTonya said that the Lord had laid this trip on her heart and had been praying for over five years for someone to host her in Africa. While browsing through the Internet, she found the Africa International Christian Mission on the web. Immediately, she communicated with our office indicating her desire to go to Liberia, West Africa. In reply, I assured her that the mission is willing to make her dream come true provided if she takes our eleven-week Short-term Missions Trip Training course, as we cannot send anyone without the training. Dr. LaTonya joyfully expressed her willingness to take our course.

In November 2010 LaTonya flew from New Jersey to Boynton Beach for a four-hour visit with Esther and me. At the end her visit she said, "Before I visit your country I wanted to know you and your wife personally; I am very excited to meet you and I appreciate the joy you all have for having me in your home." In response, Esther presented her with African-traditional attire. Esther told her, "This traditional

6

attire is an honor; we love you, and surely you will enjoy your stay in Liberia. In fact, because you flew here just to see us, this indicates your seriousness for the trip. You will lodge in my house in Liberia at no cost to you. We will pray for God's provision for your trip." In addition to this, I assured her that our ministry in Liberia (Church of the Believers) would host her.

I immediately started the eleven-week training via Conference Call with her when she returned home. She did the course successfully. Dr. LaTonya became my second bicultural missionary (I am the first), and I taught her the culture of the specific ethnic group she was to visit. In this study we considered the theology of missions; we included a careful study of the American culture, and since it was a brief trip, we covered some of the dos and don'ts in that culture. The course was completed and LaTonya went to Liberia in February 2011 for a week. She was met on arrival at the Roberts International Airport by the leadership of the church headed by Deacon John Karmo Vah. She was taken to our residence in Monrovia as Esther had promised.

During her first day in the country, I received several calls from Liberia, the church leaders and other prominent members. One of the leaders said that "the woman has an American's skin and a Liberian's heart." My son's wife, Nana said, "I have never seen a missionary like this woman all of my life; she knows everything about us and she is just a down–to-earth person. Dr. LaTonya ate with her hands this morning!" Pastor Joseph Karbonwen of Liberia said, "If all the missionaries that come from the West were like this woman, they would penetrate this society with the Gospel." Elder Abraham K. Zarwulugbo, district superintendent of the church in Monrovia at that time, excitedly said to me, "Reverend, I cannot believe what we are seeing in the life of this woman. She knows exactly how to greet people according to our culture whenever we enter any home. How does she know these things?' And I said to him, "AB, she took my short-term missions training before coming to Liberia."

On the second day of her stay in Liberia, I called to check on her; she joyfully said, "Pastor, I am with my family. I love the people and they love me. Thank you for allowing me to come. I have family in Liberia now. You and Mother (Esther) are my parents, your children in Liberia are my brothers and sisters." T. Martee Barnie, who is

the missionary pastor for the women in Liberia called me and said, "Reverend, in my judgment, Dr. LaTonya is the best missionary who ever entered this country. I wish all other missionaries could imitate her. How does she know all the things we do?" I told Martee that she had done my missionary training.

On Sunday she wore a complete African suit – the only difference between LaTonya and the African women was the *language*. While she was in Liberia, the Liberians women gave her an African name, Dekontee, which means "everything has its time." This is our time for a missionary to relate to us well by respecting our culture and people.

LaTonya (Dekontee) returned to America after a week. I did a follow up Conference Call to discuss her trip. She could not express in words how she was welcomed by the Liberian people and how the training was a tremendous blessing in her interaction with people. She said, "I still feel that there is unfinished work in Liberia and I need to go back this time for two weeks; pray for me." Accordingly, LaTonya went back to Liberia in March of 2012 for two weeks. While she was back in Liberia, more praises were reported from church leaders, laymen, and others about her *extraordinary gift* as a missionary. One young preacher in Africa summarized her activities among the Bassa, Gbee and Krahn ethnic groups as though "she was being incarnational."

Therefore, the bicultural missionary proposal in this book does work – Dr. LaTonya is a bicultural missionary. In fact, she promised at this time to take a team to Africa in 2013.

This approach to missions is effective; I am the first long-term bicultural missionary. I did some of my theological and missiological studies at home, and most of it in the States. Prior to my assignment from the Lord in the United States, I came to the United States in 1999 to do a feasibility study about the establishment of the AICM. Besides my research at home I interviewed many American friends who I came in contact with during my visit. One of them was my brother-in-law, Robert Gollmann who hosted me for six months. He taught me a lot of things about the American culture; some of his cultural lessons were very practical and I have not read some of the things he taught me in any textbook. As Robert took me around in Fort Myers to meet other pastors, knowing my objective, I asked him a series of questions. Bob would just explain to me all that he knew about his people. As a

result of my effectiveness in ministry in the United States, the Knox Theological Seminary of Fort Lauderdale, Florida learned about my work and awarded me a certificate of honor in Evangelism and Missions during my graduation in 2008. I believe that a bicultural missionary is the answer for the twenty-first century intercultural ministry. How do I know? Because we are doing it.

Summary of the Journey

This book is divided into four sections instead of chapters. Every section may contain one, two or more chapters.

Section One, Introduction: This section has two chapters. The first chapter states the problem facing modern missions and gives details for its solution. Chapter 2 deals with the definition of the title: *Growing Missionaries Biblically.* I did an extensive study showing parallels of growing from an agricultural perspective; it was limited to traditional farming – shifting cultivation and Christian mission strategy. The missionary might see his work at times as tedious, but God who calls us is faithful to lead missionaries in patiently reconciling the world to Himself (2 Cor. 5:16-20). Like a farmer, the missionary requires a high degree of carefulness, sensitivity to the farmland in clearing, felling, burning, plowing, harvesting and storing. "Growing" was also defined from a biblical perspective. Agriculture is not a new phenomenon; it is a divine institution (Gn. 2:15; 3:19, 23). Adam was placed in the Garden of Eden as a caretaker (Gn. 2:15). Various aspects of the mundane farming analogy were used by Jesus in a series of parables (Mt. 13:1-52) to teach a heavenly meaning. Jesus pictured the world as a field in which a farmer planted the good seed of the Gospel; but an enemy (devil) planted a counterfeit seed.

Gleaning from the above definitions drawn from both a traditional and biblical perspectives of agriculture, I present the following definition: *Growing Missionaries Biblically is the development of God's missionary/sower to present the Gospel cross-culturally through biblical, theological, anthropological, religious and cross-cultural communication education.* The goal is to effectively proclaim the Kingdom of God and call people to faith in preparation for the final harvest.

Section Two, *Theological Perspective of Growing Missionaries:* This section has two chapters. Chapter 3 focuses on the Biblical Basis of Missions.

This chapter traces the biblical development of missions from both the Old and New Testaments. And chapter 4 traces the diachronical and synchronical developments of missions and the message proclaimed by the missionary. Also, a review of three prominent pastors/scholars Gospel presentations was considered. These presentations have gained international acceptance. I also proposed a comprehensive Gospel presentation for the twenty-first century.

Section Three, Anthropological Perspective of Growing Missionaries: This section contains one chapter. It focuses on the man in his context. Due to the complexity of people, I proposed that a *Western missionary should be required to be bicultural.* This will enable him to bring his host country and his home culture under the lordship of Christ. I also proposed that the religion of the people, their culture and other secret societies need to be studied. This will enable the missionary to minister effectively and seek to appropriately contextualize the Gospel.

Section Four, Operational Perspective of Growing Missionaries: This section has one chapter (chapter 6) and concentrates on a comprehensive short-term missions training program. It proposes new curriculum developments for "formal" and "informal" training for long- term missionary candidates. I also make an application of the analogy drawn from the agricultural systems discussed at length in chapter 2 to missionary training in this section. Sources for recruiting missionaries were provided and fundraising methodologies and accountability of missionaries were also discussed.

Conclusion: This summarizes the discussions of each section and calls for Christians to join forces in the fulfillment of the Great Commission of Jesus Christ. In chapter 2, you will learn the definition of Growing Missionaries Biblically from both the world of agriculture, from the Bible, and from my own definition gleaned from these perspectives.

Chapter 2
Definition of Growing Missionaries

Introduction

Pivotal to spreading the Gospel cross-culturally is the need to discover and apply its meaning appropriately in every culture. Missiologists are striving to find global and biblical definitions of theological terms for each culture without losing the true biblical meaning and nuance. A true definition of the Gospel stimulates faith, and faith determines the life that one lives. This chapter focuses on the meaning of "Growing Missionaries Biblically." I seek to glean my definition of missions and missionary from both the world of agriculture and from the biblical perspectives. Let us commence with the analogy of *growing crops*, first from an agricultural perspective; this will enable us to draw some parallels (see Section Four) to the biblical mission task. There are some key facts that missionaries need to learn from these two perspectives to empower them in effective inter-cultural ministry.

Part I discusses the agricultural perspective of growing missionaries. It provides the understanding that growing crops in a traditional setting involves tilling a cursed ground. Defining "growing" provides us with a deeper understanding of its components that is necessary for understanding the mission field. It makes one appreciate the importance of preparing for missionary training. Historically, the shifting cultivation system[2] is the oldest

[2]This system of farming is also called Crop Rotation, Swidden Agriculture, and Slash-And-Burn and these will be used interchangeably in this book.

traditional agricultural system in the world. For instance, there are four steps to growing rice in an African tribal setting:

1. selection of the farmland;
2. clearing the land;
3. sowing the seeds and observing the growing process and
4. bringing in and preserving the harvest.

An excellent harvest is predicated on the blessing of God. Also, the ability of the farmer in implementing the above four steps to successful farming is indispensably essential.

Part II Presents the Biblical view of Agriculture. In this section, I note biblically that the work of agriculture is not a new phenomenon—it is a divine institution (Gn. 2:15; 3:19, 23). Cultivation of the ground is part of God's creation mandate (Gn. 2:8-9 *NIV*). Adam was placed in the Garden of Eden as a caretaker (Gn. 2:15). God provided him with a wife, Eve, as a "helpmeet" to care for the Garden of God and all of His creation. Regrettably, their transgression based upon deception from the enemy (serpent) and willful rebellion against God, resulted in their expulsion from the Garden. However, in God's providence, and in the midst of the curse pronounced upon the serpent (Satan), there stands God's *promise of redemption* that would come through the Messiah, i.e. the seed of the woman! (Gn.3:15 *NIV*).

Various aspects of the farming analogy were used by Jesus in a series of parables of the Kingdom (Mt.13:1-52*). He used features drawn from the agricultural system prevalent in his time to present a heavenly meaning.* In Jesus' explanation of His parables (the four types of soils and the wheat and the tares) He pictured the world as a field. In this field a farmer planted good seed, but the enemy (devil) also planted a counterfeit seed (Mt.13:37-39). Later, Christ's Great Commission called for the sowers (missionaries) of the Gospel to sow the seed of God's Word globally.

Part III discusses my definition gleaned from analyses of both traditional and biblical perspectives of agriculture: Growing missionaries biblically is the development of God's missionary/sower to present the Gospel cross-culturally through biblical, theological, anthropological, religious and cross-cultural communication education. The goal is to effectively proclaim the Kingdom of God and call people to faith in preparation for the harvest. My definition is discussed in two parts: (1) An examination

of Jesus' parables of the soil (Mt.13:1-52), and (2) An examination of the practical, theological, and missiological education of missionaries.

In the first place, I will begin my discussion with the agricultural perspective of growing missionaries.

Agricultural Perspective of Growing Missionaries

There are four steps in a shifting cultivation system that a farmer must honor in order to have a successful harvest in an African setting. Besides the blessings of God they include:

1. finding a new farmland yearly,
2. clearing and plowing it,
3. planting the seeds, and nurturing them,
4. harvesting and storing the crop.

First, to grow crops in a traditional African setting means one must annually select an ideal spot or location for a new farm. A personal example might be helpful to illustrate this point. I grew up in an agricultural area of Liberia. Joining my father in learning how to produce rice was both fun and hard work during my teen years. This section is the reflection of what I learned from my father. In shifting cultivation, an experienced farmer would look for termite mounds, rattans, and certain trees that have organic fertilizers for cultivating a new farmland. Excellent harvests usually depend on where one cultivates. "Shifting cultivation is a form of agriculture in which the cultivated crop is shifted regularly to allow soil to recover under conditions of natural successive stages of regrowth. In a shifting cultivation system, at any particular point in time a minority of the 'fields' are [sic] in cultivation; a majority of the fields is in various stages of natural regrowth. Over time, fields are cultivated for a relatively short time, and allowed to recover, or are fallowed, for a relatively long time."[3]

In contrast, Prince Sorie Conteh writes that the Limba Religion of Sierra Leone believes that the land and farming are gifts from God. And in spite of human effort, there will not be a good harvest without God. Since farming is a religious matter, a sacred specialist is usually invited to inspect each farmland. His responsibility is to see if there are

[3]www.answers.com accessed March 23, 2010.

evil spirits on the land. Conteh continues, "If it is found that evil spirits are living on the land or in the area, Kudama, (an offering of rice-flour, egg, kola nuts, white cloth or at times a chicken) is made to inform the spirits of the family's intention to farm on the said land, and to ask the spirits for peace and prosperity as they work."[4] This sacrifice, within the Limba Religion, must be made on the day the family starts the work.

Second, growing crops necessitates clearing the selected land. In Liberia, there is always an advanced *brushing* by a farmer on a new parcel of farmland. The farmer publicly makes an announcement about his new farm to villagers at an appointed time. On that day the farmer's wife cooks rice in a little pot. Sufficient red oil would be poured on it. The rice pot is called *mun-mah-ya-kpee* in the Gbee dialect of Liberia. The rice dish is taken to the site of the new farm; there some of the food will be eaten by those that carry it and some is offered to the gods or God to bless the farm.

The *brushing* season takes about two months. It is an acquired skill. In *brushing*, one must cut all the little trees, ropes, rattans, etc. almost to the level of the ground with machetes. *Brushing* season is also a time of phenomenal fellowship among the farmers. They sing while *brushing* and do storytelling as well. During what is commonly called "brushing season," some of the men can organize a "Ba-an." A *Ba-an* in the Gbee language is a group of men or women united with one common objective. Their goal is to help one another during the farming season in brushing, felling, planting, and harvesting. In many African cultures, the host of the *Ba-an* is responsible for feeding the *Ba-an* members. In the Gbee culture in Liberia, West Africa, hosting a *Ba-an* is an honor. Therefore, the host will go an extra mile in providing food for the people. When the brushing is complete, there is always a waiting period of at least two to three weeks. The waiting time allows all the little trees, ropes, etc. cut during the brushing to be dried. The next step to this process is felling and lopping the big trees that are on the farm. W.A. Elwell states that the same rigorous chore prevailed in biblical Palestine: "Cultivating through biblical times, much of labor for agriculture came from the farmer himself. To plant for the first time, it was necessary to clear the land of forest (Jos. 17:18), stones (Is.5:2),

[4]Prince Sorie Conteh. "*Fundamental Concepts of Limba Traditional Religion, And Its Effects on Limba Christianity and Vice Versa in Sierra Leone In the Past Three Decades,*" D.Th, diss.,(University of south Africa, 2004) 201.

weeds, and thorns. Sometimes the thin soil on hillsides was terraced, and sometimes irrigation was employed. Such tasks limited the size of farms...."[5]

Regarding the brushing season in Sierra Leone, West Africa within the Limba Religion, Conteh declares, "If a piece of land or bush proposed for farming is declared freed from evil spirits, at the time of the brushing and clearing of the land, the head of the family offers a sacrifice for the welfare of the farm and its workers, and for protection against witchcraft or evil spirits at a ceremony called *Kuloki*."[6]

Felling season is hard work and dangerous. One day in Liberia, Mr. Toweh Gbarye-whea, my mother's brother, badly wounded his leg by a tree he cut down on our farm. While the tree was falling, one of the branches landed on his left leg and broke it! Such mishaps do not keep felling from being a time of fellowship; singing and drumming continues, most especially when a *Ba-an* (work team) is helping out. Every tree cut down needs lopping. During the *Ba-an*, the elderly people's job is lopping. Failure to do so means the trees may not burn properly, and of course, this would hinder the farmer from planting and growing a good crop. Upon the completion of slashing and lopping the trees, there is also another waiting period before burning the debris cluttering the farmland. During this period, the farmers pray to their gods or God for the sun to shine. Sunshine enables the leaves, sticks, and ropes to be dried, and then the clutter on the farmland will surely burn cleanly.

Burning a farmland is dangerous and requires an experienced farmer. A man died while burning his own farm in Liberia. He mistakenly surrounded himself with the fire. Those who are skillful in this burning process know exactly when, where, and how to do it. Depending on the kind of crop, the ground needs some time to be cold before planting. However, this needed delay will also allow the ashes to fertilize the ground. The farmer needs to reexamine his farmland by touring it, and if a spot is not well burnt, he piles up available sticks and sets fire to them. It is important for the farmer to reexamine his farm because:[7]

[5]Elwell, W. A., & Comfort, P. W. *Tyndale Bible dictionary* (Tyndale reference library. Wheaton, Ill.: Tyndale House Publishers, 2001), 20-21.

[6]Prince Sorie Conteh, 201.

[7]Accessed March 23, 2010 at: www.answers.com under "Slashed-and-burned defined."

Burning removes the vegetation and may release a pulse of nutrients to fertilize the soil. Ash also increases the pH of the soil, a process which makes certain nutrients (especially phosphorus) more available in the short term. Burning also temporarily drives off soil microorganisms, pests, and established plants long enough for crops to be planted in their ashes. Before artificial fertilizers were available, fire was one of the most widespread methods of fertilization.

Third, sowing seed and observing the growing process. The first and foremost concern of the farmer once the seed is sown is to watch out for weeds[8] and predatory birds during the planting season. Ignoring the weeds is tantamount to choking the crop and keeping it from growing. At that time, the plowing was done by human hands using hoes. While plowing, one has to carefully uproot the weeds and pile them up for burning. The farmer must be observant while planting seeds because birds may come to take away the seeds. A strategy must be put in place to drive the predatory birds away. Plowing was done for the purpose of sowing. It was carried out with a wooden plow *(mahărēšâ)* having a metal tip, and drafted by cattle (oxen, cows) or donkeys. A related tool was the goad *(malmad or darban)*, which had at one end an iron tip set in a wooden shaft for prodding the animals. It also had a flat, shovel-like butt at the other end for removing the mud off the plow-tip.[9]

Missionaries need to remember that growing disciples and churches is a process; it requires preparation and caring. Besides the agricultural growth metaphor, think about the growing up of one's child and the development of a talent. Or, consider the training for a chosen profession, the growth of one's character, and the growth of the relationship between a husband and wife.

My father once said, "Birds are limited when a farm is made in a virgin bush." A virgin bush in this context means land that no one has ever cultivated. In such areas birds do not appear during planting

[8]"Cultivating throughout biblical times, much of the labor for agriculture came from the farmer himself. To plant for the first time, it was necessary to clear the land of forest (Jos. 17:18), stones (Is 5:2), weeds, and thorns."(W.A..Elwell & P.W. Comfort. *Tyndale Bible dictionary*. Wheaton, Ill.: Tyndale House Publishers, 2001), 21.

[9]D.N. Freedman, A.C. Myers, & A.B. Beck. *Eerdmans dictionary of the Bible* (Grand Rapids, Mich.: W.B. Eerdmans, 2000), 28-30.

season, but a farmer must watch out for them a few weeks prior to and during harvesting.

Groundhogs are a second issue a Liberian farmer encounters when the seeds are growing to the knee height. They get into the farm and can soon destroy the crop. For a large farm, the farmer needs to fence the area from which the groundhogs enter the farm. The farmer may also set some traps to deter these varmints. For a smaller farm, a farmer has to fence the entire farm with sticks just to protect the growing process. Other animals may pass through the farm either in the day or at night and may possibly destroy part of the crop if nothing is done to protect it.

Growing crops means one is expecting a harvest. Experience indicates that crops that are not planted during the farming season may not yield a good harvest. Also, crops planted during the farming season *without observing the four steps of successful farming already discussed, may result in a poor harvest. The task of growing food and cultivating missionaries is a continual process.* Elwell & Beitzel write,"[10]

> Palestinian farmers were heavily dependent on rainfall for the success of their crops. A five-month dry season (mid-May to mid-October) left the land baked hard, and it was not until after the "early rains" (late October-November; Ps. 84:6) that the ground could be prepared; most of the water was provided by the heavy winter rains, but the "latter rains" (March-April; e.g., Jer. 5:24) were necessary to bring the crops to harvest.

Missionaries need to understand that Jesus used agricultural parables[11] to illustrate principles of the Kingdom of God and the Gospel. *Missionaries are called to work diligently like farmers while ultimately trusting the Lord for the harvest.* Paul–the great missionary – tells Timothy in 2 Timothy 2:6-7 that Christian missionaries are to be like the toiling farmer, not the lazy farmer who is forever observing the weather. He

[10]W. A. Elwell & B. J. Beitzel. *Baker encyclopedia of the Bible* (Grand Rapids, Mich.: Baker Book House, 1988), 36-38.

[11]Parables of: the sower (Matt. 13:3–9; Matt. 13:18–23; Mark 4:3–9; Mark 4:14–20; Luke 8:4–8; Luke 8:11–15); the leaven (Matt. 13:31–2); the growing seed (Mark 4:26–9); the mustard seed (Mark 4:31–2; Luke 13:18–19); the vineyard and tenants (Matt. 21:33–41; Mark 12:1–11; Luke 20:9–18). (C. A. Day. *Collins Thesaurus of the Bible.* Bellingham, WA: Logos Research Systems, Inc, 2009).

is the one who comes during rain or shine and is out there laboring in his farm.

Another key parallel between traditional farming and Kingdom growth is to know the time the land is to be cultivated and the time it is to lie fallow. These parameters determine whether or not the farm suffers loss or gain of nutrients over time. Being mindful of these dos and don'ts in the agricultural system will enable the farmer to grow more and better crops. By analogy, this will also encourage missionaries to persevere in their mission during lean times.

Fourth, the last step for a farmer is harvesting. Harvesting is not only capturing the crops but storing it in a suitable place and manner. In Liberia, harvested crops are usually stored up in what traditional African farmers call a *"kitchen."* The *kitchen* is constructed with sticks and thatches. The thatch must be well prepared to avoid leakage and also attacks from rats that usually enter rice *kitchens* for food. It is mandatory to maintain a daily fire under the *kitchen* to keep the rice constantly dry with the proper degree of heat. From this *kitchen*, daily food is also provided for the family and some of the seeds are kept for the next planting season. "These principles of growing crops are essential," my father advised me, "They can be applied to every area of life."

In the second place, since I have discussed the growing crops from a traditional agricultural perspective, let me walk you through what the Bible says about growing crops.

Biblical Perspective of Growing Missionaries

As I mentioned earlier, Scripture indicates that farming is a divine institution (Gen. 2: 15; 3:19, 23). Three points are to be considered:

- farming originated with God,
- growing crops–since the Fall–means man is now laboring under God's punishment,
- man has become a slave to his own product due to the cursed ground.

Farming Originated with God

Man was created to care for God's garden with dominion over all of His creation.
After the creation of heaven and earth and all that is therein, God created Adam in his own image and likeness. Adam means "man/ humankind." Man is in many ways like the rest of God's creation. But, the major difference is he has the breath of life from God that entered the formed dust. This breath transformed the dust into a living *human being.* The word 'breath' can also be translated as 'spirit'. It is the Spirit of God that places human beings in a living relationship with the Creator. This makes all the difference between them and other creatures. That is why the Spirit is given *anew* to those who turn to Christ and receive forgiveness for their sins (Acts 2:7b:2:38). Later God provided a wife for Adam named, Eve.[12] She was to help him in administering the affairs of the Garden of Eden and the rest of God's creation. The word garden comes from the Hebrew gan, from the root gnn, which means "to close, protect." It is like an English garden from gart, that is, to enclose. It denotes an enclosed area with trees and vegetables designed to produce food, and symbolized blessing and well-being.[13] "Eden [also] comes from the Hebrew word; eden means luxuriance.[14] Also, Derek Kidner, argues that "[t]he phrase a garden in Eden, in the east (RSV) makes it clear that Eden is a locality here, not a symbol... [and]... means 'delight.'"[15]

A major theological error made by many laymen and some preachers is that they regard "work" itself as a curse—the result of man's Fall. Such a belief is unbiblical. *We might correct this false notion by saying God created man to be a worker, but since the Fall he has become a laborer.*

Bruce Waltke and Yu argue that God placed humanity in this temple-garden not to till it, but to engage in other horticultural activity directed toward the garden (cf. 3:17-19). Since the garden is, inferentially, a temple, human beings are inferentially priests. The responsibility to

[12]Adam gives his wife, Eve two names: The first was "woman," a generic designation with theological connotations that denote her relationship to man – she is someone taken out of man, a helper (Gen. 2:23). The second, Eve is "life." This was given after the Fall and refers to her role in the procreation of the human race (Gen.3:20).

[13]Bruce K. Waltke with Charles Yu. *An Old Testament Theology: an exegetical, canonical, and thematic approach* (Zondervan: Grand Rapids: Michigan, 2007), 255.

[14]Bruce K. Waltke & Charles Yu, 255.

[15]Bruce K. Waltke & Charles Yu, 256. Also, Derek Kidner, *Genesis: An Introduction & Commentary* (Downers Grove, Illinois: Inter-Varsity Press, 1967), 62.

'take care of and to 'work the garden are priestly terms for worship.[16] However, the context of the passage makes it clear that work was part of God's original plan for man (Gn. 2:15); work did not come as a result of the Fall.

I can affirm Waltke and Yu's view of Adam's priestly role in the sense that he had access to God in his original state and fellowship with God as a steward of His creation. Also, in terms of the temple, it can be understood in the New Testament sense of man being the temple of God (1 Cor. 3:16-17). Because Adam had the uncorrupted breath of God in him, his body was a temple; where he lives can be considered a temple because of God's presence. The problem with Christianity is that our focus is on the infrastructure to be the temple of God and not on the man who worships in that temple.

I believe that Adam was put in charge of the garden – "to cultivate and to keep" it (NASB). The word keep (*shamar*) refers to shepherds who keep watch over the flocks (1 Sm. 17:20), as well as the farmer who cares for the garden. A priest is a mediator who offers sacrifices for sins and keeps watch over those God has entrusted to him.

However, Adam was free and responsible to work in the garden and eat of every tree in the garden except the forbidden tree (Gn. 2:16-17). After the Fall, he was also barred from eating of the tree of life. What is not clear from the account of "work" is, the methodologies and processes that Adam used or would have used to till the ground while in his original state. Missionaries need to be taught that their labor in Christ's service will face many obstacles and hindrances. This is due to the dire effects of the Fall. In Genesis 3 the narrator focused on the original pair's disobedience and its harmful results. Man's disobedience resulted in four problems:

First, the serpent was cursed above all the livestock and all the wild animals. The serpent was to *crawl* on its belly and live on dust with a perpetual enmity with the *offspring* of the woman – "… he will crush your head, and you will strike his heel" (Gen. 3:15*NIV*). *This redemptive-historical thread can be traced from this text (Gn. 3:15) all the way to the Cross of Calvary. In fact, this is the first proclamation of the Gospel in the entire old and New Testaments.* Waltke & Yu provided important information about the serpent, "In the ancient Near East, serpents are rich in symbolism:

[16]Waltke & Yu, 259.

of protection (Egyptian Uraeus) and healing, of fecundity (Canaanite fertility goddess), of recurring youth (renewal of skin) as well as wisdom and magic (Nm. 21:9; 2 Kgs. 18:4), and of evil and chaos...."[17]

But, F. E. Roop warns Christians against using this text as the key for "Messianic interpretation." He made this direct allegation against some Roman Catholic and Protestant circles. He argues that given the language of the text, it is not without problems. The word *seed* consistently refers to "descendants" (a collective), rather than an individual.... He advises interpreters to lay aside the allegorical interpretation of the patristic medieval interpreters and go with the more literal understanding.[18]

Roop's scholarly lens missed the exegetical aspect of the word "seed." He fails to understand that there were several descendants from Eve, but it was one "seed" that bruised the head of Satan. All the covenantal fathers (Noah, Abraham, Isaac, Jacob, David, etc.) were descendants and seed-bearers but they were not the Messiah. They also looked forward to the coming Seed, who would crush Satan and deliver the fallen creation from the Adamic curse.

What is confusing to Roop is the parallelism embedded in this text: *The "Seed" of the woman was within her seeds.* For example: in every household in Judaism there was always a seed. But this seed comes for physical deliverance and blessing. The seed-bearer in the household of Adam was Seth, his third son, not Cain the first born who, out of jealousy, killed his brother Abel (Gn. 4:1ff). In Noah's household, the seed-bearer was Shem, his first born. In Abraham's household, the seed-bearer was Isaac, not Ishmael his first born. In the house of Jacob, the seed-bearer was Judah, not Joseph. Joseph provided physical deliverance from some of the dire effects of the Fall (famine) for his people. His dreams of temporal sovereignty were fulfilled; he did not carry the Messianic line. In fact, Joseph's life paralleled the life of Christ in many respects (A.W. Pink lists 100 parallels in *Gleanings in Genesis!*). But, at the death of Jacob, the Scepter was given to Judah (Gn. 49:8-9-12*NIV*). From the household of Jesse, who hailed from the tribe of Judah, came the seed-bearer, David the great King of Israel; it was not his oldest brother Abinadab (1 Sam 16:1-13*NIV*). Finally, from the

[17]Waltke & Yu, 260.

[18]F.E. Roop, Genes. *Believers Church Bible Commentary* (Herald Press: Scottsdale, PA, 1987), 41.

lineage of David came the final Messianic "Seed" Jesus Christ; He was born from the line of David by the Virgin Mary (Matt. 2:1-12). Walter C. Kaiser Jr., affirms, "The plan of God had from the very beginning the central figure of the "Seed" who was to come in the person of the Man of Promise, the Messiah. It was a message aimed universally at all people groups and nations from the very beginning."[19]

All the seed-bearers mentioned above were merely types of the promised Messiah in both their sufferings and glory. Imagine what David went through with King Saul who sought to kill him. Eventually David, a man after God's own heart, was crowned with honor and glory. Christ is also called the Son of David.[20] He reigns in the heavenly kingdom forever. The Hebrew word, *zera* (seed) and the context in which it is used cannot be taken out of context as Roop had suggested. Those who are accused of allegorizing the word *had indeed done justice to the text over the years by their Messianic interpretation.*

Second, the woman was cursed. In pain she would give birth to children; her desire, instead of being submissive to God by supporting her husband, would now be expressed in *strife* with her husband. He would lord it over her (Gn. 3:16). In spite of all the modern developments in modern medicine, there is always some sort of pain for women in childbirth. Note also the women's rights campaign globally.

A contemporary theologian speaks out exegetically with a fresh look at Genesis 3:16b. Susan T. Foh published an insightful article in the Westminster Theological Seminary Journal. Her article is entitled: *"What is the Woman's Desire?"* In this article, Foh reviewed three

[19]Walter C. Kaiser Jr. *Mission in the Old Testament: Israel as a Light to the Nations* (Grand Rapids, Michigan: Baker Books, 2005), 27-28.
[20]First Matthew calls Jesus son of David, a title of the rightful heir to Israel's throne (as in Jer 23:5; 33:15). Other lines of evidence support the claim that Jesus' family stemmed from this royal lineage (for example, Rom 1:3;) and ancient Jewish polemicists never bothered to try to refute it. Thus Matthew opens and closes the genealogy with a title for Jesus that is significant but rare in his Gospel: Jesus Christ, that is, the messianic king (1:1, 18). He also records that during Jesus' triumphant entry into Jerusalem, "The crowds that went ahead of him and those that followed shouted, 'Hosanna to the Son of David!' Blessed is he who comes in the name of the Lord!, Hosanna in the highest'" (Mat. 21:9). The religious leaders knew exactly what the shouting song meant. He is the fulfillment of the Davidic Kingdom that would be established forever (2 Sam. 7:14-16).

interpretations of הקושת [tashuwqah] in Genesis 3:16b and presented her translation:[21]

(1) הקושת [tashuwqah] is frequently equated with sexual desire. The woman's craving for her husband.
(2) הקושת is viewed as "the desire that makes her the willing mate."
(3) Calvin states that Genesis 3:16b means that the woman will desire only what her husband desires and that she will have no command over herself.

Foh rejected these translations for three reasons: (1) the interpretation of השו [tashuwqah] as sexual desire appears to be contradicted by etymology. The verbal root appears to be קוש. BDB relates הקושתto the Arabic root šāqa, to desire, excite desire. This suggests that the proper etymology in Arabic would be sāqa, to urge, drive on, impel. (2) The rule of the husband is not a result of, or punishment for sin. Foh argues that the headship of the husband over his wife is a part of the creation order. And (3) the tyrannous rule of the husband seems an appropriate punishment for the woman's sin. "But" Foh further notes that, "willing submission contradicts the context of judgment and clashes with the New Testament commands for wives to submit to the husband's authority (Eph. 5:22; Col. 3:18; 1 Pet 3:1), as well as experience."[22] In her research, Foh discovered that the Hebrew word הקושת occurs only three times in the Old Testament (Gn. 3:16; 4:7; Song of Solomon 7:10). And that the same Hebrew word used in Genesis 3:16b and 4:7b with an exception for appropriate changes in person and gender. Translation of either text with different meanings does not do justice to the texts. The interpretation of Genesis 4:7b is clearer. From the context, we note that sin's desire to dominate Cain involves mastery or enslavement. Cain did not win the battle to rule over sin. Similarly, man is in constant battle to rule his wife. Foh concludes, [23]

Contrary to the usual interpretations of commentators, the desire of the woman in Gen 3:16b does not make the wife

[21]Susan T. Foh, *Westminster Theological Seminary Journal*, WTJ 37:3 (Spr. 75), 377-81.
[22]Susan T. Foh, p. 378-81
[23]Susan T. Foh, pp. 370-381.

(more) submissive to her husband so that he may rule over her. *Her desire is to contend with him for leadership in their relationship.* This desire is a result of and a just punishment for sin, but it is not God's decretive will for the woman. Consequently, the man must actively seek to rule his wife. (Italics mine.)

Third, the ground was cursed including Adam. Man is now required to produce the fruit of the cursed ground through *painful toil* all the days of his life (Gn.3:17-19). Robert C. Harbach thinks the first curse pronounced against a human being ... was on Cain.[24] But the context of the text indicates that Adam also was cursed to labor in the midst of "thorns and thistles." Most importantly, Adam and Eve were now to live out of the presence of God.

Fourth, death reigns over man because of sin. Death means separation of the spirit from the body (Jas. 2:26). What if post-Fall Adam and Eve had eaten of the Tree of Life? History would have taken a different twist. Satan's objective for his deception was to first kill *man spiritually.* Spiritual death eventually leads to physical and sometimes eternal death. Physical death is when the spirit is separated from the human body, which then dies as one aspect of God's judgment. Spiritual death may be described as the distortion of our spirit's "sensor."[25] God created this sensor so that man will fellowship with and communicate with Him. When Adam and Eve disobeyed God, the first death that occurred, instantaneously, was the demise of their *spiritual sensor.* This was their first (spiritual) death! In redemption, the *spiritual sensor* can be restored through knowing God and placing faith in Jesus Christ. God created us with five senses to relate to this world; equally so, He created us with a *Spiritual Sensor* to relate to Him. And finally, eternal death occurs after the final judgment. *This is total separation from God forever! Man's greatest enemy is death. But since death could not hold Jesus our Redeemer in the tomb, because of His sinlessness the Good News is, death will not hold back from life those who are in Him.*

[24]Robert C. Harbach. *Studies in the Book of Genesis* (Grandville, Michigan: Reformed Free Publishing Association), 103.

[25]A lecture delivered by Dr. David Nicholas, founding pastor of Spanish River Church and the Church Planting Network, Inc., at his Gospel Boot Camp held in Boca Raton, Florida from May 3-4, 2010. Details of this concept can, also, be found on page 8 in his Gospel tract-booklet – *Life: What's it all about?*

God expelled Adam and Eve from the Garden of Eden (Gn. 3:23 *NIV*). The first family had experienced the important role of stewardship, as farmers in the essential community life. They took the ideas of stewardship and community with them as part of their new lifestyle out of God's immediate presence. Adam became the first traditional farmer tilling the cursed ground. Man must return to this paradisiacal Garden or his life will be characterized as vanity. He also was created for community. *Hence, the building of the first city and garden by Cain was intended to recover the lost community of Eden.* Man's agricultural system is cursed and it is his desire to keep the original tie with his Creator as if the Fall never happened. On the other hand, the City of Man is so corrupt with violence and injustice and wickedness (Gn. 4:1ff) because of the Fall that it continues under God's judicial verdict of condemnation.

An exegetical look at the idea of the curse is essential for this study. The opposite of cursing is blessing. These are two unique words in Scripture because one reverses the other. As we discussed above, Adam, Eve, Cain, serpent and the ground were cursed (Gn. 3:15; 4:1ff). Robert Harbach argues that only the serpent, ground and Cain were cursed in Genesis 3-4. In refutation, let us first define the word curse biblically and semantically. Woods and Marshall provide the following definition in their *New Bible Dictionary*: Curse.[26]

> The main biblical vocabulary of the curse consists of the Heb. synonyms corresponding to the Gk. *kataraomai, katara* and *epikataratos*; and the Heb., corresponding to the Gk. *anathematiz*; and anathema. The basic meaning of the first group is malediction. A man may utter a curse, desiring another's hurt (Jb. 31:30; Gn. 12:3); or in confirmation of his own promise (Gn. 24:41; 26:28; Ne. 10:29); or as a pledge of the truth of his testimony in law (1 Kgs. 8:31; cf. Ex. 22:11). When God pronounces a curse, it is, a. a denunciation of sin (Nm. 5:21, 23; Dt. 29:19–20), b. his judgment on sin (Nm. 5:22, 24, 27; Is. 24:6), and c., the person who is suffering the consequences of

[26]D.R.W. Woods & I. H. Marshall. *New Bible dictionary, 3rd ed.* (Downers Grove, Ill.: InerVaersity Press, 1996), 248.

sin by the judgment of God is called a curse (Nm. 5:21, 27; Jer. 29:18....

A careful analysis of this definition indicates that "curse" from God's perspective is a matter of divine justice. Its purpose is to punish the one that had sinned against God and to bring him to repentance. A curse by humans is viewed as having autonomous magical power; the *bulk of recent scholarship argues that curses, both human and divine, originate in the holiness of God (Is. 45:7).* I conclude that a curse places one in an uncomfortable condition—a condition of need, pain, and suffering.

It is misleading for anyone to argue that Adam was not cursed when, in fact, he and his wife were driven out of their comfortable garden. They were required to till the cursed ground, which will now have "thorns and thistles." The woman was now to have pain in child birth and be dominated by her husband. In fact, in the New Testament, cursing remains a sign of God's power, e.g., Jesus curses the fig tree (Mk. 11:12-14, 20-22). In Galatians 3:10, Paul seems to acknowledge the OT understanding of the curse as a divine legal sanction; yet he argues that Christ, in becoming "a curse for us" has overturned this aspect of the law. This allows for God's blessings to be bestowed upon both believing Jew and Gentile alike. He is fully prepared, however, to curse those who do not love the Lord (1 Cor. 16:22) or who teach a corrupt Gospel (Gal. 1:8-9). Jesus counsels against swearing vain oaths (Mt.5:33-37) and instructs the crowd, "to bless those who curse you, pray for those who abuse you" (Lk. 6:28; likewise Paul, Rom. 12:14).

In the Old Testament, God prevented Balaam from cursing Israel (Nm. 21-22), and David on his deathbed instructed Solomon not to neglect the punishment due Shimei for cursing him at Mahanaim (1 Kgs. 2:8-9). A curse was also pronounced against Canaan, (Noah's grandson), (Gn. 9:24-27), Meroz, (Jgs. 5:23), Gehazi, (2 Kgs. 5:27), etc. In particular, to curse either God or the monarch was regarded as a crime of utmost significance (Ex. 22:28; 1 Kgs. 21:10), although Proverbs 26:2 notes that an unfounded curse would not come to fruition. The idle utterance of an unjust curse, in anger or in jest, remained extremely dangerous. The primitive Christian community used a curse as a means of separating itself from false brethren (1 Cor.16:22; Gal.1:8-9).

Growing Crops after the Fall

Growing crops from a biblical perspective means man is currently living under a curse on the land. Man was created in the image of God to care for His creation. But his disobedience throws him out of God's presence with a *judgment to labor amidst thorns and thistles while tilling the ground. He is to earn his living by the sweat of his brow (Gn. 3:17-19).*

The first sentence of the curse fell upon Adam and then upon his son, Cain who murdered his brother Abel (Gn. 4: 11-12). The remedy of this curse comes through faith in Jesus Christ, and only *then as the curse will fall on Christ upon His cross.* Notice in the sequence of "household rules" in Ephesians 5 and 6, that there is a reversal of the curse among believers in relation to marriage, family and work. The hymn, "Joy to the World" says, "He makes His blessings flow, far as the curse is found." Missionaries are required to understand the foundation of sin and God's redemptive plan for reconciliation and the restoration of man (2 Cor. 5:18-19).

The record of farming with Adam's family was also discouraging. Adam and his wife had two children: the first born was named Cain[27] and the second son was Abel (4:1ff). Cain was a farmer and Abel was a shepherd. In the course of time, these two sons of Adam came and offered sacrifices unto the Lord. Cain offered some fruits from the cursed soil and Abel (which means exaltation – from that which ascends) "brought fat portions from some of the firstborn of his flock." The Lord showed favor on Abel's offering. Abel's offering was accepted because it was a blood sacrifice which represented the idea of substitution that was offered in faith. James M. Boice also affirms, "Abel's sacrifice involved blood and therefore testified to the death of a substitute. He was coming to God as God had shown He must be approached. God killed animals in the Garden of Eden and then clothed Adam and Eve with their skins. By this God was showing

[27]"The translation unfortunately does not give the full force of what Eve said. We need to note two things. First, the word "Cain" either sounds like or is actually based on the Hebrew verb qanah, which means "acquired." So when Eve says that she has 'brought forth' or 'acquired' a man from the Lord, she is either punning on the name Cain or actually explaining why that name was given to her first child. In view of the promise [from God] of a deliverer [Gen. 3:15], the name probably means 'Here he is' or 'I've gotten him.' Eve called her son 'Here he is' because she thought the deliverer had been sent by God." [But unfortunately, he was a killer not Christ] (James Montgomery Boice *Genesis Vol. 1* (Grand Rapids, Michigan: Baker Books, 1998) 250.

that, because sin means death, innocent victims must die in order that sinners might be pardoned. The sacrifices pointed forward to Christ."[28] The serpent *filled the heart* of Cain with envy and *anger* and he murdered his brother Abel. Consequently, God cursed Cain: "When you work the ground, it will no longer yield its crops for you. You will be a restless wanderer on the earth" (Gn.4:12). Cain appealed to the Lord for mercy and God was gracious to him.

In reversing part of Cain's punishment, God placed a mark on Cain for his safety. The mark notified people that anyone who killed Cain would suffer vengeance "seven times" more from God. The kind of "mark" placed on Cain has been the issue of debate among commentators. Some believed that it was the Hebrew letter tau (a cross); some said it was letter of Jehovah. Others maintained that it was the perpetual trembling of his hand. Others had argued that it was a mark that symbolizes "grace" so that anyone finding Cain will spare him. Since there is no actual description of the "mark," it is better to leave it as it is than to conjecture any meanings. We will not understand everything about God and His Word in this life.

Accordingly, Cain left the presence of God and lived in the land of Nod, east of Eden. He took a wife (presumably a sister or cousin), had a son and named him Enoch. Cain built a city and named it after his first-born son Enoch.

God, again, blessed Adam and his wife with a third son, Seth (meaning *God gave*). Seth had a son and named him Enosh, meaning "man in weakness," the father of the faithful. Noah descended from the line of Seth. St. Augustine argued in his *City of God* that two cities arose from this episode: Cain authored the *City of Man* while Abel (the church's proto-martyr) authored the *City of God*. There has always been tension between these cities because the *City of Man* is concerned about vanities, earthly things while the *City of God* is focused on heavenly things.[29]

Another garden mentioned in Scripture is the Noahic garden (Gn. 9:20). After the flood[30] Noah planted a garden. He drank its wine excessively until

[28]James Montgomery Boice, *Genesis Vol. 1, 251.*
[29]Saint Augustine. *The City of God.* Translated by Marcus Dods (New York: Modern Library, 2000) xviii.
[30]Warren Gage calls the antediluvian: the original creation of the earth (Gen. 1:2) and parallel of the flood a recreation (Gen. 8:1b-2) out of the deep and chaotic waters

this righteous man lost his self-control and lay naked. There is a parallel to be seen with the nakedness and shame of Adam in the Garden of Eden. Here is the reenactment of the serpent's reappearance in that garden utilizing the fruit of the vine (Gn. 9:21b). Rather than subduing and controlling the earth as the Lord had commanded (Gn.1:28), a product of the earth had subjected Noah to its control. Man is in the middle of a crossroads: *he either obeys God or Satan.*

Ham saw his father Noah's nakedness (Gn. 9:22) and mockingly informed his brothers. Shem and Japheth respectfully covered their father by walking in a backward direction so as not to see his nakedness. God commands us to honor our parents (Ex. 20:12) and that also means we will hide their nakedness, moral weakness, material poverty, and to help meet their needs (Mt: 15:1-5). Sobering up from his drunkenness, Noah cursed Canaan, Ham's youngest son. This verse has been wrongfully used to support racial prejudice and even slavery. Noah's curse, however, wasn't directed toward any particular race, but rather at the Canaanite nation – a nation God knew would become wicked. The curse was fulfilled when the Israelites entered the Promised Land and drove the Canaanites out (see the book of Joshua). Derek Kidner affirms, "For his breach of the family, his own family would falter. Since it confines the curse to this one branch within the Hamites, those who reckon the Hamitic peoples in general to be doomed to inferiority have therefore misread the Old Testament as well as the New."[31]

The purpose of Noah's curse of Canaan is debated among scholars. Some feel that his grandson had taken part with Ham in mocking Noah or had done something that made Noah angry. But there is no evidence in the text to support that. Another proposed solution may be related to the effects of the alcohol. Perhaps Noah woke up and in sobering state, felt that Canaan was the one that saw his nakedness. And he cursed him in haste under the influence of shame and anger. But these and many other suppositions are not found in the text. Bruce Waltke and Fredericks Cathi argue that, "As the youngest son wrongs his father, so the curse will fall on his youngest son, who presumably inherits his moral decadence (see Lev. 18:3; Deut. 9:3). In addition to

aided by the sending of the "wind" (rûah). This concept of the wind (Spirit) of God can be extended to the creation of Israel and of the Church.
[31]Derek Kidner. Genesis: *An Introduction & Commentary*, 104.

the Canaanites, Ham's descendants include some of Israel's most bitter enemies: Egypt, Philistia, Assyria, Babylon …."[32] Noah blessed Shem and Japheth (Gn. 9:26-27). These three sons of Noah covered the entire earth: "Shem's descendants were called Semites—Abraham, David, and Jesus descended from Shem. Ham's descendants settled in Canaan, Egypt, and the rest of Africa; Japheth's descendants settled, for the most part, in Europe and Asia Minor.

Noah's curse divided his household. By cursing Canaan, this action indirectly excluded Ham from the fellowship of his family. *Canaan was cursed to become the lowest of slaves…*to his brothers (Gn. 9:25-27). The blessing on Shem was, "may Canaan be the slave of Shem" (Gn. 9:26). The blessing of Japheth was, "May God extend the territory of Japheth; may Japheth live in the tents of Shem." Because Noah was being controlled by his own product, another seed of injustice and hate was sown through his curse.

The following are some miscellaneous references to farming in both the Old and New Testaments:[33]

- General references – Old and New Testaments: Gn. 2:15; 3:17-19; 4:2; Prv. 12:11; 20:4; 28:19; Is. 7:25; (Ez. 36: 9, 34; 2 Sm. 9:10; Eccl. 5:9; Mi. 4:3; Jb. 1:14; Dt. 22:10; Lv. 19: 3-5; 25:4-5, 11.
- Specific and figurative gardens mentioned in Scripture: Gn. 2:8; 3:23; Ez. 28:13; 31:8-9; Rv. 2:7; 2 Kgs. 21:18, 26; 25:4; Neh. 3:15; Est. 7:7; Jn. 18:1; 19:41.
- Similitude of the Garden of Eden found in Scripture: Gn. 13:10; Ez. 36:35; Jl. 2:3; Nm. 24:6; S. of S. 4:12; Is. 58:11; Jer. 31:12: Is. 1:30.
- Vineyards mentioned in both Old and New Testaments: Sg. 1:6, 14; 8:11; Jgs. 14:5; 1 Sm. 8:14; 22:7; 1 Kgs. 21:1–18; Hos. 2:15; Ex. 23:11; Is. 61:5; Gn. 9:20; Prv. 31:16; Eccl. 2:4; Ps. 107:37; 2 Kgs. 19:29; Is. 37:30; 65:22; Ez. 28:26; Mi. 1:6; 1 Cor. 9:7; Am. 5: 11; 9:14); Dt. 28:29-30; Jer. 35:7, 9.
- Metaphorical vineyards: Is. 5:1–7; 14; 27:2-3; Jer. 6:9; Mt. 20:1, 4, 7; 21:28, 39; Lk 13:6; Jn 15:1.

[32]Waltke & Cathi, 150.

[33]Collins, Day A. *Collins thesaurus of the Bible* (Bellingham, WA: Logos Research System, Inc., 2009) no page number; but search for "farmer."

- Metaphorical plowing: (Jb 4:8); Hos. 10:13); Ez. 36:9; Hos. 10:11; Jer. 26:18; Mi. 3:12.
- Metaphorical planting: Eccl. 3:2; Ez. 15:17; 17:22; 1 Chr. 17:9; Jer. 24:6; 31:28; 42: 10; Is. 61:3; 1 Cor. 3:6–8; Is. 40:24.

Reflecting on the Old Testament, in regards to farming, Jesus also used agricultural language in His teachings. We shall treat these separately below. Missionaries need to understand that the Great Commission is like commencing an agricultural industry. It requires finding the right farmland, clearing it, plowing, sowing seeds, and harvesting. It involves restoring and securing that which has already been stored in the barn through the power of the Holy Spirit.

Man is a Slave to His Product

The curse on the ground due to Adam's disobedience also means, man has now become a slave to his own product. There is much hard work in the traditional farming system. And because of population growth globally, there will certainly be times of famine with the natural farming system. Man, through modern technology, invented inorganic chemicals that are used in catering to the growing demand of populations globally. With modern technology in agriculture, with poultry, chicks take about 4-6 weeks to be marketable while organically, it should have taken 6-9 months. This is achievable by using various chemicals to feed the chicks. These added chemicals are also used to feed some livestock. The chemically-quick-growth food is consumed by us as we consume meat and poultry. We agreed that these are safe because experts have spoken or given their approval. No wonder that food additives yielding obesity has engulfed this land and plagued many countries with various diseases. We forget that the chemicals that caused such rapid growth when consumed by us can also cause obesity or other ailments in our body. Every canned food sold has an expiration date approved by some experts. We are at the mercy of experts instead of God. The New Zealand Food Safety Authority observes,[34]

[34]The New Zealand Food Safety Authority's website: http://www.nzfsa.govt.nz/consumers/chemicals-nutrients-additives-and-toxins/#P18_2042; accessed March 26, 2010.

Everything is made from chemicals, including food. We eat food to get the chemicals we need to grow and stay healthy. Food may also contain other chemicals. These include additives, toxins, contaminants and agricultural compounds. Some of these occur naturally in the food and others are added. At high enough concentrations, some of these can cause illness. For most foods, we monitor and control the presence of any harmful chemicals (natural and added). For those that are not controllable, we provide recommendations for food intake and management.

Three major facts are stated here: (1) We need chemicals to be healthy—both *natural and added*, (2) high usage of some (those added) can cause illness. And (3) the solution is the monitoring and controlling of the natural and added, and the usage of added chemicals. *The above statement does not deny the danger of chemicals in food production.* The fact is the dangers are there, but it can be controlled by experts (researchers). They will teach farmers how to safely use the added chemicals for massive production of assorted food.

A pivotal fact we need to think about is that man's decisions always determine his future. Adam and Eve deliberately decided to obey the serpent—they wanted to be like God. The effect of this resulted in their expulsion from the Garden of Eden. Noah was a gardener; his decision to drink an excessive amount of wine, a product of his farm, gave birth to a curse on Canaan. His action finally resulted to a split within his family. He tragically became a slave to his own product. The same is true with man's decision in inventing "added toxic chemicals for quick-food production. *The serpent has reappeared in our modern agricultural system.* The corrupting result is diverse diseases and even death. Man is being controlled by his own invention. The truth is, any decision without God has always been detrimental to mankind. So, the only solution is to return to God and His principles. Missionaries need to understand this global health problem. *Accepting Jesus Christ as Lord in every sphere is the only means of escape from this curse on the world caused by all its selfish decisions.*

Missionaries are to understand that God's "grace" started in the Garden of Eden when He promised the Messianic seed in the *protevangelium* (Gn. 3:15). He provided the *typical covering* for our first family (Gn. 3:21) and a promise of restoration (Gn. 3:15). Though the

ground was cursed, including Adam and his descendents, yet God provided rain for crops to sustain mankind. The Israelites knew that the land and its products were gifts from God. This was central to their religion. Hence, their three major pilgrim festivals are believed to have been derived from agricultural observances:[35]

> The Passover and the Feast of Unleavened Bread, observed in the spring (Exod. 12:1–13:16; 34:18–20; Lev. 23:4–14); Pentecost or the Feast of Weeks, celebrating in June the harvest of the first fruits of the grain (Exod. 23:16; Lev. 23:15–21); and the Feast of the Ingathering or Booths, commemorating the autumn harvest of grapes (Exod. 23:16; Deut. 16:13–16). The Sabbath may originally have been an agricultural day of rest for farm workers as well as animals, and the sabbatical year may have derived from the practice of allowing fields and vineyards to lie fallow in order to replenish the soil (Exod. 23:10–11; Lev. 25:3–5). Much of the Pentateuchal legislation concerned responsible stewardship of the land and its produce (e.g., Deut. 14:22–29; 22:1–3, 9–10; 24:25), including provision for the less fortunate (24:19–21; 26:12) and the return of a portion as an act of thanksgiving (15:19–16:17).

Freedman, Myers, and Beck concur with the above conclusion. According to their "Analysis of the Gezer Calendar, it shows that the three pilgrimage festivals (Passover/*Pesaf*, Weeks/*Šabuôt*, Booths/*Sukkôt*), which started as agricultural celebrations, occur in accordance with its seasonal divisions."[36]

These three festivals were also practiced in the New Testament era. Jesus used several agricultural images in parables, and metaphors in preaching about the kingdom of God.

Missionaries are to imitate Christ in understanding the languages, parables, stories, metaphors, religions, and cultures of the peoples or countries to which they minister.

[35]A. C. Myers. *The Eerdmans Bible Dictionary* (Grand Rapids, Mich.: Eerdmans, 1987), 27-28.
[36]Freedman, Myers, & Beck, 28-30.

Having gleaned from the agricultural and biblical perspectives of growing missionaries, I will now discuss my definition of Growing Missionaries Biblically.

Author's Definition of Growing Missionaries

Growing missionaries cross-culturally and biblically is the development of God's sower to sow seeds in preparation for the harvest through theological, anthropological, religious and cross-cultural communication education, to effectively proclaim the Kingdom of God to everyone. This definition is divided into two parts, and treated respectively below:

First, growing missionaries means developing God's cross-cultural sowers to sow the Gospel seeds in preparation for the harvest. The parables of Jesus in the Gospel of Matthew 13:1-52 play an important role to the right understanding of cross-cultural ministry of the sower. A parable may take the form of a story or a simile or a metaphor: Parables are sometimes defined as "an earthly story with a heavenly meaning."[37] Davies and Allison point out that, "When Jesus spoke in 'parables,' he was relating himself to a literary tradition firmly rooted in the OT, one which lived on in apocalyptic literature and the rabbis."[38] Also, the Middle Eastern mind-set is in concrete terms, in images and stories that are the best method of communication. The prophet Nathan told King David a parable about a pet ewe lamb in regard to Uriah's wife with this notable phrase: "You are the man!"(2 Sm. 12:5-7 NIV).

The study of parables diachronically revealed the possibility of its abuse. Jesus' parables have been understood by some mysteriously and allegorically. However, the Greek *parabole* is wider than our English word *parable*; in the LXX, it translates *masal*, which includes proverbs, riddles, and wise sayings as well as parables. Davies and Allison provide a thumbnail historical summary of those scholars that made significant contributions to the interpretation of parables: [39]

[37]Grant R. Osborne. *The Hermeneutical Spiral: A Comprehensive Introduction to Biblical Interpretation* (Downers Grove, Illinois: IVP Academic, 2006), 292.
[38]Davies W. D & Alison Dale C. *Matthew: A shorter Commentary.* Edited by Dale C. Allison, Jr.(New York, New York: T & T Clark International, 2004), 208.
[39]David & Allison, 210.

1. Adolf Jülicher is to be credited. His book, *Die Gleichnisreden Jesu*, published in 1888 on Jesus' parables made a dramatic turn in the understanding of parables. He argued that *Jesus spoke in parables and not in allegories.* He interpreted the parables as pedagogical illustrations of general moral and religious truths. "For example, he took the parable of the laborers in the vineyard (Mt. 20:1-16). But his approach did not consider both Christology and eschatology. Jülicher did not take into consideration the rabbinic corpus of parables, which illuminates Jesus' words. But his book influenced others to rethink their interpretation of parables.

2. C. H. Dodd published an influential book in 1935, *The Parables of the Kingdom.* In this book, he related the parables not to religion in general, but to Jesus' ministry in particular. Additionally, Dodd taught a realized eschatology which is consistently reflected in his parables. For example, the parable of the sower implies that the ministry of Jesus is the time of the eschatological harvest while the parable of the bridegroom (Mark 2:18-19) teaches that the messianic time has commenced; and the parable of the pearl (Mt. 13:45) means that the great treasure of the Kingdom of God can be possessed even now.

3. Joachim Jeremias came third after Dodd. In his book, *The Parables of Jesus*, first published in German in 1947, he takes up where Dodd left off. He replaced Dodd's realized eschatology with eschatology in the *process of realization.* Jeremias also made a contribution by arguing that Jesus' stories or parables were his reflection on the old rabbinic texts. Jeremias focuses on the interpretation of parables in their original setting, in the life of Jesus. Dodd began this methodology, but Jeremias implemented it.

Notwithstanding, besides these, there are many newer important scholars that have contributed to the study of parables (e.g. Darrell Bock and Kenneth Bailey), but (Jülicher, Dodd, and Jeremias) remain the most influential to this day. The parables of Jesus come as a result of the rejection experienced by Himself and His disciples. Why was the Messiah opposed? The answer to this question is given in Matthew

4:3-9 which tells about Satan's three temptations of Jesus. Satan also blinded the minds of the people of Israel (Is. 6:9-10; 2 Cor. 4:4). R. T. France points out that, "to know the truth about the kingdom of heaven is to know the secrets. The Greek *mysterion*, used only here in the Gospels [Mt. 13:11], became important for Paul to indicate that God's truth comes only by revelation, not by natural insight."[40]

Jesus knew the importance of contextualization. He used agricultural metaphors with eschatological meaning in teaching about the Kingdom of God. Farmers, in Jesus' day, depended exclusively upon God to send rain for their crops to grow. Today, many of us cannot relate to this because of modernized professional farming with modern irrigation technology. If anyone wants to purchase food, Sam's Club or Publix is the answer. In those days, every family had to have a farm or garden in order to have food. Just like today, our farm is a job; a man cannot provide food adequately for his household without it. This is why the Old and New Testaments are replete with agricultural language. The Lord is using what His contemporaries could relate to in presenting His heavenly message.

In some of His parables, Jesus emphasizes that proclaiming the kingdom of heaven is like *farming*. Commenting on the first parable of the sower, Leon Morris writes, "… but in Palestine it was common for the sower to sow his seed first and then plough it in …. P.B. Payne has produced evidence that both practices were in vogue: sometimes farmers ploughed the land first to clear it of weeds, sometimes they did it after sowing to put the seed underneath the soil, and sometimes they did it both times."[41]

Pivotal to this text is the sower. The Hebrew word *zara* has fifty-six occurrences; the Authorized Version translates *zara* as "sow" forty-seven times, "yielding" three times, "sower" twice, "bearing" once, "conceive" once, "seed" once, and "set" once. It means to sow, scatter seed.[42] The Greek, *speriro* also means to scatter seed over tilled ground.

[40]R. T. France Matthew: *Tyndale New Testament Commentaries*, edited by Canon Leon Morris (Grand Rapids, Michigan: Inter-Varsity Press, 1988), 221.

[41]Morris, L. *The Gospel According to Matthew* (Grand rapids, MI: Inter-Varsity Press, 1992), 336.

[42]J. Strong. *The exhaustive concordance of the Bible: Showing every word of the text of the common English version of the canonical books, and every occurrence of each word in regular order,* electronic ed. (Ontario: Woodside Bible Fellowship, 1996), H2232.

But what is to be noted here is that Jesus used the sower as an analogy to describe the life and work of kingdom workers. Jesus drew a parallel between the everyday hardships farmers faced and the obstacles that kingdom messengers face. In spite of His redemptive mission, Jesus and His disciples faced severe opposition from Satan manifested through various opponents.

Let us examine the meaning of these agricultural parables separately. I shall focus on the interpretation instead of stating these familiar parables:[43]

- *The Sower.* Jesus gives the interpretation of His parable to His disciples privately (Mt. 13:11, 16-17): The seed is the Word of God which is sown by Jesus in the world. The seed that fell along the path represents the hearers of the Word who are without firm understanding, Satan takes away the seed. The seeds that fell on rocky places represent professing Christians who accept or receive the Word; but, because of the concerns of this world, they did not retain nor nurture its growth; and they eventually fall away (Mt.13:20-21). The seeds that fell among the thorns represent those who have the capacity to be good Christians; but their growth was choked out due to the enticement of the things of this world (Mt. 13:22). The seeds that fell on good soil represent those who enthusiastically accepted the Word of God and allowed the Holy Spirit to nurture it in their hearts. The Holy Spirit leads them to a disciplined and fruitful life (Mt. 13:23).
- *The Wheat and the Weeds.* Jesus Christ is the owner of the field. He sows good seeds, but the enemy (Satan) sows weeds on the same field. In an effort to rid the field of the weeds by the workers, the Master advised them to leave that part of the job. God will send the professionals (angels) for the end-time harvest. During the harvest, the wheat will first be harvested and safely stored in its barn while the weeds will be burnt (Mt. 13:30).
- *The Mustard Seed and the Yeast* (Mt. 13:13-35). The parables of the mustard seed and the yeast demonstrate the *small beginnings of*

[43]Tokunboh, Adeyemo., ed. *Africa Bible Commentary: A One-Volume Commentary Written by 70 African Scholars* (WorldAlive Publisher: Nairobi, Kenya, 2006), 1136-1139.

the kingdom; it is just like a drop of water[44] when added to other drops eventually becomes a mighty river. The yeast, however is, on many occasions, used as a metaphor for evil (Mt. 16:6; Mk. 8:15; 1 Cor. 5:6, 8; see also Ex. 12:15). I believe the yeast is here to be interpreted in a positive manner. *This parable focuses on the yeast's transforming quality of an individual for the Kingdom of God.*

- *The Hidden Treasure (Mt.13:44).* This parable was told to demonstrate the seemingly accidental discovery of God's kingdom which surpasses anything we can ever imagine in this world. This treasure can only be possessed where the will of God is obeyed by the one who found it.

- *The Pearl (Mt. 13:45-46).* In Jesus' day a pearl was valuable. The parable indicates that if one finds a perfect pearl – it is worth *sacrificing all one has* to obtain it.

- *The Net (Mt. 13:45-50).* This parable is a parallel with the parable of the sower. A net let down in the Sea of Galilee would catch edible and inedible, clean and unclean fish; the fishermen would have to sort their catch (Mt.13:47-48). Similarly, the world in which the "fishers of men" work will yield nets filled with both bad and good fish. On the day of reckoning, the Lord Himself will sort the good from the bad, distinguishing the children of light from the children of darkness. The former will enter into His blessings and the latter into the fiery furnace (Mt.13:49-50).

In these series of parables Jesus presented the heart of His mission on earth (Mt. 13: 14-16). He praises the Father for His core group of disciples that has accepted the truth about the Kingdom of God. Jesus sees the world as God's farm or field in which He planted good seeds. The sowers are those who are fulfilling the Great Commission (Mt. 28:19-20) and they need to be trained to sow the seeds of God's Word. Missionaries must understand that being a sower entails being sacrificial. The joy for the sowers is that *they are sowing for redemptive purposes.* Therefore, a true missionary must:

[44]"Point of the parable lies in the contrast between this insignificant beginning and the greatest of shrubs which results"(R. T. France, 227).

- *Imitate the ministry of Jesus Christ.* God took on our humanity to save believers. Missionaries must also preach the Gospel, without compromise, in every culture. Christ is our true example: as God, He allowed Himself to be born of a woman. He came into the Garden of His world and yet His own people did not receive Him (Jn. 1:10-11). He preached and taught about the kingdom to both Jews and Gentiles. His key purpose was to reconcile us to Himself (2 Cor. 5:18-19).
- Know God, His Word and the culture to which one is called to minister.
- Believe that from the growing process to harvesting is ultimately the Lord's doing, not man's. The same is true in Christian ministry. The missionary's responsibility is to plant the seeds profusely and indiscriminately, and then *leave the results with God.*
- Believe that God created the world and that the agricultural system is man's way of providing food for himself. But because of the curse on the ground, man is a slave to his own invention. Because fallen man has also lost the ability to worship God, he is now worshipping the creation instead of the Creator. *In this complicated world, Christ calls and sends His missionaries with a message of reconciliation* (2 Cor. 5: 19).
- Like the farmers, the missionaries must seek for God's wisdom (Is. 28:26), be diligent (Prv. 27:23-27; Eccl. 11:6,) and be joyful in working hard for the Lord – toil (2 Tm. 2:6) and be patient in waiting.

Second, how does one grow a missionary to fulfill the Great Commission? It is done through theological, anthropological, religious, communicational, and cross-cultural education. With these tools, a missionary will effectively proclaim the Kingdom of God globally. This does not imply that without such education, one cannot be a missionary; but adequate training is a necessity for more effective ministry. Socrates believed that it is good for a man to know himself: a profound knowledge of oneself and a sound knowledge of what he believes determine the life he lives. Christ knew Himself. Therefore, in spite of all the oppositions that He faced, He knew His way to the cross for the redemption of mankind.

In answering God's call, one has to study His Word – reading through the Bible regularly and devotionally. Most importantly, one needs to be apt to teach—to understand and accurately proclaim the orthodox doctrinal position of His church. – This is the starting point. It is important, if at all possible, that he enrolls in a Bible-believing seminary. A good seminary is an institution that accepts the 66 books of the Bible as the inspired and authoritative Word of God in all matters of faith, life, and practice. A curriculum for seminary education of missionaries is proposed in a separate chapter. Formal religious study is required in the production of God's servants. Religion, in terms of my definition, refers to any faith outside of Christianity. One of the focuses in this book is the need to understand African Traditional Religion and Philosophy. If a missionary is sent to the Islamic world, it is a must that he studies Islam and its culture. Sadly, hundreds of missionaries are in Africa now who do not understand the peoples' religion. Many Africans believe that there are no atheists in Africa. The missionary understanding of their beliefs and practices will enable him to take them from where they are to a saving knowledge of Jesus Christ.

Another area of growing concern is *communication.* There are many courses offered in colleges and universities about public speaking. Understanding cross-cultural communication is an important key to effectiveness in intercultural ministry; *the Good News must have meaning to the people with whom we minister.*

Conclusion

In my effort to define "growing missionaries," I have analyzed it from both an agricultural and biblical perspectives. To grow crops historically is hard work. The shifting cultivation system is preferred as a useful metaphor for missionary training, instead of the modern mechanized agricultural system. The concepts gleaned from the agricultural and biblical perspectives can be applied to growing a missionary. In His series of agricultural parables, Jesus compared agricultural growth with spiritual ministry and personal growth. Like human development, growing is a process.

In shifting cultivation, the farmer must locate an ideal spot for the farm. Not every land/bush is good for traditional farming methods. Traditional farmers are trained. They know how to proceed with the growing process of their crops after the clearing and planting seasons. A farmer works twenty-four hours a day and seven days a week. Here

is the pertinent truth for missionaries: "This is the Word of the Lord to Zerubbabel, 'Not by might nor by power, but by my Spirit, says the Lord Almighty'" (Zec. 4:6).

Biblically speaking, farming began with God by creating the Garden of Eden. Adam was God's steward and farmer. He was commissioned to "dress, till and keep" God's garden (Genesis 2:15). His disobedience resulted in his expulsion from the Garden of Eden. The ground was cursed to create more hardship and toil for Adam. We can infer that growing crops from a post-Fall perspective means man is living under God's curse in trying to feed himself from a cursed ground. The only remedy of this curse is knowing God, and believing in Jesus Christ; it is also discovering, developing, and using the inventive gifts God has shown him. *The cross and ultimately the new heaven and new earth are God's final answer!*

I believe that Growing Missionaries Biblically is the development of God's cross-cultural sowers to sow seed in preparation for the harvest through theological, anthropological, religious and cross-cultural communication education. The whole world is God's farm and the sowers are to sow the seed of the Gospel everywhere. "For the vineyard of the Lord of hosts is the house of Israel, and the people of Judah are his pleasant planting...." (Is. 5:7.) "I am the vine, you are the branches. Those who abide in me and I in them bear much fruit, because apart from me you can do nothing" (Jn. 15:5). In I Corinthians 3:9, Paul, the great missionary, compares his work in the ministry to the work of a farmer. "I planted, Apollos watered, but God gave the growth. So neither the one who plants nor the one who waters is anything, but only God who gives the growth.... For we are God's servants, working together; you are God's field...."

But notwithstanding, the fact that the world has been corrupted by sin and was cursed, the presence of God is in the world through His Word and the Holy Spirit. Also, through His Christian disciples who are fulfilling the Great Commission; there will eventually be a true harvest. In this endeavor, let the missionaries remember: *As growing and harvesting are perpetual processes, likewise growing missionaries biblically is a continual process for the world and the people to whom they minister.* With these principles as background, (the two agricultural systems and my definition) application of these precepts is found in Section Four Chapter 6 in my proposed Short- and Long-Term Missionary Training Program. However, Section

Two will focus on the theology of missions, the sower (missionary), his message, and methods.

Section Two
Theological Perspective of
Growing Missionaries

The Christian mission begins with God and ends with Him. The Biblical basis of Christian Missions is an anatomy of God's redemptive-historical progression throughout the Bible. Adam's disobedience in the Garden of Eden corrupted his nature. In God's justice sin cannot go unpunished. To restore man, the Lord initiated a (re)covering program beginning with Adam and culminating with Christ on the Cross of Calvary.

Chapter 3
The Biblical Basis of Christian Missions

Introduction

The Christian mission begins with God and ends with Him. The Biblical Basis of Christian Missions is an anatomy of God's redemptive-historical progression throughout the Bible. Adam's disobedience in the Garden of Eden corrupted His nature. In God's justice sin cannot go unpunished. To restore man, the Lord initiated a (re)covering program beginning with Adam and culminating in the Cross of Calvary.

This chapter focuses on the theological basis of Christian Missions. I argue that mission lies at the heart of God and that man's redemption is His main focus. Because of His missions's priority, God called Abraham and sent him out as a missionary (Gn.12:1-3). Everywhere he went, the people recognized God's blessing and power at work in his life and in his descendants.

In the Old Testament, God delivered the Hebrews from the Egyptian bondage through Moses. This redemptive act was an historic event that impacted nations around the then-known world. The key function of Israel's election when she became a nation was to serve God as a priestly nation, a holy people (Ex. 19:6). Israel was to make known to the world that their God is the one true God, the Creator of the universe. But because of man's fallen nature, God appointed priests, judges, kings, and prophets. They proclaimed God's heart for the world, even in the midst of their captivities and slaveries. Wherever

the Israelites were planted, they bore fruit in their missionary service to God and to their captors.

In my discussion of Missions and the New Testament, I succinctly pointed out the key to Christ's Mission. It is *to remove the covering of Adam that went through the covenantal fathers and to reconcile man to God (2 Cor. 5:17-20)*. After Christ's resurrection, He gave, what I term, the Second Great Commission to His apostles and to us today. The first Commission was given to Abraham (Gn.12:1-3). Because of Peter's ethnocentrism, God revealed to him in a vision that *what He had made clean, Peter must not call unclean (Acts 10:15)*. This was the beginning of the Gentile mission in the house of the Roman gentile Cornelius (Acts 10:1ff). Knowing the limitations of man, God in His divine wisdom, appointed Peter as the primary apostle to the Jewish people and Paul to the Gentiles (Acts 9:15; Gal. 2:8).

Man's Redemption: The Focus of God's Mission

God launched a recovery mission after Adam and Eve listened to and believed in the deceptive words of the serpent (Gn.3:1ff). Accordingly, they were cursed and driven from God's beautiful Garden. However, prior to their expulsion, two things occurred which signified a promise of God's redemptive mission for them: (1) God provided *garments of skin* for the couple in place of their self-made aprons. "The Lord God made garments of skin for Adam and Eve and clothed them" (Gen. 3:21). And (2) He embedded in the serpent's curse a promise of the coming Redeemer (the Seed) which would come from among the woman's seeds: "And I will put enmity between you and the woman, and between your offspring and hers; he will crush your head, and you shall strike his heel" (Gn. 3:15*NIV*).

First, the "Garments of Skin" - There are disagreements among biblical scholars as to the meaning of their covering. The purpose of this section is not to discuss all the arguments, ramifications and refutations, but rather to focus on the text. The garments of skin provided as a covering for the guilty pair were taken from some of the animals in the Garden. An innocent life was taken to provide a covering for our first family. Scripture did not indicate whether these skins were the skins of goats, leopards, snakes, deer, etc. Honestly, there is no reason to argue as to how God got the skins for our first parents. He created everything by

His Word (Gen. 1:3 *NIV*). *God can create something out of nothing.* John Phillips writes,[45]

> There, in Eden, in paradise itself, blood was shed for the very first time. Adam and Eve must have stood there aghast as they saw the creature taken in their stead and slaughtered before their eyes – its bloodshed, and covering made for them. It was the first dramatic illustration of the ultimate cost of Calvary, of the horror and dreadfulness of sin.

Robert C. Harback concurs with the atoning significance of the shedding of blood, but he was not specific in regard to the kind of animal that was killed: "For the coats of skins were not made from tree bark, nor from the serpent's skin, nor from some miraculously produced clothing, but from the skins of animals."[46] On the other hand, James Montgomery Boice declares, "It [the text] does not say here what animals God killed to get the skins with which he then clothed Adam and Eve. But I tend to think, though this is a guess and may well be wrong, that the animals were probably lambs and that the skins were lambskins."[47] Warren Austin Gage, Assistant Professor at Knox Theological Seminary asserts,[48]

> It is fitting that the Lord God, who was to make the last sacrifice (Heb.9:26), should make the first; to furnish the first Adam with robes of righteousness, the last Adam would suffer nakedness and shame (Ps. 22:18; Mt 27:35). This slaughter is the first sermon, and there is much Gospel in it. Here the Lord provides the skins of the innocent to 'cover' the shame of the guilty.

[45]John Phillips. *The John Phillips Commentary Series: Exploring Genesis* (Grand Rapids, MI: Kregel Publications, 2001), 62-63.
[46]Robert C. Harbach. *Studies in the Book of Genesis* (Grand Rapids, MI: Reformed Free Publishing Association, 2001), 91.
[47]James Montgomery Boice. *Genesis Volume I: Creation and Fall (Genesis 1-11)(Grand Rapids, MI:* Baker Books, 1998), 237.
[48]Warren Austin Gage. *The Gospel of Genesis: Studies in Protology and Eschatology* (Eugene, OR: Carpenter Books, 1984), 102.

Let us analyze the covering episode exegetically. There are differences in translation in regard to the garments and skin mentioned in Genesis 3:21. In the *NIV* "skin" was the preferred translation of the Hebrew word *"owr"* eighty-nine times in seventy-eight verses, while garment(s) was the preferred translation one hundred twenty-three times in one hundred and three verses. The ESV, one hundred and four times in ninety verses renders it as "skin" and garment was used two hundred and fourteen times in one hundred and ninety-one verses. The *NASB 95* translated the Hebrew word as *skin* ninety-two times in seventy-six verses and as *garment* one hundred eighty-eight times in one hundred sixty-two verses. *NRSV* translated the word as *skin* one hundred thirteen times in ninety-nine verses and rendered it as *garment* one hundred fourteen times in one hundred and seven verses. And in the KJV, *skin* was the translation one hundred and one times in eighty-four verses and as *garment(s)* one hundred eighty-nine times in one hundred seventy verses.[49]

However, generally animal skins were goatskins. Garments (Heb. *hēmet.* Gk. *askós*) were used for the storage and protection of liquids (e.g., Gn. 21:14; Jos. 9:4; Jges. 4:19; 1 Sm. 16:20). Wine was both fermented and stored in skins. Goatskins (Heb. *tahaš*; Gk. *aígeion dérma*) were also used in the covering of the tabernacle (Ex. 26:14; 36:19; 39:34; Nm. 4:25), donated by the people (Ex. 22:5; 35:7, 23). It was also used to cover the ark, the vessels and utensils of the altar (Nm. 4:6, 8, 10-12, 14).

The meaning of the Hebrew word *tahas* is debated. The KJV "badgers' skins," the RSV "goatskins," has no philological basis. The NEB translates *tahas* as "porpoise-hide." Other theologians suggested "dolphins' skins" which reflects the possible Arabic cognate *tuhas* "dolphin." So the NJV suggested "dugong," the NIV "sea cow." The only other occurrence of the Hebrew term is at Ezekiel 16:10, where it refers to footwear and thus to leather. This supports the view that *tahas* was from a commonly available animal like the goat; it was not a relatively rare creature such as other options suggest. Moreover, the people of Israel would hardly have had access to large numbers of dolphin skins. *But the matter must remain uncertain.* The New Testament mentions goatskins only in Hebrew 11:37, where they are said to have

[49]Logos Bible Software.

been the clothing of prophets and other holy persons (cf. the "hairy mantle" of Zec. 13:4). Such ascetic dress was later common for Near Eastern monks.[50]

Let us further examine the "garments of skin" (Gn. 3:21); most translations pluralized skin (*KJV, NRSV,* and *ESV*). The Hebrew word, *owr,* ore (for skin) is an *absolute noun* within the construct chain and is a construct noun, common, singular, masculine. The construct[51] noun is "garments" (*Heb. Katnot/ kâthoneth*). *Rightly so, it is plural in the original language.* Garment is defined by *Strong's Exhaustive Concordance of the Bible* as "… from an unused root meaning *to cover* (H3801 and compare to (3802): 29 occurrences; AV translates as "coat" 23 times; garments five times, and robe once.[52] Skin (*owr/ore*) occurs ninety-nine times in the Authorized Version and translated ninety-six times as "skin," "hide" twice, and "leather" once.

I concur with John Phillips who boldly said that God took the life of innocent lambs and the skins were used for their clothing. Phillips' problem was his inability to give any biblical evidence for his claim. There are differences among theologians regarding this text and the best treatment is to delineate the claim scripturally. It is in this light that I am confident to prove biblically that innocent lambs were killed to clothe our first parents. The best commentary on Scripture is Scripture itself. Establishing a doctrinal position on just one text of the Bible is like building a house on sand; it will not survive the storms of criticism.

The most important root of this argument is Christ is called the Lamb of God that takes away the sins of the world (Jn *1:29*). With this in mind, we shall support our claim through the Redemptive-historical progression, which is pivotal to teaching Christ from the Old Testament. Preaching Christ should center on the history of redemption. The sacrificial lamb theme is rooted in the Old Testament and culminated in the New

[50]A. C. Myers. *The Eerdmans Bible Dictionary* (Grand Rapids, Mich.: Eerdmans, 1987), 424 & 956.

[51]There is no word for "of" in biblical Hebrew. Rather, Hebrew expresses the "of" (possessive) relationship between two nouns by what is called the construct chain. And because it is implied by the fact that each set of nouns is side by side, that is in a construct chain. In most cases two translations are required. For example: the servant of the king can also be translated the king's servant.

[52]James Strong. *The exhaustive concordance of the Bible: Showing every word of the text of the common English version of the canonical books, and every occurrence of each word in regular order.* (electronic ed.)(Ontario: Woodside Bible Fellowship, 1996).

Testament. All the biblical priests and prophets point to this redemptive lamb theme.

Finding Christ in the Old Testament started with the New Testament writers, Apostolic fathers, the Church fathers, apologists up to the reformation and continues to this day. You will find direct quotations and paraphrasing of Old Testament texts nearly on every page of the New Testament. Hence, in order to delineate the garments of skin and their relationship to the redemptive work of Christ, we shall follow *this cohesive thread throughout Scripture.*

First, the "covering" signifies God's grace and promised redemption for mankind. Missionaries must be aware of this fact: *The first covering of Adam and Eve signifies God's grace* as the Gospel is preached at home and cross-culturally. In God's justice, sin cannot go unpunished. The first punishment for man's sin was placed typically on the animal kingdom – *the blood of a lamb was shed for Adam's covering.* This act of God symbolized a promised redemption assured to our first family.

John Phillips shifted Adam's burden of guilt a bit by declaring that, "Sin did not begin on earth; it began in heaven. This mystery of iniquity did not originate in the heart of a human being. It had its sad source in the breast of an angelic being of the highest order. It entered the Garden of Eden full grown, introduced there by Satan disguised as a serpent." [53] John Milton vividly described the fall of Lucifer in his epic poem, *Paradise Lost.* However, God knew that the woman was deceived but that Adam willfully chose to rebel and had thereby corrupted human nature.

The *Paradise Lost* is an epic poem which gives details of Satan and his armies rebelling against God; but they were defeated. However, the fallen angels were faithful to Satan and his lieutenant Beelzebub. They considered another course of action. Accordingly, Satan succeeded by corrupting man in the Garden of Eden. In response, God pointed out Satan's journey to His Son, who offered to reconcile man to God. The Son came down and judged them: Eve was condemned to painful childbirths and submission to her husband; Adam was condemned to a life of hard work. The serpent was condemned to crawl on its belly, always at the heel of Eve's son. God promised to send His Son as a man to earth to sacrifice Himself; and, in so doing, He will conquer

[53]John Phillips, 56.

the evil trinity. Hence, man must be redeemed at all cost through the *seed of the woman who was originally deceived* (Gn.3:15). The woman, who had delivered (Gn. 3:15) man into sin, would deliver him. Warren Gage declares,"[54]

> As the true faith will be pictured as a woman arrayed with sun and moon and crowned with twelve stars (Rv. 12:1-3), so the chameleon Babylon would imposture itself as a woman, though she is dressed in scarlet and is drunk with the blood of the saints (Revelation 18). This conflict of the two women, the one delivered of a Son who is the Saviour (Revelation 12), reflects the hostility of the seed (Gn. 3:15), for the one is in truth the church, the congregation of the righteous, and the other is the world, the assembly of the reprobate. The enmity continues until the Son, of whom the church is delivered, at last destroys this Babylon the great (Revelation 18).

Waltke & Yu also argue that, "The collective seed is the holy offspring of the patriarchs (Gn. 15:5; 22:17). After Genesis we do not hear again of the promised seed from the loins of a hero of faith until God promises David a seed from his loins (2 Sam. 7:12) ... [who would sit on his throne forever]."[55]

Second, the lamb substituted for Isaac on Mount Moriah (Gn.22:1ff) was the reenactment of the paradisiacal "covering." God spoke to Abraham, calling upon him to sacrifice his promised son Isaac, in the region of Moriah on a mountain, about 50 miles (or a three-day journey) from Beersheba. Abraham did not tell his wife Sarah about this sacrifice. He must have heard about pagan human sacrifices to gods in the culture of his day. But his God had not required such sacrifices of him heretofore. However, in obedience he went with his son. When they got to the top of the mountain and while preparing an altar, something triggered in Isaac, "....The fire and wood are here, but where is the lamb for the burnt offering?' (Gn. 22:7 *NIV*) "And Abraham answered, 'God will provide himself the lamb for the burnt offering, my son...'" (Gn. 22:8). Then the story reached its peak: Abraham completed building the altar, bound his son and laid him on it, and took out his knife to slay him.

[54]Warren Austin Gage, 140.
[55]Waltke & Yu, 280-281.

But the angel of the Lord called out to him from heaven, 'Abraham! Abraham! …. Do not lay a hand on the boy… (Gn. 22:11-12). *God provided a ram in a thicket as a substitute for Isaac.*

There are many views about this text. Addressing these debates is not our purpose here. *The point is to link this sacrifice of an innocent ram to calvary instead of to Isaac.* Abraham was blessed for his obedience. Thus the ram serves as a covering for Isaac. Abraham names the place *Yahweh yireh, i.e. the Lord will provide.* Eugene Roop maintains that,[56]

> The word *yireh* can be a play on the Hebrew word 'to see,' which in 22:8 we normally translate 'provide.' But it can also play off the word 'fear'/'obey.' So this may be the place where 'Yahweh is seen' or 'Yahweh is obeyed or 'Yahweh provides'—probably all of those views are intended. In the context of this event, it remains a place beyond naming.

Tokuboh Adeyemo asserts that this text is the reaffirmation of God's commitment to Abraham because of his unwavering faith in him:[57]

> He is promised many offspring: *I will surely bless you and make your descendants as numerous as the stars in the sky and as the sand on the seashore (22:17a; see 13:6; 15:5).*
> He promised victory: *Your descendants will take possession of the cities of their enemies (22:17b; see 13:15, 17; 17:8).*
> He is promised that he will be a blessing: *Through your offspring all nations on earth will be blessed (22:18a; see 12:2-3).*

The testing of Abraham's faith on Mount Moriah can be paralleled with the Garden of Gethsemane narrative, a test of the faithfulness of Jesus. *God demands that the carrier of the promise give up any control or claim on the promise and leave the future of the promise with God.*[58] Abraham unwaveringly surrendered to the faithfulness of God believing that God who gives life has the right to take it away and is able to raise it

[56]Eugene F. Roop. *Genesis. Believers church Bible commentary* (Scottsdale, Pa.: Herald Press, 1987), 148.
[57]Tokuboh Adeyemo, 43.
[58]Eugene F, Roop, 150-151.

up again. The obedience of Abraham on Mount Moriah points to the crucifixion and resurrection of Christ in the faith of the New Testament according to Romans 4.

On Mount Calvary, God saw the faithfulness of another man, Jesus, who risked His life. Typologically, the Isaac that was covered by the ram was put on the *cross naked.* Our sins were placed on Him when Jesus was crucified, died and was buried in a tomb. But on the third day death and the tomb could not hold Him. He was resurrected, and took His own blood into the celestial Holy of Holies for the redemption of mankind. Like Abraham, Jesus believed that God the Father is the *promise keeper* and would provide, even at the point of his Son's forsakenness (Mt. 27: 46; Mk.15.34). And through the obedience of Christ all the believing families of the earth receive the blessing of salvation.

Third, the Passover in Egypt symbolizes the Adamic, Noahic, and Abrahamic coverings. The shedding of blood of innocent lambs signifies a type of covering for the Israelites (Ex. 12:1ff). The blood was a sign between God and His people. God promised to "pass over" the Hebrew households that have been marked with blood (Ex.12:13). This was the origin of the Passover Celebration in Judaism. The Hebrew word for "Passover" is *pesah.* There is also a verb, *pasha* ("to pass over"). It is used three times in Exodus 12: "When I see the blood, I will pass over you" (12:13 *NIV*). "It is the sacrifice of the Lord's Passover; for he passed over the houses of the people of Israel in Egypt" (12:17 *RSV*). To pass over then means to "to protect," or as the NEB suggests in a footnote, "stand guard over." What is important about this is the blood that was smeared over the doorposts (12:7, 13) was a protective covering. *There is a true sense of substitution – the lambs were killed instead of the Israelites.* Missionaries need to understand the biblical background of the cross; it is rooted in the Old Testament and culminated in the New Testament.

The purpose of this section is to point back to the Adamic, Noahic, Abrahamic, and the Mosaic coverings. They paralleled to the perfect sacrifice of Jesus Christ on the Cross of Calvary (Mk. 15:33-41; Lk. 23:44-49; Jn 19:28-37). Jesus substituted Himself for our sins on the cross that through faith in Him we might have eternal life. At the last Passover meal, Jesus ate with His disciples; He asserted that the Passover was a "New Covenant in His blood which would be poured

out for many for the forgiveness of sins" (Mt. 26:28). Christ assured His disciples that He would not drink of the fruit of the vine again in this life. The Lord clarified that He would drink it anew in the heavenly kingdom (Mt. 26:26-30). Jesus' statement teaches us two facts:

1. He was the fulfillment of the Mosaic Passover, which was aimed at physical deliverance.
2. He instituted a new covenant, not in the blood of sheep, goats and lambs, but rather in His own blood.

This new covenant is for the remission of the sins for many. It is also a spiritual deliverance from the tyranny of Satan to our gracious return to the Paradise of God, thus eating the Tree of Life by faith in Jesus Christ.

Fourth, the coming of the Promised Messiah was foretold by the prophets. The corporate Jewish hope for the coming of the Messiah was further developed dynamically from the period of David's reign. It was prophesied that his kingdom would endure to the end of time (2 Sm. 7:16). Israel was told that, through David's descendants, his throne would have dominion over all the earth (2 Sm. 22:48-51; Jer. 33). The Jewish mindset was traditionally preoccupied (Acts 1:6) with hope. This hope was nurtured even following the death of Solomon and the split of the nation of Israel and its sad history of apostate kings. The Qumran community lived in anticipation of "the Coming One's" advent, the teacher of "Righteousness" and "the Expounder of the law." They hoped to be God's final witness prior to the glorious revelation of the Davidic Messiah.[59] In fact, the coming king was especially considered to be the Lord's anointed. He was viewed to hold a secure portion before men (1 Sm. 12:14; 2 Sm. 91:21) and God (Ps. 2:2; 20:6). Along with numerous Messianic prophecies, these helped to inform the Jews about the Anointed One, who would eventually bring salvation to Israel. Elwell & Beitzel affirm,[60]

At one time the rabbis applied no less than 456 passages of Scripture to his person and salvation. Preoccupation with

[59]Elwell, W. A., & Beitzel, B. *Baker Encyclopedia of the Bible* (Grand Rapids, Mich.: Baker Book House, 1988), 1446-1449.
[60]Ibid, 1446-1449.

the Messiah is evident in the tractate *Sanhedrin* (Babylonian Talmud) where passages state that the world was created for him and that all the prophets prophesied of his days (*Sanhedrin* 98b, 99a). By and large, orthodoxy still retains its time-worn belief in the Messiah's reign in Jerusalem, the rebuilding of the great temple, and the reestablishment of both priesthood and sacrifice.

The origin of the Davidic Messiah is linked to the house of David (2 Sm. 7:14; Hos. 3:5). The first Messianic passage (*protevangelium*) is found in Genesis 3:15. In the fullness of time, the "seed" of the woman would inflict a fatal blow to the head of the serpent; it took place on the Cross of Calvary.

The nature of Messianic prophecy is progressive; each prophecy casts more light on the subject. For example:

(1) The Messiah is to be born of a woman (Gn. 3:15)
(2) He would come through the line of Shem (Gn. 9:6)
(3) Specifically through Abraham (Gn. 22:18); and
(4) Isaiah presents the Messiah as a suffering Anointed Servant (Is. 53:1ff)

The four great Servant Songs of Isaiah all present the servant as an individual who ministers to Israel and the nations (Is. 42:1-7-7; 49:1-6; 50:4-9; 52:13-53:12).[61] To reject the corporate solidarity of the servant figure is to leave oneself with an *unsolvable* enigma in these all-too-human sons, or is at least a flat contradiction in divine revelation. Also, the Anointed One would bring light unto the Gentiles (Is. 55:4). The title of Davidic "branch" rests upon Him (Isa. 11:1-4). Missionaries need to understand the prophecies of the Messiah from the Old and New Testament perspectives.

However, the collapse of David's dynasty points to Israel's need for an anointed monarch. This Messianic ruler would heal the nation's apostasy and disobedience which continually characterized her relationship with God (Ex. 33:5; Hos. 4:1). More and more, the Old Testament history presents Israel's comprehensive moral failure. Her problem, which she shares with the rest of mankind, can only be solved

[61]Walter C. Kaiser Jr., 57.

by the making of a new covenant, and this covenant's *surety and focal point are both a personal Savior and sovereign Lord* (Jer. 23:7; 31:31–34). The advent of such a Messianic champion lives in the recorded promise of "a shoot from the stump of Jesse's fallen tree." He will bring the light of life to God's people (Is. 11:1; 9:2).

It is difficult to get away from the idea that the concept of servanthood and lowliness belongs within the sphere of royalty (Zec. 9:9). For the Messiah is to fulfill the offices of *prophet, priest and king.* For all this, it is highly doubtful apart from revelation that anyone imagined the Messiah would accomplish His salvific work by means of His own death (cf. Is. 53:12). Biblically, *it is evident that the Anointed One's terrible ordeal of suffering and death is but the necessary prelude to infinite glory.* He is pictured not only as a great king (Is. 52:13; 53:12) but also as a humble (Is. 53:2), humiliated (Is. 52:14), rejected servant (Is. 53:3), bearing the consequences of mankind's rebellion (Is. 53:5, 6). Yet He is raised up to intercede for, and richly bless His people (Is. 53:12). The Messiah, having accomplished with full obedience which Adam and Israel failed to achieve, will bring Israel and the nations back to God (Is. 42:18, 19; 49:3, 6).

While the birthplace of the Messiah is well established as Bethlehem in Judah (Mi. 5:2), His deity is a hotly contested matter. Although few in ancient Israel disputed the belief in a superhuman Messiah, it is doubtful that anyone imagined Him to be *"God with us"* in the fullest sense of the expression (Mt.1:23; Heb.1:3). Many theologians contend that the Messiah's divinity is not well established but merely suggested in the Old Testament by compound pronouns representing God (Gn. 1:26; 11:7), theophanies through the Angel of the Lord (Gn. 16:7–13, 18:1–21; 19:1–28; Mal 3:1), the multiple personages in the psalms (Ps. 33:6; 45:6, 7; 110:1), and the Word of God personified (Ps. 33:4, 6; Prov. 8:12–31). Divine inter-relationships also appear to be at work in Isaiah 48:12, 16; 61:1; and 63:8–16.

The New Testament Concept of Messiah

The New Testament writers discerned that He who is the child of supernatural origins (Is. 7:14; Mi. 5:2) carries the full weight of divinity (Is. 9:6; Phil. 2:6; Col. 1:19). He is truly the Son of God and worthy to receive the worship of all men (Ps 45:6, 7; cf. Heb 1:8, 9). The Jews

of first-century Palestine knew that the Messianic promise would be fulfilled in the coming of One like Moses (Dt. 18:18). The parallels between Jesus and Moses are abundant. As mediators, innovators, and propagators of new phases of spiritual life for the people, they are unexcelled. Specifically, both are providentially spared in infancy (Ex 2; Mt 2:13–23); both renounce a royal court for the sake of serving the people of God (Phil. 2:5–8; Heb 11:24–28); both exhibit intense compassion for others (Nm 27:17; Mt 9:36); both commune "face to face" with God (Ex 34:29, 30; 2 Cor 3:7); and each mediates a covenant of redemption (Dt. 29:1; Heb 8:6, 7).

The Messiah is the maker and master of all things (Heb 3:3–6; cf. John 1:1, 2, 18). The rabbis agreed upon the absolute necessity of the Messiah's Davidic lineage based on Hosea 3:5 and Jeremiah 30:9. The angelic announcement recorded in Luke immediately establishes the correct lineage for Jesus (Lk. 1:32, 33; cf. 2:4), a genealogy which Matthew expands in depth (Mt.1:1–17). The Lukan list, like that of Matthew, sets forth the exclusive kingly retinue verifying Jesus as the Davidic Messiah (Lk. 3:23–38). Although variations occur between the two genealogies there is a firm solidarity emphasizing an ancestry within the unique Messianic stock. It is not uncommon to find the omission of one or more generations in a given biblical family chronology. This is true in both Old and New Testaments. For example, six of Aaron's descendants, lacking in Ezra 7:1–5, are given in 1 Chronicles 6:3–14.

Fully aware of the Messianic focus of Scripture (Jn 5:46; 8:56), Jesus revealed Himself to be the Christ on numerous occasions. He accepted the title "Son of David" from blind Bartimaeus (Mk. 10:46–48). He accepted it from the crowds when He entered Jerusalem (Mt. 21:9); from the children at the temple (Mt. 21:15); and in other contexts as well (Mt. 16:16–18; Mk. 14:61, 62; Lk. 4:21; Jn. 4:25, 26). He nonetheless warned His disciples not to broadcast His mighty acts as Messiah prior to His resurrection (Mt. 17:9; cf. Lk. 9:20, 21).

Owing to the commonly-held notion that the Messiah's role is primarily that of a political liberator, Jesus actually avoids the use of the term Messiah. He prefers to identify Himself some 80 times in the Gospels as the "Son of Man." Before His revealing use of the titles "Son of God" and "Son of Man" it was by no means assumed that both designations referred to the same person (Mk. 14:61, 62). Jesus'

teaching in this regard enabled His disciples to correct their erroneous views concerning His mission (Mt. 16:21–23). In time, they would come to see Him not only as Messiah but also as the theme of the entire Old Testament (Mt. 5:17; Lk. 24:27, 44; Jn. 5:39; Heb. 10:7). When Jesus expounded the Scriptures on the road to Emmaus beginning with the Torah (Lk.24:27), He did so as the living exegesis of God, the Word made flesh (Jn 1:14, 18).

In the New Testament Christ is called the Lamb of God who takes away the sin of the world (Jn 1:29, 36). He is the son of David who will reign forever in the heavenly kingdom. The animal skins that were used to clothe Adam and Eve in the Garden of Eden were probably lambs' skins, and not that of goats or dolphins. The disobedience of Adam was covered; but it did not completely satisfy God's standard of atonement for the sins committed. The blood of sheep, lambs, and goats could only cover sins; they had no power to actually remit them.

All other sacrifices made by the people of Israel were just foreshadows of the fact that the perfect lamb without blemish would one day come. John the apostle, while suffering for Christ on the Island of Patmos, saw in his vision the Lamb standing in the midst of the throne and as the shepherd of His people He will wipe away their tears (Rv. 7:17). And John declares: "No longer will there be anything accursed, but the throne of God and of the Lamb will be in it, and his servants will worship him" (Rv. 22:3).

Let me summarize my argument. If we believe that Christ is God incarnate, the Word made flesh (Jn 1:1, 12, 14), that means Christ is the creator of everything. God provided the tunics for Adam and Eve for their "covering." This act of 'covering' was repeated to Abraham in his typical sacrifice of his son, Isaac and for the Israelites in their physical redemption from the death angel in Egypt. *The sacrifices made in the Tent of Meetings, Tabernacles, and Temples were also coverings.* The prophets spoke about the deliverer of Israel, the Messiah, who would come from the line of David and whose kingdom would be everlasting (2 Sm. 7:8-16). Yet the prophets spoke of Him also as a suffering redeemer (Is. 53:1ff). Warren Gage concurs,[62]

[62]Warren Gage, footnote, 96.

.... The significance of this search seems to be that once man is a sinner he cannot confront the presence of God without a 'cover.' Consequently it is not for nothing that Israel's great Day of Atonement is called in Hebrew the 'Day of Covering,' and that the same Hebrew verb used to describe the covering of the nakedness of Noah by a literal garment is used metaphorically to describe the blessed man of the psalm whose sin is 'covered,' (cf. Gen. 9:23; Ps 32:1; and also Rom 4:7-8). Man's sense of shame, then, and his instinct to cover his nakedness are left as a mark upon the consciousness of all mankind, offering silent but universal testimony to the pervasion of sin in the seed and the unfitness of man to stand in the presence of a holy God apart from a covering.'" [But these coverings were removed through the nakedness of Jesus on the Cross and now we are in Him.]

Missionaries must understand this redemptive-historical progression thread from the "covering" of our first family to the "uncovering" of our Lord Jesus on the Cross of Calvary.

In the next section, I will lead you into a comprehensive study of missions in the Old Testament

Missions and the Old Testament

Background

After the flood, Noah's three children (Ham, Shem and Japheth) spread out to the four corners of the earth. Can we infer that these men were among our earliest Old Testament Missionaries? Yes. They went out with the Good News of God's supernatural power of His deliverance from the flood (Gn.6-8) and the Messianic seed promised to their descendants. Noah was the son of Lamech (Gn. 5:28-29; Lk. 3:36). He was the last of the ten antediluvian patriarchs and the hero of the flood. The meaning of his name is uncertain. However, many commentators connect it with the root *nwh*, 'to rest'. It is also associated with the verb *nhm* and translated 'comfort' in AV and RV (Gn. 5:29); 'bring relief' in RSV.[63]

[63]R. D. W. & I. H. Marshall. *New Bible dictionary*, 3rd ed. (Downers Grove, Ill.: Inter-Varsity Press, 1996), 826-827.

Typologically, Noah's Ark was another *covering* (pointing to the coming of the perfect Ark of safety, Jesus Christ) for them. Noah's descendants spread out over the earth with the testimony of the greatness of God in saving them from the flood. They did not lose sight of their old memories of the destroyed world. Neither did they lose sight of their corrupt nature inherited from Adam, nor of the promise of the coming Messianic seed of the woman.

Moses continued his narration in Genesis 11 by introducing another aspect of mankind's fallen condition. Instead of scattering to repopulate the four corners of the earth, the people under the tyranny of Nimrod came together with a new plan. They planned to build a tower whose top was to reach heaven to "make a name for themselves," not God. Responding in judgment upon this intended reversal of God's plan for the world, the Lord came down and confused their language. Accordingly, they were scattered by God's judgment over the face of the whole earth (Gn. 11:1-9).

Missionaries need to remember that these prideful attitudes of the postdiluvian people originated in heaven. Lucifer, the Morning Star, wanted to establish his throne above God (Is.14:12-15). This heavenly civil unrest resulted in the dethroning of Lucifer who was thrown down with his co-conspirator angelic rebels.

Some commentators think that at this point Isaiah ceases to speak about the overthrow of early Babylon. They argue that in Isaiah 14:12-15 he describes the fall of Satan. In support, they link the reference to him as the Morning Star (Lucifer in Latin) to Paul's comment that Satan can disguise himself as an angel of light (2 Cor. 11:14). Also, Jesus spoke about having seen Satan fall from heaven (Lk. 10:18). However, a star is also a symbol of the Jewish Messiah (Nm, 24:17; Jewish believers (Dn. 12:3) and Christ (Lk. 1:78-79; 2 Pet. 1:19). Christians are also called to shed light (Mt. 5:14-16; Phil. 2:15).

With this background, I argue that the text presents parallelism in which one parallel is greater than the other: It refers to the Babylonian kings' pride. Indeed, they were worshipped as deities, which led to their consequential fall. This was also compared with the heavenly unrest, in which the "Morning Star" was thrown down because of his desire to establish a throne above God. *The fact in this parallel is Babylon will surely fall just like the Morning Star who desired evil against the throne of God.* Similar

parallelism can be traced biblically. The death of an animal for the covering of the first family points to the certainty of Christ's suffering; the wooden ark relates to the human Ark—Jesus; the blood of the Passover animals that was slain parallels to the greatest Lamb, Jesus; the substitution of Isaac with a ram points to the cross; the dynasty of David to exist forever refers to David as an earthly king over Israel, and Jesus is our new David who will rule on David's throne forever. Further, the serpent was cursed, but this curse was also on Satan in the spiritual realm; the pride that caused Eve to consume the forbidden fruit, would be exonerated by the woman who would bear forth fruit to crush Satan's kingdom. This text (Is.14:12-15) is another parallelism that the prophet used in assuring his audience that Babylon will surely fall as did the "Morning Star." This same seed of pride was deceptively sown into our first parents' hearts (Adam and Eve, Gen.3).They accepted the serpent's lie, "...you will be like God..." (Gn. 3:4). They were guilty of arrogant disobedience just as Adam was, and they knew about the flood. But the rebels at Babel united themselves (instead of scattering) and began to construct a tower that they expected would eventually reach into heaven, thus to "make a name for themselves." Their plan was a direct violation of God's plan for missionary expansion. God's plan was for them to build a horizontal bridge that would reach the world with the Good News of the promised Messiah, Jesus Christ (Gn. 3:15).

Waltke and Cathi assert that, "God clearly exposes that humanity's sin in building the tower is its refusal to live within God-given boundaries."[64] The repetition of the term, "ourselves" and the focus on their *"names"* shows that the people had made themselves the center of life instead of God. *The sin of Babel is mankind's refusal to obey the command of God to scatter and fill the earth (Gn. 1:28).* Robert Harbach also maintains that the City of God is the true basis of world unity and its builder is God. The bricks are living stones (1Pt. 2:5), cemented with love (Col. 3:14) and the atoning blood of Jesus. God is our Strong Tower (Prv. 18:10).[65]

We sense postmodernism in the Tower of Babel epoch—*We can do it ourselves; we don't need God to direct us!* History is repeating itself in our

[64]Waltke & Cathi, 180.
[65]Robert C. Harbach, 213-214.

own society today. Man has a legitimate place in space in this century. Although we appreciate scientific accomplishments, but equally so, we are guilty of trying to make a name for ourselves. Man's zeal for self-protection now causes the world to be sitting on a "time bomb." The nuclear weapons modern scientists have invented could destroy the world if and when they are fired! We are disbursing billions of dollars yearly to maintain the Kennedy Space Center while the street is filled with homeless people and millions without jobs. "It is the boast of godless science," Harbach declares, "that man will be master of space and time, of light and the speed of light, harnessing the powers of the sun and the lightning, conquering all the forces of nature."[66]

It is clear from Scripture and linguistic studies that the people who covered the face of the earth initially spoke one language (Gn.11:1). The third expulsion of man occurred when they were expelled from building the Tower of Babel. It was not like Adam and Eve who were driven from the presence of God, or like Noah during and after the flood. And most importantly, God confused their language by giving them multiple languages. This created chaos and they abandoned the job and scattered to the four corners of the earth.

In this endeavor God did a new thing. The angelic fallen forces were united by a common language, the same with Adam and Eve, then with Noah and his family. God gave them new languages and only those who understood one another went in the same direction to live as a community. *God knew that unity of strength and purpose originated from their common language and interest; "they will do anything!"* (Gn.11:6)

Missionaries should understand that the Gospel is given to transform men by destroying their prides and allowing God to reign in their hearts. The unity of language that man lost because of pride will be restored in Christ (see Zep. 3:8-13). We will all speak one heavenly language and sing to the glory and praise of God Almighty! *Until then, missionaries are to learn the language of the people with whom they minister; they are to lead them from diverse languages to that one glorious heavenly language.*

The Tower of Babel[67] was a great human achievement, a wonder of the world. But it was an egocentric monument to the people themselves

[66]Robert C. Harbach, 214.

[67]Utley writes in his commentary that archaeology has unearthed literary documents (about Babel) from the Sumerian culture in Mesopotamia which assert that at the time all people spoke in one tongue...the popular Hebrew etymology is "confusion"

rather than to God. We are free to develop in many areas, but we are not free to think that we have replaced God. In this regard the missionary's task is to preach Christ as the center of every achievement. Christ is to have the preeminence in all things. *He is all in all!*

The Call of Abraham: The First Great Commission

> The LORD had said to Abram, 'Leave your country, your people and your father's household and go to the land I will show you. I will make you into a great nation and I will bless you; I will make your name great, and you will be a blessing. I will bless those who bless you, and whoever curses you I will curse; and all people on earth will be blessed through you' (Gn. 12:1-3 *NIV*).

At the heart of God's mission is His desire *to be known throughout His creation.* As a steward, man is a chosen vessel to reach the world. After the Fall of Adam, his son, Seth became the seed-bearer for God's redemptive plan. Sidney Greidanus is a professor emeritus of preaching at Calvin Theological Seminary and a prolific author. He confirms,[68]

> ... when one is preaching on the narrative of Cain murdering Abel (Gn. 4), the fact that God provides Seth 'instead of Abel' (4:25) to continue the line of the seed of the woman constitutes a link in the chain of redemptive-historical progression that leads to the birth of Jesus Christ, the Seed of the woman (Gal. 3:16), and ultimately to his victorious Second Coming.

Noah, from the line of Seth, became the Messianic seed-bearer of God prior to the flood (Gn. 6:9-21; 7:1ff). Of the three sons of Noah, Shem became the seed bearer. Following another downward step in the fallen state of man at the Tower of Babel, Moses the author of Genesis, reconnected his narrative to the genealogy of Shem. His aim was to prove that Abraham, the father of the faith, hailed from the line of

(i.e. balal), which seems to describe God's confusing their one language.(R. J. D. Utley. *Vol. Vol. 1A: How it All Began: Genesis 1-11.* Study Guide Commentary Series (Marshall, Texas: Bible Lessons International, 2001), 109.

[68]Sidney Greidanus. *Preaching Christ From Genesis: Foundations For Expository Sermons* (Grand Rapids, Michigan: WM. B. Eerdmans Publishing Co., 2007), 3.

Shem (Gn. 12:1ff). Warren Wiersbe, a prolific author notes a contrast between the call of Abraham (Gn. 12:1ff) and the rebellion at Babel (Gn. 11:1-9). "At Babel, men were concerned about self-achievement (making a name for themselves) while God would make Abraham's name great. At Babel, the workers strived to unite men, but through Abraham the whole world would be blessed and all believers are united in Christ (Gal 3:14)."[69]

I term Abraham's call the First Great Commission (Gn. 12:1-3). There are several promises made to Abraham. I also understand the ongoing scholarly debate regarding the major translation difficulties in Genesis 12:3a. The Hebrew text could be interpreted in either of two ways. First, God could be promising that Abraham will be a blessing to the nations by going out and testifying to them. His message was about the true God who has revealed Himself to him. In this case, Abraham's leaving and blessing the nations with the true knowledge of God would be for missionary and evangelistic purposes. Second, the alternative interpretation takes Genesis 12:3a in a reflexive manner; it means that the people would bless themselves by believing and imitating Abraham's faith and example. If this reflexive view is the right translation as Vos and others believe, then the passage speaks of the effect in the lives of the people who are impacted by Abraham's life and faith. I hold to the former interpretation – that God sent Abraham to bless the nations by making His name known to the whole world.

Another bigger picture of the debate in Genesis 12:3 among evangelicals and other Christians, is whether or not the Jews in the Old Testament were universally called to be missionaries. My position is God elected the Jews to be His witnessing people in an informal sense. In this way, the whole world might come to know the true God. One cannot conclude (though I know some do) that every Jew in the Old Testament was called to be a missionary in a formal sense. Many of the Jews, however, were called to be missionaries in the formal sense of being called to bring God's Word to the nations, e.g. Jonah, Jeremiah, Ezekiel, Daniel and Amos. A corollary of this position is that it is unbiblical to claim that every Christian is called to be a missionary in the formal sense of the word. However, every Christian, by virtue of his faith in Christ, is expected to be a faithful steward of the Gospel.

[69]Warren Wiersbe, W. *Be Obedient* (Wheaton, Ill.: Victor Books, 1996), 14.

He is to bear witness to Jesus Christ everywhere. Again I repeat that some Christians are called to be missionaries in the formal sense of the word either at home or overseas.

Now, let us focus on the text. God said to Abram (who was later called Abraham):

- I will make you a great nation
- I will bless you
- I will make your name great
- You will be a blessing
- I will bless those who bless you
- I will curse those who curse you, and
- All people on earth will be blessed through you

We need to note in the five "I will" phrases that two of them, I will **make** you a great nation and I will **make** your name great, are directly linked to the future aspect at the time of the promise. The Hebrew word translated as "great" is *gadól*, and it is a noun, common, adjective, singular, masculine, and normal. It denotes: big, big ones, great or that which expands. Also, the verb, *'sh* (to make) has the idea of doing, preparing, manufacturing, putting into effect, etc. The concept of making or recreating is embedded in this text. The second Hebrew word translated "great" (*agaddela*h) has the same root as *gadol* but with a slightly different meaning. Note the promise, "I will make your name *great.*" The Hebrew word for great here is *agaddela*(h). It is a verb, *piel*, active cohortative, common, first person singular. It means growing up as in developmental stages to be strong. This promise was achieved through a growing process. *Abraham grew in his great name and in his walk with God.* The call of Abraham to be a blessing, i.e. to evangelize the world, includes "leaving" his old country behind. This also signifies his spiritual rebirth into a new re-creative era. The new creation typically began with Abraham and shall end with Jesus Christ. The same God, who created this present universe, has begun His work of re-creation; it shall be finalized in the second coming of Jesus Christ with a new heaven and a new earth.

God re-created the world through the flood and promised not to destroy the world by water again (Gn. 8:20-21). Because of this promise,

God raised up Abraham and gave him His first Great Commission to "go." He was called to re-create the world through the Gospel of making God's name and true nature known to the world. These Abrahamic covenantal promises can be categorized into two groups:

1. the blessing of Abraham and
2. the blessing of the world through him.

The blessing of Abraham includes nearly every promise. When God blesses anyone, no one can put a curse on that person. Balaam could not curse Israel because they were descendants of Abraham (Nm. 24:9). *Also a blessed man can and must be a blessing to others.*

I wonder what Abraham would have done if God had said, "I am sending you like sheep among the wolves" (Lk. 10:3; Mt. 10:16). "Foxes have holes but the Son of Man has no place to lay his head" (Lk. 9:58; Mt. 8:20). One may argue that Abraham's calling was impregnated with materialism. He knew the meaning of *blessings* and *greatness* in his day. He may have read or by way of a revelation perceived what God has done. But these wonderful promises were conditional: "leaving" and "going" are the key verbs in the text. It is misleading for one to conclude that Abraham obeyed merely because God promised him material wealth. As a human, Abraham was not faultless. He saved his own life at the expense of his wife by denying her as his wife (Gn. 20:1-5, 13). He listened to his wife, because of her age, by having an affair with her handmaid, Hagar (Gn. 16:1-5). God proved to Abraham and his wife Sarah that age cannot deter His promise. At their old age, the promised child (Isaac) was born (Gn. 21:1-7).

In many aspects of Abraham's walk, he stumbled in his pilgrimage with God. But the righteousness of Abraham was by his faith in God alone (Gn. 15:6). The author of Hebrews confirms and lists Abraham's exploits of faith in his walk with God (Heb.11:7-12). The author of Hebrews stresses one key act of Abraham's faith. That is, by faith Abraham was willing to sacrifice Isaac, the promised child on Mount Moriah. Abraham believed that the God who promised is the Promise Keeper. God tested Abraham's faith to see if he loved God's gift (Isaac) more than the Giver (*Jehovah-Jireh*). Abraham was willing to sacrifice his son but God provided a ram instead of Isaac for the sacrifice. Abraham truly believed in the divine "promise keeper" and not merely in the

promise (Gn. 22: 1-19). From the above arguments, we can conclude that Abraham's walk with God was not prompted by covetousness for material blessings but by his love for God.

The key message for missionaries is that they should preach/teach faith in Jesus Christ alone as our atoning substitute and risen savior. We may have all the promises about God's blessings; but they are all *conditioned* on one's faith in God. Walter Kaiser argues that, "The whole purpose of God was to bless one people so that they might be the channel through which all the nations on the earth might receive a blessing. Israel was to be God's missionaries to the world and thereby so are all who believe in this same Gospel."[70]

Actually, the first verse of the Bible (Gn.1:1) proclaims Yahweh as the God of the whole world. With that grand opening begins a story whose plot quickly takes a crucial turn (human sin). Immediately there comes God's first – though veiled – promise to send a Redeemer–the "seed of the woman" (Gn.3:15). In fact, Genesis 1-11 is the introduction to God's covenant with Abraham, the First Great Commission, and a crucial event that finds its fulfillment ultimately in Christ. These first eleven chapters set the stage for the story of redemption. And then in Genesis 12 God boldly announced His recovery mission to the world by choosing and sending Abraham as His third missionary (the first being Adam and the second was Noah) globally: "All peoples on earth will be blessed through you" (Gn. 12:3). That covenant was later repeated to Abraham, and then to Isaac, and finally to Jacob (Gn. 18:18; 22:17-18; 26:24 and 28:12-14).

The apostle John describes the fulfillment of that promise in Revelation 7:9, "I looked and there before me was a great multitude that no one could count, from every nation, tribe, people and language, standing before the throne and in front of the Lamb." Between that promise in Genesis 12 and the vision of its fulfillment in Revelation 7 as mentioned, the entire Bible is replete with indicators of God's passion that all peoples would know and serve Him. At Mt. Sinai, the Lord told Moses to say to the people "although the whole earth is mine, you will be for me a kingdom of priests" (Ex. 19:5-6). This is an indication that Israel, as a nation, was chosen to be God's ambassador or agent of

[70]Walter C. Kaiser Jr., 20.

reconciliation between God and humanity. That is, Israel as a priestly nation was to be a light to the nations of this earth.[71]

Following the miraculous crossing of the Jordan River, Joshua told the Israelites that God "did this so that all peoples of the earth might know that the hand of the Lord is powerful…" (Jos. 4:24). In King Solomon's dedicatory praise to God, he said that the Temple had been built "so that all the peoples of the earth may know your name" (1 Kgs. 8:43). Throughout the Old Testament God is calling His people to be involved in world evangelism using two forces: centripetal (attracting the nations to God's Temple) and centrifugal (going out to the nations).[72]

Missions and the Prophets

The prophets of Israel affirmed that the world, not just Israel, is God's focus for missions:

- Isaiah expresses God's heart for missions to the nations of the earth (66:19; 5:26; 6:8-10: 12:4-5; 45:22; 21:11-12; 49:6; 60:3; 52:7; 65:1-5).
- Ezekiel speaks of the watchman's responsibility to warn the wicked (3:18-19; 33:7-9; 22:30).
- Daniel affirms those who witness will shine like stars (12:3).
- Amos calls for the need of missions because there is a famine of hearing the Word of God (8:11-12).
- God's first and second call to Jonah to go to Nineveh (1:1-2; 3:1-9). Jonah refused to go on God's mission to Nineveh initially; yet God captured him through the storm. He was thrown overboard from the ship; and then God delivered him on the shore near Nineveh by a great fish that had swallowed him. With anger in his spirit, the prophet Jonah reluctantly preached God's message to the people of Nineveh and they repented and were forgiven.
- The Book of Psalms is also replete with a call for an outreach to all nations of the earth (9:11; 65:5; 67: 1-2; 68:11; 96:3-10).

[71]Walter C. Kaiser Jr. also sees Israel as a light to the Nations. Norman Gottwald titled his Old Testament introduction: A Light to the Nations."
[72]Walter C. Kaiser, 83.

- Malachi prophesied that because God is mission-minded, His name will be great among all the nations of the earth: "My name will be great among the nations, from the rising to the setting of the sun. In every place incense and pure offerings will be brought to my name..." (3:11).

Every missionary believes that God is on a *redemptive mission* for mankind. This mission was primarily accomplished by Jesus on the Cross of Calvary.

God had a chosen people, in the Old Testament—the Jews, and in the New Testament predominantly the Gentiles—through whom he has planned to save and bless the believing world. Today, God still wants to save and bless His people throughout the world through Jesus Christ – Jews and Gentiles. This mission begins in our homes and in our neighborhoods (Acts 1:8), but it doesn't stop there. We must work and pray for God's worldwide mission. *Missionaries are called upon to teach that Christian Missions is rooted in the Old Testament.*

In spite of all these missions's emphases in the Old Testament, Jacob's seed habitually focused on themselves. Though on many occasions they preached the Gospel to those to whom they ministered. But, in order to be saved Gentiles must become proselytes. Proselytes were to live like the Jews and deny every ungodly aspect of their pagan idolatrous culture. There were also Gentiles in the New Testament who became "God-fearers." They were not willing to be circumcised Jews, but rather they worshiped God and kept the moral Law of God. Because of the limited mission activities of Judaism, God used a series of captivities as another means to thrust them out of their comfort zone to reach the world.

Missions and the Kings

Missions in the Old Testament took various forms and directions. During the reign of King David, the fame of God and His servant David reached the world. As result, gifts of tribute were brought to David (2 Sm. 5:10). Adeyemo confirms, "David also began to enjoy international recognition as ambassadors from Hiram, King of Tyre, arrived in his new capital... [who later] sent David both the materials and the manpower he would need to construct a palace."[73]

[73]Tokunboh Adeyemo, 385.

69

Also, during the reign of David's son Solomon, Jerusalem became a famous city because of Solomon's wisdom and the magnificent temple he built. This temple became a *wonder of the world* and attracted pilgrims from all over the ancient world.

Because of the wisdom God gave to Solomon (1 Kgs. 3; 2-4: 34), Jerusalem became the *center of wisdom.* Solomon wrote 3000 proverbs and 1005 songs; most of the Book of Proverbs, Ecclesiastes and Canticles, are attributed to him (25:1).

The Queen of Sheba came to visit Solomon and she confirmed the wisdom that God had given to him. Elwell & Beitzel declare, [74]

> The Queen of Sheba came to see and hear if the fame and Wisdom of Solomon was correct. After viewing all he had in Jerusalem and hearing his wisdom, her final response was a blessing to the Lord God of Israel who raised up such a wise person to sit upon such a magnificent throne (1 Kgs 10).

Missions and the Captivities/Slaveries

Because God is concerned about reconciling the world unto Himself (2 Cor. 5:18-20), in some cases He used times of exiles and slaveries as a means of raising up missionaries. They bear fruits for Him where they were sent. "Exile" means the forced removal of people from their familiar associations and patriotic memories, the placing of the defeated exiles under the watchful eye and control of a foreign government. Exile and captivity have the same meaning in the Old Testament and are used interchangeably. Biblically speaking, God sent the Israelites into exile many times as a judgment for their disobedience. Israel underwent many exiles, but I would like to focus on the few most prominent ones mentioned below:

- Assyrian Exile in 842 B.C. King Jehu of Israel paid tribute to Salmanseser, king of Assyria.
- The first Babylonian Exile circa 705 B.C. King Hezekiah of Judah tried to restore the religious unity of Israel and Judah and King Sennacherib of Assyria nullified it by his invasion.

[74]W.A. Elwell & B. J. Beitzel. *Baker encyclopedia of the Bible* (Grand Rapids, Mich.: Baker Book House, 1988), 1977.

- The second Babylonian invasion of Judah occurred in 597 B.C. King Jehoiakim refused to pay tribute to Babylonia.
- A fourth deportation from Judah occurred in 582 (Jer. 52:30). After vengeance had been taken for the revolt under Zedekiah, Nebuchadnezzar appointed Gedaliah as governor over the sadly reduced territory of Judah.

In the ancient world every country had a patron god or gods, so warfare between two nations was considered as a battle between deities. The Lord who worked so mightily for Judah before had now apparently gone down in defeat, or so it seemed. When Jerusalem was destroyed and the temple vessels seized, many concluded that *Marduk*, Babylon's god, had proved himself stronger than Judah's God, Yahweh. But Jeremiah rebuked them for such a notion and insisted on the sovereignty of the God of Israel (Jer. 29:10, 14).

However, in the midst of their suffering, many exiles were assimilated into their captor's culture; but the faithful became missionaries to the nations where they were planted. The exile brought both the desire for revenge and stirrings of repentance (Jer. 51:1ff; Lam). The festivals of Sabbath and regular commemorative feasts were reinstituted (Zec. 7:1-3; 8:18, 19). Elwell & Beitzel affirm,[75]

> As a result [of the captivity], there was a renewed emphasis on reading and observing the Law, an emphasis that led to the development of the synagogue as a place of worship. The institution of the prophets and priests, however, continued to function; that is evident in Jeremiah's address to the captives, naming first the elders, then the prophets, priests, and people (Jer. 29:1).

Release from Exile

Babylonia was conquered by the Persians under Cyrus in 539 B.C. King Cyrus issued an edict in 538 B.C. releasing the Jews from captivity and allowing them to return home to rebuild the temple at Jerusalem (Ezr. 1:1-4). Some say that he favored the Jews because he saw some similarity between Judaism and Persian religion. But Cyrus's edict negates this

[75]W. A. Elwell, & B. J. Beitzel. *Baker Encyclopedia of the Bible* (Grand Rapids, Mich.: Baker Book House, 1988) 732-736.

claim: *"…. The Lord, the God of heaven, has given me all the kingdoms of the earth and he has appointed me to build a temple for him at Jerusalem in Judah…"* (2 Chr. 36:23 italic mine). This was the first year of Cyrus which was the end of the 70 years of captivity prophesied by Jeremiah (2 Chr. 36:22). The spiritual life of some of the Israelites in captivity spread in other nations and Cyrus believed that the God of Heaven had given him victory in conquering many kingdoms. Such a belief was the result of the missionaries' fruitful activities in exile.

As Jonah was sent to Nineveh against his stubborn will, so Israel was sent to Babylon against her will. But God used them both with the result that Nineveh repented at the preaching of Jonah and Cyrus, the Persian king, and others believed in God.

The first missionary sent to Egypt through slavery was Joseph (Read Genesis 37-50). Joseph was Jacob's 11th son and the firstborn son of Rachel. Rachel named the boy Joseph, meaning "May He add," expressing her desire that God would give her another son (Gn. 30:24). Joseph was the favorite of his father, since he was the son of his old age (Gn. 37:3) and the firstborn son of his favorite wife. Because of this his brothers hated him. God fulfilled His promise to Joseph. He became the second to Pharaoh and his brothers bowed down to him because of the position he held.

The second missionary was Moses, who was born into slavery in Egypt. Providentially Moses was brought up in the house of Pharaoh. He was sent to awaken the Egyptians again about the power of God. Moses was born at the time when the Pharaoh had given instructions for every Jewish-born male to be killed. God sent Moses as His missionary with the Good News and God delivered the Israelites through Moses and Aaron. Moses' life can be divided into three sections: (1) His birth and life in Egypt, 40 years; (2) 40 Years as a shepherd in Midian, in the house of Jethro; and (3) 40 years leading the Hebrews from Egypt to Canaan. Like the account of Joseph, missionaries should know that God has been reaching the world in many ways throughout history.

The third group of missionaries raised up in captivity included Daniel and his three companions. Daniel and his companions (Dn. 1:1-21), Hananiah, Mishael, and Azariah were exiled to Babylon nineteen years before the main exile following the destruction of Jerusalem. Daniel and his three friends were selected among the exiles at the king's command

to be assigned to a three-year training program to serve in the king's palace (Dn. 1:3). The King offered them the best food and wine from the royal kitchens, but a Jew's diet was restricted by the dietary laws of God (Dt. 14). They appealed to the king's steward to provide instead a diet of vegetables and water, just to remain faithful to God and His Law (Dn. 1:8-11). Accordingly, God gave these four young men wisdom and understanding in literature and learning above and beyond their peers. "Daniel could understand visions and dreams of all kinds" (Dn. 1:17). "The chief official gave them new names: to Daniel, the name Belteshazar, to Hananiah, Shadrach; to Michael, Meshach; and to Azariah, Abednego." (Dn.1:6). At the end of the three years Nebuchadnezzar put them on his staff of advisers (Dn. 1:19). Here are four Hebrew missionaries, not witnessing with scrolls in their hands, but with obedience to the Law of God in their hearts and faith that was shown forth in their lives by their works.

Daniel interpreted King Nebuchadnezzar's dream (Dn. 2:1-49) and he and his companions were promoted. They trusted God and prayed for wisdom and direction and the Lord answered their prayers. "The king said to Daniel, *'Surely your God is the God of gods and the Lord of kings and a revealer of mysteries, for you were able to reveal this mystery'"* (Dan. 2:46-47, italic mine). The Babylonian king anticipated the coming of a greater kingdom, which belongs to Jesus Christ. Daniel was also delivered from the lions' den for his refusal to serve other gods, and the plotters were thrown into the lion's den along with their wives and children. They were torn into pieces by the lions (Dn. 6:26).

Another demonstration of God's power was performed on behalf of Daniel's three Hebrew friends, Shadrach, Meshach and Abednego who refused to worship the 90-foot-high golden image made by Nebuchadnezzar (Dn.3:1-30). They were arrested and brought before the King. Note, the collective voice of these three missionaries:[76]

Shadrach, Meshach and Abednego replied to the king, 'O Nebuchadnezzar, we do not need to defend ourselves before you in this matter. If we are thrown into the blazing furnace, the God we serve is able to save us from it, and he will rescue us from your hand, O king. But even if he does not, we want you

[76]Daniel 3:16-18.

to know, O king, that we will not serve your gods or worship the image of gold you have set up.

As a result of their faith, God delivered them from the fiercely burning furnace. Miraculously, they did not burn, and a fourth being appeared with them in the furnace, "whose likeness was as of the Son of Man." As they emerged unharmed from the ordeal, the king acknowledged God's power of salvation and rewarded them (Dn. 2:28-29). They were faithful to God's first commandment, "You shall have no other gods before me" (Dt. 5:7).

A double message emerges from the story. God's servants must be faithful in prayer and worship, regardless of the outcome; God often delivers, and in that case He did deliver Daniel from disaster. On the other hand, the effect of Daniel's faithfulness was that the king, who had ordered his subjects to worship him, learned about true worship (6:25–27). Daniel was extremely gifted by God in dreams and visions: he interpreted Nebuchadnezzar's second dream and time of madness (4:1-37). Because of the faith of this missionary in exile, King Nebuchadnezzar confessed faith in the living God twice: once through the witness of Daniel (2:47) and then upon the release of Daniel's three companions from the furnace (3:28). Nonetheless, the king's faith was shallow and the consequence was madness for seven years as the king lived like a beast. Elwell & Beitzel affirm,[77]

> The king was afflicted with a rare and peculiar form of mental illness today called 'boanthropy.' The true meaning of the story lies at a deeper level: to think that one is God, having absolute power and control of one's own life, is madness. That kind of madness can be cured and overcome only with the realization that absolute power and authority belong to God alone.

Pivotal to God's missionary work among heathen nations was the victory of Queen Esther, a Jewess orphan, and her cousin Mordecai in Susa. Mordecai was a Benjamite, descendant of Kish, the father of King Saul. He was among those who left Palestine during the captivity of Nebuchadnezzar. His remarkable life's drama is intertwined with

[77]Elwell & Beitzel, 571-577.

Hadassah (Esther), his cousin, who became his ward following the death of her parents.

Esther's sudden, unexpected rise to the position of queen following Queen Vashti's deposition was an essential link to the deliverance of her people from ethnic cleansing. Behind both of these women, however, moved their sovereign God. Because of His love for Israel, He provided protection against the malevolent designs of Xerxes' Prime Minister, Haman. *Haman had determined to exterminate the Jews of Persia because of Mordecai's unwillingness to pay him homage.* Bruce & Yu contrast Mordecai's faith to that of Daniel, Ezra, and Nehemiah who paid homage to the Persian monarch, "... unlike Daniel and his three friends, Mordecai refused the king's command to bow before the pagan magistrate, Haman, presumably out of pride – no other reason is given."[78]

But the faith of Mordecai and Esther turned the kingdom upside down! The Jews were delivered and Mordecai was promoted. Though the name of God is not mentioned anywhere in the book of Esther, His hand is everywhere present. But, I can infer from the faithfulness of Mordecai and Esther that they served as God's missionaries in Persia. Mordecai refused to bow down to any human ruler because the God of Abraham, Isaac, and Jacob is the lone Creator of the entire universe. According to his faith and his promotion in that kingdom was God's method of revealing Himself to that heathen nation.

I would like to summarize this section of the book with an appropriate quote from Christopher J.H. Wright, "God's people, even under judgment, remain God's people for God's mission."[79]

The following are Old Testament references regarding God's heart for Mission(s) to the world:

- Gn.12:1-3 (repeated in Gn. 18:18, 22:17-18, 26:24 and 28:12-14).
- Ex. 9:14-16; 19:6; Nm. 14:21; Dt. 4:6-8; 10:19; 28:10; 32:1.
- Jos. 4:24; 1 Sm. 2:10; 17:46; 1 kgs. 8:41-43, 59-60; 2 kgs. 19:15; 1 Chr. 16:23-24; 16:31; 2 Chr. 6: 32-33.

[78]Bruce & Yu, 767.
[79]Christopher J.H. Wright. *The Mission of God: Unlocking the Bible's Narrative* (Downers Grove, Illinois: Inter-Varsity Press, 2006), 99.

- Ps. 2:7-10; 7:7-8; 8:9; 9:11;18:49; 19:1-4; 22:26-28; 24:1ff; 33:1ff; 45:17:46:10; 47:1ff; 48:10; 49:1; 50:1ff; 57:1ff; 59:13;65:5-8; 66;1ff'; 68:32;72;1ff; 72:9; 72:17, 19; 82:1ff; 83:18; 86:8-13; 87:1ff; 96:1ff; 97:1ff; 98: 3, 9; 99:1-3; 102:15, 22; 105:1; 106:8; 107:3; 108:3, 5; 110: 3; 113:3; 117; 126; 135; 138:4.

- Eccl. 3:11;Is. 2:3; 5:26; 6:3; 11:9,10; 12:4; 24:14-16; 25:6; 34:1; 37: 16; 42:4, 6; 43:6; 45:6, 22; 49:1-6, 22; 51:4; 52:7, 10; 56:7; 59:19; 60:3; 62:11; 65:1; 66:18-19.

- Jer. 3:17; 16:19; Ez. 36:22-23; 38:20; Dn. 2:47; 4:1-2; 6:25; 7:13, 14.

- The entire book of Jonah – missionary book of the Old Testament; Mi. 1:2; 4:2; 5:4.

- Hb. 2:14; Zep. 2:11; 3:9; Hg. 2:7; Zec. 2:11; 8:20-23; 9:10; 14:0 Mal. 1:10-11.

Missions and the New Testament

The New Testament revealed Jesus as a missionary. Replete in the NT is the history of Jesus Christ, the God-man who came to reconcile the world unto Himself (2 Cor.5:18-19). Jesus started His public ministry by recruiting His core group – the apostles (Mk. 1: 16-19; Mt. 4:18-22) and He trained them. He taught them the importance of prayer by His own commitment to praying daily for every decision He made (Mk. 1:35; Mt. 14:22-23; Lk. 3:21; 5:16). He taught them faith in the midst of a storm when the apostles did all they could to handle the roughness of the sea. He calmed the storm by just speaking *peace* to it (Lk. 8:24-25; Mt. 8:23-27; Mk. 4:31-41). The training of Jesus' disciples was done by doing. There was no formal classroom with lecture notes as we do today; but rather His students traveled with Him day-by-day and observed Jesus' doing and teaching. Every activity of Christ was a teaching moment intended to transform the world. His historic ministry in Samaria was a vivid lesson for them to love their enemies through teaching the Word of God. His suffering and victory on the cross[80] was an indication to the apostles and to us that there is no victory without pain. By this

[80]"So the cross was the unavoidable cost of God's mission. But it is equally true and biblical to say that *the cross is the unavoidable center of our mission.* All Christian missions flows from the cross – as its source, its power, and as that which defines its scope." (Christopher J. H. Wright), 315.

we know that taking up the cross is not a "cake walk." There is a real possibility of Christians suffering, but in and through Christ we have won the victory.

Christ's resurrection (Mt. 28:1ff; Mk. 16:1-8; Lk. 24:1-12; John 20:1-9) and ascension into heaven (Mk.16:19-20; Lk. 24: 50-50) strengthened the faith of the apostles; that in Jesus' name there is life after death in His heavenly kingdom. For the Old Testament saints, their heavenly destination was not revealed as clearly to them. At the time of their death, they would always say that they would be "joining their parents in the realm of the dead" (Gn. 49:29; Nm. 20:24). But Jesus' death, His bodily resurrection and ascension in the presence of witnesses gave a new revelation of where a believer goes after this life. His methodology of training, on many occasions, was both by precept and example/doing.

Luke recorded (Lk. 9:1- 6; 10:1-24) that Jesus sent out the apostles to implement what they had learned from Him. This was the beginning of the Second Great Commission (Mat. 28:19-20). It is certainly not wrong for missionaries to have a formal seminary education; a sound knowledge of theology without practical implementation is useless. Jesus taught the disciples the importance of Gentile Missions by deliberately passing through Samaria with them. He preached the Gospel in that city beginning with the Samaritan woman at Jacob's Well (Jn. 4:1ff). The conversation between Jesus and the Samaritan woman opened the door to reconciliation between the Samaritans and Jesus Christ. This is the first Gentile Mission recorded in the New Testament. Luke reports Philip's missionary tour in Samaria (Acts 8:4-40) following the visitation of the apostles in that city (Acts 8:14 NIV).

The root of bitterness between the Jews and the Samaritans needs some clarification: After the Northern kingdom, with its capital at Samaria, fell to the Assyrians, many Jews were deported to Assyria; foreigners were brought in to settle the land and help keep the peace (2 Kgs.17:24). The intermarriage between those foreigners and the remaining Jews resulted in a mixed race, impure in the opinion of Jews who lived in the southern kingdom. Thus the pure Jews hated the mixed race called Samaritans because they felt that their fellow Jews who had intermarried had betrayed their people and nation. The Samaritans had set up an alternate center for worship on Mount Gerizim (4:20) to

parallel the temple at Jerusalem. But it had been destroyed 150 years earlier. The Jews did everything they could to avoid traveling through Samaria. But Jesus had no reason to live by such cultural restrictions. The route through Samaria was shorter, and that was the route they took.

The Second Great Commission

Jesus Christ gave the Second Great Commission following His death and resurrection: "Therefore go and make disciples of all nations, baptizing them in the name of the Father and of the Son and of the Holy Spirit, and teaching them to obey everything I have commanded you. And surely I am with you always to the very end of the age" (Mt. 28: 19-20NIV). In the Greek text of the second Great Commission there are three participle verbal nouns: going, baptizing, and teaching. Each of these is a part of the command to "make disciples." Christ made an outstanding promise: "I am with you always," not someday, or for a while but rather *always*. Missionaries are to focus on the going, making, baptizing and teaching aspect of Christ's command in the knowledge that God is with them. Most of my discussion in the rest of this book will focus on the four activities mentioned. Jesus makes missionary activity a key focal point of how to read the Old Testament in a Christian way (see Luke 24:47 on a missiological reading of the Old Testament that is just as crucial as Christological reading).

The apostles at first were complacent in worshiping at the temple regularly in Jerusalem (Acts 3:3-10), confining their message of Christ to the Jews (Acts 4:11). This was displeasing to the Lord. Accordingly, the Lord manifested His power for the continuation of the Great Commission in three ways: (a) A call to Peter through vision for Gentile Missions, (b) Missions incentive through the persecution of Christians in Jerusalem, and (c) the call of Paul as an apostle to the Gentiles.

Peter and the Gentile Missions

Cornelius, a centurion and God-fearer at Caesarea had a vision at three in the afternoon. An angel of the Lord stood before him and said that his "…prayers and gifts to the poor have come up as a memorial offering before God. Now send men to Joppa to bring back a man named Simon who is called Peter. He is staying with Simon the tanner,

whose house is by the sea" (Acts 10:4-6). Without delay, Cornelius sent three of his men to call Peter. While the messengers were on their journey to fetch Peter, on the following day, Peter went up on the roof to pray.

> He became hungry and wanted something to eat, and while the meal was being prepared, he fell into a trance. He saw heaven opened and something like a large sheet being let down to earth by its four corners. It contained all kinds of four-footed animals, as well as reptiles of the earth and birds of the air. Then a voice told him, 'Get up, Peter. Kill and eat.' 'Surely not, Lord!' Peter replied. 'I have never eaten anything impure or unclean.' The voice spoke to him a second time, 'Do not call anything impure that God has made clean.' This occurred thrice, and immediately the sheet was taken back to heaven (Acts 10:10-16).

While Peter wondered about this vision, the three men sent by Cornelius had reached Simon the tanner's home and they asked for Peter. The Lord also revealed to Peter that there were men at the door seeking him and he should not hesitate to go with them (Acts 10:19). This was the beginning of Peter's first Gentile mission. He went with them the next day and prior to his arrival, Cornelius had invited others to hear what Peter had to say. Note Peter's opening remark: ".... You are well aware that it is against our law for a Jew to associate with a Gentile or visit him. But God has shown me that I should not call any man impure or unclean" (Acts 10: 28). Cornelius, with humility explained his vision from God to Peter. And then Peter spoke."I now realize how true it is that God does not show favoritism but accepts men from every nation who fear him and do what is right..." (Acts 10:34-48). While Peter was speaking about the Lord Jesus Christ, the Holy Spirit came upon everyone who was listening and they spoke in tongues! Accordingly, Peter baptized them. He was the first apologist for Gentiles Missions. He defended his missionary activity when other circumcised Jewish believers rebuked him for his ministry to the Gentiles (Acts 11:1ff).

Missions Because of Persecution

Immediately following the martyrdom of Stephen (Acts 7:54-60) for his boldness of preaching the new faith in Christ, persecution broke out against the Christians. It forced the believers, with the exception of the apostles, out of their homes in Jerusalem. As they fled the persecution they took the Gospel with them. (*Sometimes we have to become uncomfortable before we will move.* We may not want to experience persecution, but discomfort may be the best thing for us because God may be leading and working through our hurts to reach others with the Gospel.) Escaping from persecution in Jerusalem, Philip the deacon fled to Samaria, where he continued to preach the Gospel. While he was there, an angel commanded him to meet an Ethiopian official on the road between Jerusalem and Gaza. The man became a believer before continuing on to Ethiopia. Philip then went from Azotus to Caesarea (Acts 8:1ff). *The harsh persecution of the saints in Jerusalem was the re-enactment of the lesson of Old Testament missions being spread through exile and captivity.* What missionaries need to be mindful of today is that if God wants a person to "go" and he is holding back, God can send you *anyway.* He can send you into the mission field like Jonah, or through some sort of persecution.

Missionaries Commissioned: Paul and Peter

God commissioned *Paul as a missionary to the Gentiles and Peter to the Jews.* Deep down in the heart of God is the plan that the Great Commission will reach to the four corners of the earth. There are some cultural implications when it comes to cross-cultural ministry by the Jews. Because of this, God called Saul of Tarsus, a zealous Jewish young man, to be an apostle to the Gentiles (Acts 9:15). And also Peter was called to be an apostle to the Jews (Gal. 2:8). Paul had a dramatic conversion. He received authority, upon his request, from the High Priest and Sanhedrin to go and capture Christians in Damascus; but instead he was captured by Christ (Acts 9:1ff). Paul suffered many things for Christ's sake, planted many churches wrote many of the New Testament Epistles we have today. He eventually became a martyr in Rome.

Missionary Activities in the New Testament

Philip the deacon was one of the missionaries (Acts 8:4-5, 26-40). The apostles Peter and John took a mission trip to visit new believers in

Samaria (8:14-25). God sent Peter on his first Gentile Mission to the house of Cornelius (Acts 9:32-10:48). Barnabas went to Antioch as an encourager; he traveled on to Troas to bring Paul back to Jerusalem from Antioch (Acts 11:25-30). Barnabas, Paul, and John Mark left Antioch for Cyprus, Pamphylia, and Galatia on their first missionary journey (Acts 13:1-14:28). Barnabas and John Mark, after a breakup with Paul, left Antioch for Cyprus (Acts 15:36-41). Paul, Silas, Timothy, and Luke left Antioch to revisit the churches founded in Galatia, and then traveled on to Asia Minor and Europe. They traveled to Macedonia, and Achaia on their second missionary journey (Act 15:36-18:22).

Apollos left Alexandria for Ephesus; he learned the complete Gospel story from Priscilla and Aquila, preached in Athens and Corinth (Acts 18:24-28). And Paul, Timothy, and Erastus revisited churches in Galatia, Asia, Macedonia, and Achaia on their third major missionary journey (Acts.18:23; 19:1-21:14). Missionary activities started in the Old Testament and have continued with the church to this day—even to the uttermost parts of the earth.

Conclusion

Because of man's fallen condition, God launched a redemptive mission to restore man to his original sinless state. Biblically speaking, Missions is not just a New Testament invention. It commenced in the Garden of Eden after Adam's Fall (Gn. 3:1ff). The substituted animal (I believe it was a lamb) slaughtered to cover the sinful nakedness of our first parents found its true meaning as a type of the promised Messiah – the seed of the woman (Gn. 3:15) – *the first Gospel in the Old Testament.*

The first recorded agriculture industry in Scripture started with Cain and his brother Abel (Gn. 4:1ff). The narrator, Moses reminds us that Adam's children knew the importance of worship. They brought from their produce gifts to sacrifice to their God. God's acceptance of Abel's gift resulted in the serpent's poisoning of Cain's heart and the killing of his brother Abel (Gn. 4:122).

Noah descended from the line of Seth, the third son of Adam and Eve. Noah became the Messianic seed bearer. God used Noah to preach for 120 years while building the Ark (Gn. 6:9-2). There was a work of destruction and re-creation during the days of Noah when the flood destroyed the world with the exception of eight people (Noah

and his family) and the animals that were placed in the Ark. After the flood, Noah worshiped the Lord by offering a sacrifice unto Him (Gn. 8:20-21). But Noah's garden resulted in his drunkenness and nakedness through excessive wine consumption. God's sovereign purpose resulted in the cursing of Noah's grandson Canaan and the blessing of Japheth and Shem. The sons of Noah spread over the entire ancient world. They took with them the message of God's deliverance from the flood to their descendants and the promise of a coming Messiah redeemer. *In Acts 8 – 11 we read of the salvation of a Hamite (the Ethiopian Eunuch), a Semite (Saul of Tarsus) and a Japhethite (Cornelius).*

I discussed the rebellion of mankind at Babel when they came together to construct a tower whose top was to reach to heaven. Their rebellion was aimed at (1) hindering the coming of the promised Seed of the woman (Gn. 3:15) and fostering the humanistic belief that man could claim world dominion for himself, and (2) disobeying the command of God to scatter and populate the earth (Gn. 1:28; 9:1, 7). In response, God came down and confused them by giving them different languages. The result was that they finally scattered globally as God had commanded. God may choose to accomplish His aim in many ways:

- With Adam and Eve, He substituted a sacrifice for them with a covering from the skins of animals, and then expelled them from the Garden of Eden;
- With Cain, he was cursed and driven out of the presence of God and destined to live as a wanderer (Gn. 4:16) in the land of Nod, east of Eden;
- With Noah, He spoke to him and saved him and his family through the Ark. As a new Adam, Noah was used for the recreation of the physical world (Gn. 7 and 8);
- With Abraham, He called him from his own country and sent him to Canaan to become the father of many nations (Gn. 12:1- 8);
- With Jonah, He sent him to Nineveh through a whale (Jonah 1:1ff);
- The Israelites were, on many occasions, sent into exiles and captivities and they usually worshiped the Lord where they

were planted and served as missionaries and witnesses unto the God of Abraham, Isaac, and Jacob.

The heart of Missions in the Old and New Testaments is God in Christ reconciling the world unto Himself (2 Cor. 5:17-20). It is God removing the covering of Adam in Christ on the Cross and thereby reconciling man and giving him the ministry of reconciliation. The Great Commission of Jesus Christ was given to the apostles and to every Christian throughout history. Because of God's passion for people and missions, He even used persecution to spread His Gospel. He did this through the early church just as He did by exile and persecution in the Old Testament.

Jesus also commissioned Paul as an apostle to the Gentiles and Peter as an apostle to the Jews (Acts 9:15; Gal. 2:8). In summary, Mission begins with God and ends with Him. He is sending out His ambassadors with the message of the Cross of Calvary and the apostolic calling to fulfill the Great Commission.

In the next chapter, I will focus on the definition of a missionary and his message. A careful analysis is made according to the term's usage and meaning in the Old and New Testaments. Reviews of three outstanding evangelistic tools will be considered together with a proposal of a fresh Gospel presentation for the twenty-first century.

Chapter 4
The Missionary and His Message

Introduction

This chapter focuses on the missionary and his message. I will begin by first tracing the derivation of the term "missionary." Like the word Trinity, the word *missionary* is not specifically found in Scripture. It was coined by the Roman Catholic Church from a Latin word, *mitto*, which means "to send." This is an equivalent of the Greek words *apostolos*, *apostolleo, pempo*, which also mean "to send."

The Greek terms (*apostolos, apostolleo, pempo*) and Latin (*mitto*) are rooted in the Hebrew verb *bśr* (Pi. and *Hithp.)* which carries the sense to "spread (good) news" (e.g., Ps. 40:9-10; Isa. 60:6). A noun related to this is *běśōrâ*, which means (good) news and comes from the root word "tidings" (e.g., 2 Sm. 18:27; 2 Kgs. 7:9) or "reward for (good) news" (e.g., 2 Sm. 4:10). It also means the messenger of Good News (*měbaśśēr*, Na. 2:1; Is. 40:9; 52:7). A possible New Testament equivalent of besora is evangelist. An evangelist is one who declares the Good News (Rom. 10:15), a preacher of the Gospel. He was often not located in any particular place but traveled as a missionary to preach the Gospel and establish churches (Acts 21:8; Eph. 4:11; 2 Tim. 4:5).

A missionary is one who is *sent* on God's Mission (*Missio Dei*); he is also an *apostle* by definition that is called by God and affirmed by a local church for service locally or globally. The focus of Christ's message is His substitutionary death for the sins of His sheep, His burial and

resurrection as a sign of our justification and our calling to the ministry of reconciliation (2 Cor. 5:17-19).

Three prominent theologians and church leaders' Gospel presentations will be reviewed. In a fresh approach, I propose my own Gospel presentation. The Gospel message is summarized in 1 Corinthians 15:3-5 and 2 Corinthians 5:17-19.

Let us begin with the derivation of the definition.

Derivation of Definition

Scholars and Christian leaders continue to debate the true meaning of *missionary*. Some pastors and theologians believe that every believer is a missionary but others disagree. Though the definition of missionary may be up in the air to some, most missiological organizations and Christian denominations have embraced the use of the word missionary to denote those who are sent out for cross-cultural ministry. The word missionary is etymologically related to four other words: messenger, mission, apostle, and evangelist. I will define these separately.

First, Messenger: It comes from the Hebrew word, *malak*, Greek, *angelos*, an angel; it also refers to a messenger who runs on foot, the bearer of dispatches (Jb. 1:14; 1 Sam. 11:7; 2 Chr. 36.22). A messenger is one who carries a message, a herald. It is used in four ways:

- In the Old Testament, *messengers* carry messages from one person to another. He might bring: news (2 Sm. 11:22, requests or demands (1 Sm. 11:3; 16:19), and act as an ambassador of one nation to another (Is.37:9). The blessing of a good messenger is mentioned in Proverbs 25:13. The New Testament concept of messengers includes those who were sent to the churches (2 Cor. 8:23; Phil. 2:25).
- Israel was called to be God's messenger bringing messages from God to His people and the nations. But Israel often showed herself to be spiritually blind and deaf (Is.42:19). Prophets (Hg. 1:13) and priests (Mal. 2:7) were God's primary messengers under the Old Covenant (2 Chr. 36:15-16; Mal. 3:1).
- The concept for messenger in both Old and New Testaments also includes "angel."

- Metaphorically, the word messenger was used in Proverbs 16:14 and 2 Cor. 12:7.

James Strong asserts, "... מלאך [*malak* /mal·**awk**/] n m. From an unused root meaning to dispatch as a deputy; ... 214 occurrences; AV translates as "angel" 111 times, "messenger" 98 times, "ambassadors" four times, and "variant" once....[81]

Second, *Mission:* There are four Hebrew words used for mission in the Old Testament: *mitzvah, mahaseh, derek,* and *tsavah* and each is translated as way, journey, commandment, charge, and mission. For example, *derek* occurs 705 times. AV translates it as "way" 590 times, "toward" 31 times, "journey" 23 times, "manner" eight times. In Joshua 22:3 *mitsvah* is translated mission in the *NIV,* charge, in *ESV, NASB95 and NRSV.* In Isaiah 48:15 *derek* is translated: way (*ESV*), mission (*NIV*), way (*NRSV*), and ways successful (*NABN95*). In 1 Samuel 21:2, *tsavah* is translated: mission (*NIV*), charged (ESV), commissioned (*NASB 95),* and charge (*NRSV*).

In the New Testament, there are two Greek words that are used and associated with mission: *dromous* and diakonia. The former comes from the Greek word, *edramon,* aorist of *trexo* (run). It bears the concept of a race course or place for running. Figuratively, it is one's purpose in life and or an obligation in relation to a task or mission (Acts 13:25; 20:24). The latter comes from and is associated with "service" (Acts 12:25). *The idea of commissioning someone with a responsibility to go and run a race is implied in this term semantically.*

Third, Apostle: Biblically *apostle* is defined in relationship to three New Testament Greek words: *apostolos, apostello, and pempo* ("to send"). *Pempo* and *apostello* are synonymous terms describing the authoritative mission and commissioning of Jesus (Jn.20:21). *Apostolos* is used eighty times in the New Testament. Most of these occasions are found in New Testament writings, thirty-five times in Pauline Epistles, thirty-four times in the Gospel of Luke and eleven in other New Testament books. The word apostle is a reflection of the Hebrew term *shaliach* used by the Jews in negotiation between two parties on secular or religious matters. The one sent by a party to another for such a mission was called a

[81]James Strong. *The exhaustive concordance of the Bible: Showing every word of the text of the common English version of the canonical books, and every occurrence of each word in regular order.* (electronic ed.).(Ontario: Woodside Bible Fellowship, 1996).

*shaliac*h.[82] The mission of Jesus was a kind of work done by a *shaliach*. He, by His coming and death, acted as a mediator; God the Son, Jesus Christ negotiated a just reconciliation between God the Father and believers by paying the price of man's sin with His own blood.

In the New Testament, the word (shaliach) is used to designate His apostles, those who had been sent by Jesus with the proclamation of the Gospel. From among the wider group of those who followed Him, Jesus selected 12 men (Mt 10:1–4; Mk 3:13–19; Lk 6:12–16) who maintained with Him a particularly close relationship. They received His private instructions and witnessed His miracles and controversies with the Jewish authorities. On one occasion, Jesus sent these men out to preach the message of repentance, to cast out demons, and to heal the sick; that is, to minister in ways that were characteristic of His own work (Mt 10:1–15; Mk 6:7–13, 30; Lk 9:1–6). The same *shaliach* relationship is reflected in the saying, "He who hears you hears me, and he who rejects you rejects me, and he who rejects me rejects Him who sent me" (Lk 10:16, RSV; cf. Mt 10:40). It is clear that the twelve disciples were not merely to pass along Jesus' teachings but rather, they were to represent His very person. After the resurrection, Jesus commissioned His disciples (Mt 28; Lk 24; Jn 20–21) to proclaim God's redeeming act in Christ to all men. This commission is also given unto us to this day.

There are two views in regard to who is to be called an apostle. Some scholars argue that, in the technical sense of the word, only those who had been with Jesus from the beginning of His ministry to His resurrection and ascension were qualified to be His apostolic witnesses (Acts 1:21–22). In contrast, other scholars and Christian leaders believe that the apostolic commission is not confined to the original twelve. They assert that by definition, anyone called and sent by God through a church or mission organization for the evangelization of the world is an apostle. A case in point would be the apostle Paul.

In the 17th century, the Roman Catholic Church used the term *missionary*. Before that in 596 A.D. Gregory the Great sent the Benedictine monk Augustine of Canterbury to lead a missionary delegation to the British Isles. The term was also used to mean the monastic orders who were to be the "sent ones." It commenced with the Franciscans in the

[82]Scott & Moreau, 73.

thirteenth century and in 1622 the Jesuits or Congregation for the Propagation of the Faith. The Jesuits are direct representatives of and answerable to the Pope.

Fourth, Evangelist: It comes from the Greek word, euaggelist's (used in the genitive case). An evangelist serves as what we term as a missionary today. He was a travelling minister who went everywhere to preach the Gospel and plant new churches (Acts 21:8; Eph. 4:11; 2 Tm. 4:5). The only evangelist named is Philip (Acts 21:8). He was one of the seven who were appointed to serve the physical needs of the church in Jerusalem. The noun "evangelist" occurs only three times in the New Testament (in 2 Tm. 4:5; Acts 21:8; Eph 4:11).

Definition of Missionary

The term missionary can only be defined accurately from its theological and historical context. It derived from the Latin word, *mitto* ("send") or *missus* ("sent"). The word "missionary" is not found per se anywhere in the Bible. *Moreover, it is not a precise equivalent of New Testament words that denote authorized sending or the status of a commissioned messenger.*

Traditionally, a missionary is one called by God for a specific task and sent on a mission for God like the Lord Jesus Christ, the model representative of *missio Dei* (mission of God). Or, the person can be sent out by a church or mission society to propagate the Gospel or carry out a specific mission. Fahlbusch and Bromiley emphasize, "A close relation exists between the aim, intention, and authority of the sender, the credentials of the person or persons (missionaries) sent, and actual nature and purpose of the mission."[83]

Reflecting on the derivation of the word, it is clear that the Latin translators of the Bible from the Greek text gleaned their definition from the Greek words, *apostolos, apostello* and *pempo*. They also considered the Old Testament Hebrew concept of *shaliach* in regard to missions. Jesus is the true apostle sent to earth for the redemption of His people. Christ told His disciples, "As the Father has sent me so send I you" (Jn. 20:21f).

Hebrews 3:1 says, "Therefore, holy brothers, who share in the heavenly calling, fix your thoughts on Jesus, the apostle and high priest

[83]Erwin Fahlbusch and Geoffrey William Bromiley, *The Encyclopedia of Christianity* (Grand Rapids, Mich.: Wm. B. Eerdmans; Brill, 1999-2003), 3:557-581.

whom we confess." Jesus, in turn, sent out the apostles and all those who He gives a special calling for the salvation of mankind with the *message of reconciliation* (2 Cor. 5:16-20).

The Missionary's Message

Background and Definition

A missionary is to be saturated and commissioned with the orthodox message of the Gospel biblically and theologically. Like an ambassador of a foreign country who represents his king and country in theory and practice, a missionary represents Christ wherever he is sent. In order to define the message the missionary is to proclaim, a careful examination of the word *Gospel* from the Old and New Testaments is necessary. I am using the words Gospel and message interchangeably.

First, Old Testament and Septuagint (LXX): The Old Testament uses the Hebrew verb *bśr* meaning: "spread (good) news" (e.g., Ps. 40:9-10; Isa. 60:6. A noun related to this is *běśôrâ*, which means "(good) news or from the root word "tidings" (e.g., 2 Sm. 18:27; 2 Kgs. 7:9) or "reward for (good) news" (e.g., 2 Sm. 4:10). In Deutero-Isaiah and Psalm 96:2, the verb can also relate to news of the dawn of God's rule. It also means the messenger and message of Good News (*měbaśśēr*, Na. 2:1) proclaimed to Israel (and the world) i.e. the coming of God (Isa. 40:9; 52:7). According to Isaiah 61:1-4 the one who bears this message that promises liberty to the poor is anointed by the Spirit, that is, the true prophet.[84] The Hebrew words *bśr* and *běśôrâ* occur along with other words for "proclaim (e.g., *śm* Hiph.) and "message" (e.g., *šěmûâ* as discussed above. In the Targums, *běśôrâ* is used for the message of the prophets. In the early text of Targums for Isaiah 53:1, it also has *běśôrâ* rather than *šěmûâ*. The use of *běśôrâ* specifically in Isaiah 53:1 enables us to understand the New Testament examples in Revelation 14:6 and Mark 1:15. Isaiah 61:1 is understood messianically.[85]

The *Septuagint (sometimes abbreviated LXX)* is the first Greek translation of the Bible from the Hebrew language. It is believed that 70 to 72 renounced Jewish scholars were commissioned during the reign of Ptolemy Philadelphus to carry out the task of translation. The term

[84]Ibid, 3:557-581.
[85]Ibid, 3:557-581

"Septuagint" means seventy in Latin, and the text is named to the credit of these 70 scholars. The LXX makes no actual use of *euangelion*. It uses *euangel* which stems from the Hebrew root *bśr*. *This, however, alerts Greek readers to the fact that messages of salvation are at issue (e.g., Ps. 95:2[96:2]; Is. 40:9; 61:1).*

Second, Greek usage: The word "Gospel" is a translation of the Greek *euangelion*. The word is often found in the plural, and means "that which is proper to an *euangelos*, or messenger of Good News." The verb *euangelizomai* (mid. and pass.) means "speak as an *euangelos*," that is, "bring (good) news." The verb and noun have religious significance in the Greco-Roman world. The New Testament word for evangelist comes from the Greek verb *euangelizomai*, which means to announce news. This New Testament term best echoes the Hebrew words, *mē baśśēr, mē baśśeret* in Is. 40:9; 52:7.). This verb is commonly used in the New Testament and is applied to God (Gal. 3:8), to our Lord (Lk.20:1), and to ordinary church members (Acts 8:4) and to the apostles on their missionary journeys.

The synonym for *Euangelion* is *kerygma*. *Kerygma* is used eight times in the New Testament. But these two words are identical in definition. And because God shall bring all things in heaven and on earth together under one head, even Christ, it is His will that this Gospel "must first be preached to all nations" (Eph.1:10; Mark 13:10). Thus, the missionary task of being an evangelist and ambassador for Christ by definition is to go to the nations with the message or Gospel of the Kingdom of God. He is to walk in obedience to the Great Commission of Jesus Christ (Mt.28:19-20). There is a cost to discipleship. A. B. Bruce writes, "He [Jesus] told them plainly... 'Behold, I send you forth as sheep in the midst of wolves...they should be delivered up to councils, scourged in synagogues, brought before governors and kings..., and hated of all for His name's sake.'"[86] But these sufferings come with an assurance and promise: "All authority has been given to me" ... and "I will be with you always" (Mt. 28:16-20).

Review of the Gospel Messages

Jesus' message of God's rule was the Gospel of Jesus Christ. Many great Christians have over the years prepared a brief biblical Gospel presentation for use

[86]A.B. Bruce. *The Training of the Twelve* (Grand Rapids, Michigan: Kregel Pubnlications, 1980) 115.

in evangelism, preaching and teaching. Their tools, and those of many others, have been effective in spreading the Good News. At this point I will review the work of three prominent Christian leaders that have made significant contributions to the Gospel presentation. They are Drs. D. James Kennedy, David Nicholas, and Bill Bright. And gleaning from them I propose a Gospel presentation for the twenty-first century.

First, David Nicholas believed that the Gospel consists of "Bad News" and "Good News." He was the founding pastor of Spanish River Presbyterian Church in Boca Raton Florida, and the Church Planting Network, Inc. The Spanish River Church's Global Outreach Conference held on April 24-28, 2010 reported the planting of 235 churches around the world in partnership with church planters. He used the Bad News and Good News presentation for many years. The following is just a paraphrased summary of his effective Gospel presentation.[87]

1. *The Bad News:* Man has committed sins against God in thoughts, words and deeds. Because of God's righteousness, He will not tolerate sin. Because God is just therefore sin cannot go unpunished. The punishment for sin is death, eternal separation from God. Because of the gravity of man's sin there is nothing that man himself can do to make himself acceptable to God.

2. *The Good News:* Because of God's love, He provided an atoning substitute for man. That is, God the Son, Jesus Christ, became a man and lived a sinless life, stepped into the place of the elect people of God and acted to save them. He allowed Himself to be arrested, tried, convicted and hung on a cross in our stead. God the Father took all of the believers' sins and put them on Christ our sin-bearer and punished Him in our place. He took for me the wrath that I deserved. He was placed in the tomb but was resurrected on the third day from the dead, "never to die again." Jesus offers forgiveness of sin and the gift of eternal life to those who believe in Him; thus He saves those who trust in Him for deliverance *from* "eternal condemnation and deliverance *unto* a new life lived with and for him forever."

[87]David Nicholas, The Church Planting Network: Gospel Boot Camp Training Manual, April 2010, page 80.

Second, D. James Kennedy's Gospel presentation outline: James Kennedy was the founder and Senior Pastor of Coral Ridge Presbyterian Church in Fort Lauderdale Florida, and founder and president of Evangelism Explosion International (EE). He prepared the following Gospel presentation outline that is being used in bringing millions to Christ yearly. I shall exclude details of his introduction which is intended to lead one into the Gospel of Jesus Christ as well as his follow-up plan: [88]

I. The Introduction
II. The Gospel
 A. Grace
 1. Heaven is a free gift
 2. It is not earned or deserved
 B. Man
 1. Is a sinner
 2. Cannot save himself
 C. God
 1. Is merciful – therefore He does not want to punish us
 2. Is just – therefore He must punish sin
 D. Christ
 1. Who He is - the infinite God-Man
 2. What He did – He died on the cross and rose from the dead to pay the penalty for our sins and to purchase a place in heaven for us, which He offers as a gift
 E. Faith
 1. What it is not – mere intellectual assent or mere temporal faith
 2. What it is – trusting in Jesus Christ alone for eternal life
III. The Commitment
 A. Transition: "Does this make sense to you?"
 B. Commitment: Would you like to receive the gift of eternal life?"
 C. Clarification: "Let me clarify this…"
 D. Prayer
 E. Assurance

[88]D. James Kennedy. *Evangelism Explosion*, fourth edition (Wheaton, Illinois: Tyndale House Publishing, Inc., 1996), 31-53.

VI. The immediate follow-up

Third, Bill Bright was the founder and president of Campus Crusade for Christ International with headquarters in Orlando Florida. As a useful tool to fulfill the Great Commission of Jesus Christ, he prepared the "Four Spiritual Laws" for the Gospel presentation. This tool has been effectively used globally and millions of souls have been won to Christ through it. Here is his Gospel presentation: [89]

Just as there are physical laws that govern the physical universe, so there are spiritual laws which govern your relationship with God.

Law One

God loves you and offers a wonderful plan for your life.

A. God's love (read John 3:16)
B. God's Plan (read John 10:10)

Why is it that most people are not experiencing the abundant life? Because...

Law Two

Man is sinful and separated from God. Therefore he cannot know and experience God's love and plan for his life (read Romans 3:23).

Man is Separated from God (read Romans 6:23)

The third law explains the only way to bridge this gulf...

Law Three

Jesus Christ is God's only provision for man's sin. Through Him you can know and experience God's love and plan for your life.

[89]Bill Bright: *Have You Heard of the Four Spiritual Laws* booklet, 1-15.

He died in our place (read Romans 5:8).

He rose from the dead (1 Corinthians 15:3-6).

He is the Only Way to God (John 14:6).

It is not enough just to know these three laws...

Law Four

We must individually receive Jesus Christ as Savior and Lord; then we can know and experience God's love and plan for our lives.

We must receive Christ (John 1:12).

We receive Christ through Faith (Eph. 2:8, 9).

We receive Christ, and we Experience a New Birth (Read John 3:1-8).

We receive Christ by Personal Invitation (Revelation 3:20).

You can receive Christ right now by faith through prayer...."

Bill Bright's **Four Spiritual Laws** booklet has been effective over the years. What I have presented above is just the outline but there are other helpful details and diagrams in his Gospel presentation booklet that are captivating and useful.

I have been trained in the use of all of the above Gospel presentations. In Liberia, I received five months of training in presenting the Gospel using the *Four Spiritual Laws*. During my M.Div studies at Knox Theological Seminary, I received two semesters of Evangelism Explosion Training and was certified as an EE Trainer. Also, I attended the Spanish River Church's Global Outreach Conference and participated in the Gospel Boot Camp training led by Dr. Nicholas after the conference. There are thousands of other Gospel presentations out there that have been developed by scholars, pastors, and Christian workers; I have decided to focus on these three prominent Gospel messages because of their effectiveness in soul-winning over the years.

I am thankful to God who has given such great wisdom to these heroes of the faith who are impacting the world with the Gospel.

Gleaning from the above Gospel presentations and reflecting on the theology of missions already discussed, I present the following Gospel presentation for the twenty-first century.

A Fresh Look at the Gospel Message

This Gospel presentation is intended to combat evolutionism and other creationisms that are unbiblical. It is prepared to set the foundation of the authenticity of the origin of sin and God's gracious plan of redemption promised in the Garden of Eden (Gn. 3:15). This promise was culminated on the Cross of Calvary (Mk. 15:33-41; Lk. 23:44-49; Jn.19:28-37). God's purpose of giving His only begotten Son (Jn. 3:16-17) is to restore man to his original state. Three main points of God's love for man are emphasized: (1) God's Love in man's Fall, (2) His love in man's redemption, and (2) God's love in re-creation of all things for His own glory.

Introduction

- God loves you; do you want to know how? (This is the starting point. If yes, then I'll begin with salvation is a...)
- Salvation is a free gift from God; it's provided by God's unconditional love (Eph. 2:8; Jn. 3:16).
- His love was demonstrated when He created a paradise for man, the Garden of Eden (Gn. 2:8ff).
- Man was God's steward with dominion over His creation (Gn. 1:28; 2:15).
- Adam named and exercised authority over all of God's creatures including His wife Eve.
- God's love placed Adam in His kingdom where there was no lack of anything good.
- In the first place, let's begin with God's love even in man's Fall.

I. God's Love was Demonstrated even in the Fall of Man (Gn. 3:1ff)

- Man fell by accepting the deception of the serpent, when Eve and Adam ate the forbidden fruit (Gn. 3:6).
- Result of their disobedience: Adam and Eve hid themselves from God's presence and tried to cover themselves with leaves (Gn. 3:7-8).
- The first Gospel in the Garden of Eden
 - Through God's judgment: "...He (the Messiah) will crush Satan's head and Satan will strike His heel" (Gn. 3:15).
 - The promised redemption: the woman who led man into disobedience would one day bring forth a deliverer.
- God's grace is demonstrated: (Gn. 3:21)
 - God clothes Adam and Eve.
 - Animal blood was spilled to make their covering.
 - This initial covering pointed to the saving death of the promised Redeemer.

In the second place, God's unwavering love was demonstrated to its fullest in man's redemption.

II. God's Love was Demonstrated in His Redemption of Man

- Man is a sinner.
 - Sin is transgressing God's law (1 Jn. 3:4).
 - Man cannot save himself – this is the Bad News (Gn. 3:1-7; Rom. 3:23).
- God is Holy and Just.
 - Because God is just, sin must be punished (Ex. 34:7; Ez. 18:4).
 - Because God is also merciful – He does not want to punish us (1 Jn 4:8; Jer. 31:3).
- God is faithful.
- In His faithfulness, God the Father sent God the Son – the promised Messianic seed of the woman (Gn. 3:15), i.e. Jesus

Christ to redeem man. He is the infinite God-man (Jn. 1:1, 14).

- To satisfy the justice of God, God the Son, Jesus Christ was put on the cross for our sins; God placed on Christ our sins and punished Him for us (Is. 53:6). He laid down His life, was buried in the tomb, and rose from the dead on the third day. The worst enemy of man is sin and death and the antidote of both is holiness imputed and imparted. Because of Christ's sinlessness, death could not hold Him. And the door to eternal life, in the New Heavenly Kingdom, is opened by faith in Christ alone. Our holiness is in Christ, the most perfect man who ever lived. Salvation is by grace through faith alone in Christ. (Eph. 2:8-9). Salvation is God's gift to believing man and there is nothing man can do by his own effort to attain it. Thus heaven is a free gift received by faith in Christ alone.

In the third place, God's love is demonstrated in creating man anew in this life and the promised recreation of all things.

III. God's Love is also Demonstrated in the New Creation of Man and all Things

- The New Creation is a present reality and future hope (2 Cor. 5:17).
- Every believer in Christ is a New Creation (2 Cor. 5:17).
- It is also futuristic – the promise of the New Heaven and New Earth (Rev. 21:1).
- Only those who are in Christ are members of His new Creation (2 Cor. 5:17).

Man's reconciliation with God is an act of God extended and applied through missions: "All this is from God, who reconciled us to Himself through Christ and gave us the ministry of reconciliation" (2 Cor. 5:18). The true Gospel as expressed by Paul is summarized thus:

- 1 Cor. 15:3-5 "...that Christ died for our sins, that he was buried, raised the third day,... he appeared to Peter and then to the twelve,... he appeared to more than five hundred brothers at the same time...."

- 2 Cor. 5: 17-19 ".... Therefore, if anyone is in Christ, he is a new creation; the old has gone and the new has come...God, who reconciled us to himself through Christ and gave us the ministry of reconciliation...."

Christ is the Creator of heavens and earth. He who redeems us from the power of sin by His grace has promised us a new heaven and new earth at His second coming. (See 2 Pt. 3:7-11). Would you like to accept Christ's redemptive work to be your Lord and Savior? If yes, the person would be led in a prayer for salvation. If no, this salvation booklet will be freely given to the person.

The message of the Gospel must also pass through the lens of the grammatical, historical, and theological structure of Scripture. The Bible was written in human language, in a Middle Eastern cultural setting. Hence, the missionary needs to *interpret* and *apply* Scripture based upon the grammatical and cultural analysis of the people he seeks to reach. He will do justice to Scripture if he does a careful analysis of Scripture. Biblical interpretation (Hermeneutics) is a vitally important course offered in most seminaries. The course is designed to equip pastors and missionaries to do proper exegesis of Scripture. It is not my intention to treat these sub-topics separately, but rather to point missionaries to the need for further study in these areas.

Conclusion

The word Missionary is like the term Trinity; it is not found *per se* in Scripture. It is derived from the Latin word *mitto*, which in turn is a translation of the Greek *apostello* (to send). The term mission or missionary as an English term has no direct biblical equivalent.

In 596 A.D. Pope Gregory the Great sent the Benedictine monk Augustine of Canterbury to lead a missionary delegation to the British Isles. The term was used in the 13th century of the Franciscans and meant that their monastic order was comprised of the "sent ones." It was later applied to the Jesuits in 1622 when the Congregation for the Propagation of the Faith was instituted.

The definition of a missionary was a reflection of the Hebrew verb bśr in the sense of "spreading (good) news" (e.g., Ps. 40:9-10; Is. 60:6).

A noun related to this is *bĕsōrâ*, which means "(good) news or from the root word, 'tidings'" (e.g., 2 Sm. 18:27; 2 kgs. 7:9) or "reward for (good) news" (e.g., 2 Sm. 4:10). It also echoes the Hebrew words, *mebaśśēr* and *m̊baśśere* in Isaiah. 40:9; 52:7. It is also used in direct reference to God in the New Testament (Gal. 3:8), to our Lord (Lk. 20:1), to ordinary church members (Acts 8:4) and to the apostles on their missionary journeys. The Hebrew word, *besora* corresponds with the Greek word, *euaggelist's*, meaning evangelist – one who preaches the Good News everywhere and plants churches.

In discussing the message of the missionary, the Gospel presentations of Drs. D. James Kennedy, David Nicholas, and Bill Bright were reviewed. I also presented my Gospel presentation for the twenty-first century. In my presentation I argue, as they did, that the Gospel begins in the Garden of Eden and culminated on the Cross of Calvary. *Pivotal to the Gospel is Jesus Christ is the fulfillment of the promised Seed.*

In the next chapter, I focus on an anthropological perspective of the Gospel. For effective ministry, a profound knowledge of the man you meet, his society, culture and religions are indispensable. Missionaries can best help a man with the Gospel when they understand and speak to his worldview.

Section Three
Anthropological Perspective
of Growing Missionaries

What makes a man complex is that he is born into a family and has inherited his family's cultural values. He is a member of a tribe, a clan, a tribal religion and may be part of a secret society as well as a citizen of a country.

Chapter 5
The Man You Meet

Introduction

One of the most important obstacles a missionary encounters on the field is the complexity of the man he meets. What makes a man complex is that he is born into a family and has inherited his family's cultural values. He is a member of a tribe, a clan, a tribal religion; he may also be part of a secret society as well as a citizen of a country. The people that missionaries meet have cultural values and baggage that may be complimentary to, or contrary to the Gospel. The natives of any country usually believe, without any doubt, that their country and culture are the best in the world. In entering their land for mission work, a missionary must be sensitive to their cultural traditions and differences. They must be willing to learn and work with them as they are, so that the Gospel will transform their lives.

A missionary belongs to, and usually comes from, a different country and culture. He may be very patriotic about his own country. This includes the values of his family and the laws and traditions governing his people. There are many cultural differences between Western missionaries and the Africans they seek to reach with the Gospel. For example, Western society is much more individualistic than African society. Western individualism stems from the *cultus* of family, city, country, and religious tradition. By contrast, *Africans prize their corporate identity*. Again, Westerners prize their freedom of speech.

A child from a Western culture can inconveniently question his parents in the presence of guests, and the parents are somehow, compelled to give an answer. In contrast, Africans live a communal life where children revere their elders and do not question their authority. This patriarchal pattern begins in the home where the father reigns as the king of his family. Submission and respect are hallmarks of his home. Children must submit to an elder's authority. This hierarchical lifestyle is predominant in African countries.

Missionaries in the past (during the colonial and imperial epochs) did many wonderful works in Africa. But regrettably, they damaged some of the good elements of those cultures that could have easily been assimilated into Christianity. Some Western missionaries took the baggage of colonialism and cultural imperialism with them to the mission field. Paul Hiebert affirms, "The modern mission movement was born during a time of Western colonial and technological expansion, and too often Western missionaries equated the Gospel with Western civilization."[90]

Personally speaking, I was converted in a Western, missionary-operated church in Liberia, West Africa. At that time, wearing traditional African attire was prohibited and considered to be a sin. Every member of the church was required to drink boiled water, which I believe now was for hygienic reasons. But the mission pastor told us it was one of the required practices of Christianity. Missionaries were like kings. What they said on any issue within the church was the final word, and any contrary view held by native parishioners was considered sinful and unacceptable. We were barred from participating in any cultural program of a village, town or city which was not Western Christian in nature. For example, we could not attend any meeting chaired by the town elders or even take part in a political party or support a family who ran for a political office. *The major danger during the colonial period of missions, and even now in some sectors, is equating Christianity with Western culture.* The Gospel was used to reinforce a Western sense of cultural superiority. Such ideology in Christian missions makes the Gospel foreign to other cultures.[91]

[90]Paul G. Hiebert. *Anthropological Insight for Missionaries* (Grand Rapids: Michigan, 2001), 9.
[91]Ibid, 53.

The sad result was that many people rebelled against the missionary's authority and the divided church could not grow. The mission pastor was being faithful to his sectarian views or missionary board policies. They may have had good intentions but they often hurt the work due to ignorance or cultural pride. Because there is a vast difference between individualism and communalism, I would propose that every missionary who is desirous of working in Africa or in any part of the world should be a bicultural missionary. That is, he shall (1) study his own culture, and (2) learn the culture of the country or state to which he/she will be ministering, including the local customs, religion(s), and secret societies of the host country.

His Country

Every country is governed by some sort of foundational document agreed upon by its citizens called a *constitution*. A constitution is a set of legal principles and policies that people have made and agreed upon for governing their society. A *constitution* enumerates and limits the powers and functions of their government. These rules constitute and define what the legal entity is. In the case of countries and autonomous regions of federal countries, the term refers specifically to a written document defining the fundamental political principles. It establishes the structure, procedures, powers and duties of the government. The term constitution can be applied to any overall system of law that defines the functioning of a government. It also includes several uncodifed historical and social conventions that existed before the development of the modern codified constitution.

Let us briefly examine the Constitution of the United States of America which was similarly adopted by Liberia. The American founding fathers agreed to establish three separate branches of government. They are (1) the Executive branch, (2) the Judicial branch, and (3) the Legislative branch. The framers were especially concerned with limiting the power of the different branches of government and securing the liberty of citizens. The Constitution's separation of the legislative, executive, and judicial branches of government, with the *checks and balances* of each branch against the other is essential. It is for the explicit guarantees of individual liberty listed in the Bill of Rights. These were all designed to strike a balance between duly constituted

authority and individual liberty. America has been the promoter of Republican democracy globally. However, a careful study of it raises questions on the role of senators and the electoral college within its democracy. A presidential candidate may win an election by popular vote of the citizens and still lose the election through the decisive vote of the electoral college. But all in all, these differences and questions are part of what American democracy was established to be.

Pivotal to the American democracy is freedom of speech, which stems from God-given inalienable rights of individual citizens. Every American can speak his opinion on any issue, be it against the president or any leaders within the government without going to prison. Since Americans are brought up in an individualistic lifestyle, there is no problem in a nuclear family for a four-or five-year old child to demand an answer from his parents even in the presence of guests. The values of every citizen of the United States are meant to be respected by their follow Americans.

I was shocked one day at the Community Outreach of Boynton, after conducting a Bible study, when a five-year-old girl asked me, "Are you marry?" Even though I was somewhat offended, in response I introduced her to my wife Esther. Asking a personal question of an over sixty-year-old man by a five-year-old girl, is taboo in Africa. This will be discussed later in the cultural aspect of a man in his context.

Because there are differences in the constitutions of each country, missionaries should do a study of the government of the country in which he wants to serve. Other countries that have democratic governments have differences mostly based upon how they are wired culturally. For example, Liberia is a democratic nation modeled after the United States. Liberia was founded by freed slaves from America in the 1820s. The three branches of governments were adopted by the Liberian government in its constitution. But what I will term electoral college in Liberia is the "Concerned Citizens." They consist of all the chiefs (including the *Zoes*) that are ruling their people in their political subdivisions, such as in every clan, chiefdom and district.

The Concerned Citizens are presently called "The Traditional Councils of Liberia." Whatever decision that this group reaches seems to be, on many occasions, the final word on political matters. If the Traditional Councils agreed to vote for the incumbent president, then

it is very difficult for any rival candidate to win the election. Because Africans enjoy communalism, we make collective decisions through our chiefs and other leaders. This also affects our vote during elections. These are complicated issues in African Democracy. A careful study of the country's form of government will enable a missionary to understand more about the worldview and political heartbeat of the people he serves.

American missionaries, who want to travel or serve in Africa, need to view this website: www.travel.state.gov. The United States government provides tips for its citizens who want to travel and live overseas. The website provides helpful information on every country in the world. This includes a description of the country, and the registration and embassy location of the country. The website also provides information about the country's entry and exit requirements, safety, security and crime; it includes criminal penalties, special circumstances in that country, medical facilities and health information. The website includes information about traffic safety and road conditions as well as the aviation oversight and children's issues in that country. There is a special section that provides advice for medical insurance for those who want to travel or live overseas.

It is also important for the missionary to be in contact with the host church or denomination in that country in order to collect other related information from them. There may be changes in the country that may not have been updated on the U.S. State Department's website. Note too that there may be some slight differences in what is on the website and that of the host church or country. At times there may be some shocking information from the host church or denomination that you will not find on the government's website. My advice is for missionaries to do all that they can to be fully informed about the country before landing and settling there. Information provided on this website is just an introduction to the country. You may Google the name of the country and read all appropriate information that comes up. The more one learns about the country, the better he/she will be prepared to minister to the people there. *Let your host church be encouraged by how much you know about their country.* They will be proud of you and see that you truly love them. Check your library and read voraciously

about the country. Here are some of the areas that missionaries need to research:

- What is their national language?
- Do they have multiple dialects?
- Study some historical facts about the country.
- What form of government do they have?
- Read the constitution of the country. If you want to serve as a missionary in a country on a long-term basis, you need to also study the various amendments the country has made in their constitution.
- Learn about the makeup of their population and natural resources.
- Is it a Christian nation or predominately Moslem?
- Has this country enjoyed stability over the years or not?
- Has there been any religious uprising in that country or not?
- Is there any persecution threat to Christians in that country?
- Learn more about other religions in that country including any secret societies you may run into. There are volumes written on African Traditional Religion, but many secret societies do not have organized published books, for example, the *Zoe* and *Porter* societies in Liberia.
- Read more about the dominating Christian denomination in that country. If it is an African Independent Church, study their distinctive doctrines. You will be well prepared to minister to them; Africans have accepted doctrinal religious conflict similar to how it is in the West.
- Helpful information can be obtained from the work of Patrick Johnstone, Jason Mandryk and Robyn Johnstone. In their book *Operation World, 21ˢᵗ Century Edition*, Updated and revised 2005 (Waynesboro, GA: Authentic Media, 2005).

Some may argue that learning all of these things about a particular country in order to minister there more effectively is unbiblical. They may claim that the most important thing for a missionary to know is the Gospel and the skills necessary to teach it in the power of the Holy Spirit. But a careful analysis of the Bible reveals that obedience

to the Great Commission of Jesus Christ is a matter of spiritual warfare. Paul teaches this in his letter to the Church of Ephesus in Eph. 6:11-12: "Put on the full armor of God so that you can take your stand against the devil's schemes. For our struggle is not against flesh and blood, but against the rulers, against the authorities, against the powers of this dark world and against the spiritual forces of evil in the heavenly realms." We are engaged in a spiritual battle globally – all believers find themselves subject to Satan's attacks because they are no longer on Satan's side. Thus Paul tells us to use every piece of God's armor to resist the enemy's attacks and to stand true to God in the midst of those attacks. Paul advised that every believer use the belt of truth, the breastplate of righteousness, the footgear in readiness to spread the Good News, the shield of faith, the helmet of salvation, and the sword of the Spirit–the Word of God. However, believe that the full armor of God is only possible in Christ alone, not in our own strength. *Preaching the Gospel in any culture is also a spiritual warfare universally between good and evil.* Therefore, modern missionaries will struggle with the political and religious establishment of every culture such as the Zoe in Africa.

Our Lord Jesus Himself commanded His disciples when He first sent them out: "See, I am sending you out like sheep into the midst of wolves; so be wise as serpents and innocent as doves" (Mt.10:16 NRSV). I believe this command to be "wise as serpents" is the theme of this chapter. Matthew chapter 10 commences with Jesus calling His disciples and giving them special authority for spiritual warfare – "to drive out evil spirits and to heal every disease and sickness" (Mt.10: 1). In fact Jesus was specific in His warning to them in verse 17: "Be on your guard against men; they will hand you over to the local councils and flog you in their synagogues." The key to this chapter is Jesus' pronouncement of sending "a sword" of decision and division, which is the Word of God, into the world (v. 24). "For I have come to turn a man against his father, a daughter against her mother, a daughter-in-law against her mother-in-law – a man's enemies will be the members of his own household" (vv. 35-36). Accordingly, Jesus helped His disciples prepare for the rejection that many of them would experience because they had become Christians. Being a man of God will usually create reactions from others who are resisting Him – from the government

(Mt.10:18-19), from the religious community (Mt. 10:17) and from one's own family (Mt.10:21).

Paul's advice to the Church of Ephesus stems from Jesus' command to His disciples and the outcome of His commission as the Gospel is preached. Missionaries need to have, besides their biblical knowledge, a clear knowledge of the culture to which they are to minister. This is important for effective ministry because they are sent as a sheep among wolves, and so missionaries must be "wise like *serpents* and innocent like *doves*" (Mt.10:16).

His Culture

The goal of missions must be larger than understanding. Our goal is to bring our cultures into conformity to the Kingdom of God and its fullness.[92]

People create a great variety of cultures. They eat different foods, build different kinds of houses, speak different languages, and greet each other in different ways. Yap women wear grass skirts reaching to their ankles: Dinka men coat their bodies with ash. Muslim women are hidden in public in Burkas; and some South Sea Islanders wear only lip plugs.[93]

I agree with Harvie Conn's conclusion that the goal of missions is to bring all cultures into conformity to the Kingdom of God. On the other hand, Harvie is also concerned about the variety of cultures and differences in their worldviews. How do we bring every culture into conformity to the Kingdom of God without imposing on them our culture and making it the standard? If a particular culture is imposed or equated with Christianity, then in reality, we are bringing the people to whom we minister into subjugation to our own provincial culture. The truth is that such a "missionized" person has been *acculturated* under the guise of the Gospel.

Adam's fall in the Garden of Eden resulted in the creation of man's community and subsequently his own culture. Depending on a

[92]A. Scott Moreau, 254.
[93]Paul G. Hiebert, 62.

man's geographical location, be it in the West or on any continent, that person is born and enculturated into a cultural mold. God selected the Hebrews within their culture to be a priestly nation (Ex. 19:6). The Jews equated knowing and believing in God with cultural Judaism – hence, Jews insisted that a Gentile must become a Jewish proselyte in order to be saved. The problem the Jews had was that they could not differentiate between their culture and their revealed religion. Similarly, this problem developed at the inception of the Church. As the Church spread through the persecution and the calling of Paul as an apostle to the Gentiles' culture; the necessity of ritual circumcision became an issue. This was the focus for the first conference held by the Church (Acts 15:1ff). Peter was one of the spokesmen at the conference. He shared his experience with Gentiles while ministering in the house of Cornelius. He described his heavenly vision for the acceptance of Gentiles ("what God pronounced clean you cannot say it is unclean" Acts 10:15). Paul and Barnabas spoke of the mighty works that were happening among the Gentiles (Acts 15:12).

After a careful deliberation by the apostles and elders of the church, the conference concluded not to bind or enslave the Gentiles to Jewish culture and practices. The apostles and elders issued an official decree that was to be circulated to all of the churches.

We have heard that some went out from us without our authorization and disturbed you, troubling your minds by what they said...therefore we are sending Judas and Silas to confirm by word of mouth what we are writing. It seemed good to the Holy Spirit and to us not to burden you with anything beyond the following requirements: You are to abstain from food sacrificed to idols, from blood, from the meat of strangled animals and from sexual immorality...Acts 15:24-29).

The council's basis for deciding what was right conduct was Old Testament Scripture (Lv.17-18). This historic decision of the Jerusalem council became the *dividing wall* between Christianity and Judaism. A Gentile does not need to be circumcised or become a Jew to become a Christian.

Many mission organizations and missionaries have forgotten the decision of the Jerusalem Council with regard to Gentile Missions. The

apostles, elders, and the council participants set the true parameters many years ago, that the Gentile cultures will only come into conformity to the Kingdom of God and its fullness by the preaching and teaching of the Word of God. The Gospel will result in their faith in Jesus Christ, and not by trying to squeeze the people into a foreign cultural standard.

My effort in this section is to help missionaries avoid equating the Gospel message with their cultural traditions. Jesus and Paul warned against the Pharisees who were guilty of "teaching as doctrines the traditions of men" (Mt. 15:9; Mk. 7:7-9, 13; cf. Mt. 15:7; Col. 2:8; Gal. 1:14; 1 Pt. 1:18, 19). This snare can only be avoided by being a *bicultural missionary* and allowing Christ to bring the heathen culture into His kingdom on His terms. We shall define what a culture is, its origin and differences as they relate to practices. This will enable the Gospel to weed out evil practices of cultures from the hearts of the people to whom missionaries preach.

Definition of Culture

A true knowledge in the use of a word begins with its definition. That is, using a word without knowing its meaning is tantamount to committing academic suicide. Therefore, I want to start with the definition of culture: The word, "culture" comes from the Latin word, "*colo*," which means to "till, cultivate, honor." and *cultura*, "cultivation, training." Harvie Conn defines it thus,[94]

> The word 'culture' may point to many things – the habits of the social elite; disciplined tastes expressed in the arts, literature, and entertainment; particular stages of historical and human development. We use the term 'culture' to refer to the common ideas, feelings, and values that guide community and personal behavior, that organize and regulate what the group thinks, feels, and does about God, the world, and humanity.

Culture is the full range of learned human behavior patterns. The term *culture* was first used in this way by the pioneer English anthropologist Edward

[94]Harvie M. Conn. *"Culture," in the Evangelical Dictionary of world Missions*, Edited by A Scott, e al (Grand Rapids, Michigan: Baker Books, 2000) 252.

B. Tylor in his book, *Primitive Culture,* published in 1871. Tylor said that culture is "that complex whole which includes knowledge, belief, art, law, morals, custom, and any other capabilities and habits acquired by man as a member of society." Of course, a culture's origin and development is not limited to men. Women possess and help create it as well. Since Tylor's time, the concept of culture has become a central focus of anthropology.

The Origin of Culture

Human culture can rightly be traced in the biblical account to Adam's Fall (Gn.3:1ff). Following Adam's expulsion from the Garden of Eden, he created his own community outside of the presence of God. It was God's original plan for man to populate the earth (Gn. 1:28), but that would have been according to His divine principles. The full picture of human culture is found in Genesis 4 when Cain, due to jealously, killed his brother Abel. God cursed Cain and he went out of the presence of God and lived in the land of Nod, east of Eden (Gn. 4:16). There Cain's wife had a baby and they named him Enoch. Cain built a city and named it Enoch in honor of his firstborn son (Gn. 4:17). What do we expect from the accomplishment of a fugitive from God and his community?

The famous book of St. Augustine of Hippo, *The City of God* found its root in Genesis 4 – the Cain and Abel episode. Abel, though he later died, was initially concerned about the City of God. Abel righteously sacrificed the appropriate offering unto God. But Cain, on the other hand, was concerned with the City of Man in which there was disobedience to God's will and wickedness. Reflecting on this root of culture, Augustine discusses two cities and two loves: The earthly, which is shaped by the love of self, even to the contempt of God, and the heavenly culture, which is shaped by the love of God, even to the contempt of self. The heavenly city's architect and builder is God while the earthly city was built on the wickedness of man. Augustine also uses these two cities and two loves in discussing the fall of Rome in 476 A.D. He saw Rome (or the new Babylon), as symbolizing all that is worldly, and he saw Jerusalem (the city of heaven), as a symbol of the Christian community. Augustine saw the world in which he lived as a mixture of the two cities. But the temporal city of this world will eventually perish,

giving way to the eternal city. As he introduced this idea, he drew on Paul's notion of "original sin" derived from the rebellion of Adam and Eve to explain how the lesser, flawed "city" came into being.

God destroyed the earthly cities but saved eight persons, (Noah and his family) through the Ark that he built (Gn. 6:5-8; 7:1ff; 8:1ff). After the flood, Noah's descendants populated the earth, but they spoke one language (Gn. 11:1). In defiance to God's will to scatter and refill the earth, the post-diluvians came together with one accord to construct a tower whose top was intended to reach into heaven. In response, God came down and stopped the project by giving them different languages so that they could not understand one another. Thus, scattering them in order to repopulate the earth - this is the origin of culture. There has been tension between the City of Man and the City of God throughout history. Through Christ, the City of Man will be eventually conformed to the City of God in the heavenly kingdom. The return of Christ will certainly reverse the Babel curse and man will once again speak one language.

Growing missionaries for the twenty-first century requires that they be bicultural, and not infected by a colonial or imperial concept of missions. Being a colonial missionary would mean Christianity is subjected to the bias of "a superior" culture. The prospective missionary of this century must study other cultures well in advance of his deployment to the mission field. By being bicultural or a "world Christian" I mean one who knows his own culture and the culture of the people to whom he is sent to minister. We must not forget the notable phrase of Socrates: "Know thyself." A bicultural missionary will be able to discern and weed out by the Holy Spirit what is cultural bias and what is the Kingdom of God.

I shall discuss how people of different cultures are wired in their thought patterns, such as time, judgment, handling crises, and goal setting. A careful study of the dos and don'ts in some cultures will be considered. These cultural norms (dos and don'ts) will enable the bicultural missionary to know, understand, and learn how to accept people as they are. Paul Hiebert, a Christian anthropologist, declares, "We learn a culture best by being involved in it. Although it helps to read all we can about a culture before we arrive, there is no substitute

for participating in the lives of the people."[95] Hale Thomas confirms that we can best know the people that we want to serve "by reading about them, their culture, their history, their religion. Much of this reading should be done while one is still at home, but it will obviously continue on the field...."[96] Let me discuss some major cultural differences below.

Major Cultural Differences

Knowing cultural differences is a key to effective inter-cultural ministry. Missionaries are required to take courses, prior to their deployment, in the specific culture that they will serve. They will also continue the study of that particular culture while they are serving in the field. The following are some major cultural differences:

Thought patterns: Knowing the differences in the thought processes of each culture will enable a bicultural missionary to accept his target audience. Accepting a culture for what it is will enable the missionary to rightly present the Gospel in an effective cross-cultural manner. For example, African thought patterns are different from Western thought patterns. A man in the West is dichotomistic[97] and his philosophical bent is pragmatic rationalism. Because he uses scientific tools, he wants to dissect, compartmentalize and quantify things. Western man develops systematic theology that reflects his background and is unique to him. He takes such stance because his general view on life is rationalistic and individualistic. His Theology also includes his psychological and cultural makeup. Africans, on the other hand, are holistic in their approach to life. An African, in my judgment, is not interested in dissecting truth and life and peering at the insides. For the

[95]Hiebert Paul G., 81-82.

[96]Hale Thomas. *On Being A Missionary* (Pasadena: William Carey Library, 1995), 63.

[97]Lingenfelter & Mayers also identifies two distinct orientations in thinking patterns: dichotomy and holism. "Dichotomy is that pattern of segmental thinking that exhibits great concern about the particulars of any problem or situation, with a tendency to reduce each to right and wrong options. This type of thinking examines and sorts the details, and reasons on the basis of perceived ordered relationships between them...Holism is that pattern of thinking in which particulars are not separated out from the context of the larger picture. A holistic thinker insists that the whole is greater than the parts and reasons on the basis of perceived relationships within the whole. " (p. 55)

Africans, social amenability is more important than the correct analysis of doctrine.[98] Therefore, if you present the Gospel rationalistically in a village in Africa, the participants will walk away wondering what you really meant. A Western man may think that because the villagers are illiterate, they need more training to understand the Gospel. No, the truth of the matter is that the missionary did not present the Gospel in a palatable or holistic way! As an African, I am not interested in dissecting the characteristics of God. I am more interested in what God does than what He is. I want you to tell me that God is the creator of the universe, savior of His people and that He has power to change lives. Then you may later reason with me deductively from the whole (which is God) to the particulars or characteristics of God. In the same vein, if an African preacher presents God holistically in a Western church, the members will certainly walk away too with lots of questions – what is he talking about? Lingenfelter & Mayers confirm, "...the Gospel writings suggest that as Jesus taught He utilized right-hemisphere, pictorial, concrete, holistic, and analogic strategies rather than left-hemisphere, verbal, abstract, dichotomistic, and analytic thought."[99]

Both thinkers (holistic and dichotomistic) may make negative value judgments about others, but for different reasons. With the dichotomist, it may be because of a particular mistake the person made; while a holist may say that all persons are flawed because of any number of mistakes. However, the key issue here is not the way of thinking but what we do with the way we think. Missionaries need to understand the biggest problems we have in our families, churches, and missions. *The problem is we often insist that we think and judge and try to remake those around us into our own provincial image.*

The communication styles in Africa can vary considerably across the continent, depending on language, culture, and tradition. Some issues are decided by men only, others by women only, and still others by men and women together. One thing is certain, however, no matter where you go in Africa, decisions are not made on the spot but rather take some time to reach through *consensus.* Africans believe that reaching a decision through consensus has the advantage of taking into account all dissenting opinions, whereas majority rule does not. Reflecting

[98]Pius Wakatama. *The Third World Church: Independence For the Third World Church, An Africans' Perspective on Missionary work* (Downers Grove, Illinois, 1978), 26-27.
[99]Lingenfelter & Mayers, 62.

and incorporating all differences of opinion within a group is a key African value. In the African village, most decisions are made by the chief or headman after all views have been fairly heard, including his own, which may be presented by another speaker, who will conclude, "The chief says…" The Western concept of "majority rule" is foreign to many parts of Africa. *This may be one of the sources of much civil unrest in African countries that are now practicing democracy.*

A bicultural missionary will be able to discern when and where to use a majority rule principle and where to build consensus. Majority rule is best practiced among the Western educated classes and the consensus-building approach would work well among the indigenous people in African villages and towns.

Tensions about time: Lingenfelter & Mayers argue that "… Americans and Germans belong to time-oriented cultures, whereas Latin American and Yapese cultures are more events oriented. People who are time-oriented express great concern about punctuality, the length of time expended, and utilization of time to its maximum potential."[100] By an oversight, they left out Africa. Africans are also event oriented. In the time-oriented cultures, everyone is programmed by time in their daily activities. Also, the event-oriented people are concerned more about the details of what is going to happen than about when it begins and when it ends. For Africans, if a meeting is to be held early in the morning, it may actually start probably by 10:00 a.m. when the last person arrives. What is important to Africans is the fellowship among them as they come together. Lingenfelter and Mayers confirm, "…Event-oriented persons will often be late to time-structured meetings because the event in which they are previously engaged is not completed on time. For time, meetings begin when the last person arrives and ends when the last person leaves."[101]

Imagine a missionary from the West serving in Zarwulugbo Town, Liberia scheduling a church meeting for an important discussion to commence at 9:00 a.m. Imagine the first person arriving around 10:15 a.m.! At 10:30 a.m. three others come and they start discussing farm work while waiting for the rest to finally arrive. How will the time-

[100]Sherwood Lingenfelter G. & Marvin Mayers K. *Ministering Cross-Culturally: An Incarnational Model for Personal Relationships* (Grand Rapids, Michigan: Baker Book House, 1986), 38-39.
[101]Lingenfelter & Mayers, 42.

oriented missionary feel? At 11:00 a.m. ten additional members may come in and join the group. While the Western missionary was out venting his frustration about the delayed meeting, one of the members asked him to wait because the town chief (a member of the church) is coming to the meeting. These are two different orientations. The missionary would be right to start the meeting because it is after 11:00 a.m. But culturally, it would also be better for them to wait for the town chief, that is, the meeting would start when the last person arrives. In such a case what should the time-oriented missionary do? Lingenfelter & Mayer advise, "An important key to effective cross-cultural ministry is an incarnational attitude toward time and event – we must adapt to the time and event priorities of the people with whom we work."[102]

It is important to note too that the Jewish culture, during the life of Christ, was predominantly event oriented. Entering a culture and often bringing a cultural blindness to this issue is unbiblical. Some Western missionaries feel the tyranny of time and orient their lives to reflect their own culture. God commands us to "Do nothing out of selfish ambition or vain conceit, but in humility consider others better than yourselves. Each of you should look not only to your own interests, but also to the interests of others. Your attitude should be the same as that of Christ Jesus" (Phil. 2:3-5).

Crises handling: There are two ways to do crisis management: (1) crisis orientation and (2) non-crisis orientation. A crisis-oriented culture would take proactive measures in anything while a non-crisis-oriented society would just walk by faith. Most of the Western nations are crisis-oriented cultures. The Continent of Africa and other countries are non-crisis-oriented cultures. Below is a detailed comparison of both crisis and non-crisis-oriented cultures.[103]

Crisis Orientation:

- Anticipates crisis
- Emphasizes planning
- Seeks quick resolution to avoid ambiguity
- Repeatedly follows a single authoritative, preplanned procedure

[102]Ibid, 51.
[103]Lingenfelter & Mayers, 75.

- Seeks expert advice

Non-crisis Orientation:

- Downplays possibility of crisis
- Focuses on actual experience
- Avoids taking action; delays decisions
- Seeks *ad hoc* solutions from multiple available options
- Distrusts expert advice

The above differences often appear between national church leaders and foreign missionaries with regard to cultural conflicts and management style. It is often necessary in the interest of furthering the Kingdom, to think in ways different from the way we normally do. Incarnationally, we must learn to think as they do in responding to crises and decision making and accommodate to their crisis management style. Lingenfelter & Mayers declare, "Our goal must be to build up the unity and fellowship of the body of Christ. To achieve that goal, we must always consider others better than ourselves. Our position is to be that of a servant."[104]

Goal setting: Another area of concern that missionaries need to carefully study is the issue of goal setting and task orientation versus person orientation. Africans, Asians and other countries are person-oriented countries. Western nations are task oriented. Below are descriptions of both kinds of orientations.[105]

Task Orientation:

- Focuses on tasks and principles
- Finds satisfaction in the achievement of goals
- Seeks friends with similar goals
- Accepts loneliness and social deprivation for the sake of personal achievement

Person Orientation:

- Focuses on persons and relationships

[104]Lingenfelter & Mayers, 80.
[105]Ibid, 83.

- Finds satisfaction in interaction
- Seeks friends who are group oriented
- Deplores loneliness; sacrifices personal achievements for group interaction

Lingenfelter & Mayers declare, "When task-oriented individuals serve as missionaries in a person-oriented culture, they often fail to grasp the importance of interaction in the daily work routine and become extremely judgmental of their national co-workers."[106] They also fail to realize that, with the nationals, working together is primarily a matter of building relationships. *American society tends to take a negative view of the highly social but nonproductive person, while African societies disapprove of the individual who appears hard, unkind, and striving to accomplish a task.* These differences suggest that, for mission work to succeed, the most productive Americans may not be the best people to send to interaction-oriented non-Western cultures. And that the most productive nationals may not be the best candidates for church leadership in a task-oriented culture.

Missionaries must understand and adapt to how each culture is wired in terms of thought patterns, time, judgment, handling crises, and goal setting. A common error made by missionaries is they feel that, because they are born into their culture, they do not need further enculturation.[107] A study of one's culture will help him to know himself. And studying the culture in which he wants to serve will prepare him for effective ministry in that culture. A bicultural missionary will not equate his culture with Christianity. With the knowledge of his host culture, he can discern the practices in the culture that can easily be incorporated and assimilated into Christianity. In a separate chapter I shall focus on the American culture and point out the areas that an American would need to be careful about when serving in another culture. Now, I want to focus the discussion on the dos and don'ts in some African and other cultures.

[106]Lingenfelter & Mayers, 84.

[107]Enculturation is the process of formally and informally learning and internalizing the prevailing values, and accepted behavioral patterns of a culture.

The Dos and Don'ts in Some African and Other Cultures

"Follow the customs or flee the country."[108]

Zulu Proverb

"When in Rome, do as the Romans do."

"All authority in heaven and on earth has been given to me. Therefore go and make disciples of all nations...." (Mt. 28:19-20)

I had proposed that missionaries make an in-depth study of the culture in which he/she wants to serve. However, in this section I would discuss some of the dos and don'ts of other cultures including practices that are foreign to Western missionaries. These dos and don'ts are essential. In Africa, there is an adage that says, "First impression counts a lot." A missionary's first mistake against their cultural *mores* would cause them to be skeptical about him, and accordingly keep a close eye on him.

Dress code: A Westerner may be considered an atheist if he wears clothing that is inconsistent with the African belief system. This is true even in the African Christian Church. For example, a missionary couple in Liberia once visited an African Flea Market, commonly called, "General Market" to share the Gospel. The husband got out of his jeep and his wife immediately followed. She wore very short pants with a thin blouse because of the high temperature on that day. When the women at the market saw her, other women came running to her with *lappas* and surrounded her in a lappas' fence. A *lappa*, in Africa, is like a yard of cloth; it is the formal attire for the majority of women in Liberia and other parts of Africa. The missionary was afraid while standing in the midst of those women. Her husband was distressed and wanted to know why the women were doing such a thing to his wife. Immediately, one of the ladies told him, "Your wife is naked and we are trying to protect the pride of womanhood!" This was not only a cultural shock for the family, but also a hindrance to the Gospel. Why? Because the indigenous women were upset with her immodest appearance concluding that a good believer in Christ would not go

[108]Richmond & Gestrin, 90.

out *naked*. With her Western mind-set, she did nothing wrong. In some African cultures, it is unthinkable for a woman to wear trousers or pants. This taboo is still strong in many cultures today and some changes are taking place in other cultures, mainly among the educated class. Similar practices prevailed in the Western nations regarding women wearing trousers, but things have changed due to cultural transformation. Paul Hiebert confirms, [109]

> All cultures have their own definitions of what constitutes sin. As the cultures change, so do their ideas of sin. For example, it was once considered evil in the West for woman to wear trousers. Today it is widely accepted. Formerly, young couples were publicly condemned if they live together without marriage, but this no longer raises comment in some modern circles.

Attitudes that are considered impolite in the Western nations are, in many cases, polite in some parts of Africa. For instance, if a younger person is speaking to an older person in many parts of Africa, she/he will not look at the person eye-to-eye as is done in the West. In Africa, eye contact is seen as a sign of disrespect to an older person. Again, in the West, it is a common practice for a woman to sit down with her legs crossed; but it is unacceptable in many African cultures. According to some African cultures, only men are allowed to sit in that manner. It is also a sign of disrespect in other African cultures for a person to give anything to someone with the left hand. This is quite acceptable in the West but scandalous in much of Africa. Though Yale Richmond and Phyllis Gestrin are not Christian authors, they have written a masterpiece, in their book, *Into Africa: Intercultural Insights*. They covered the similarities across sub-Saharan Africa – the cultural characteristics that a visitor is likely to encounter in almost every country. Richmond & Gestrin declare,[110]

> Be careful, however, in Muslim regions, where body language and gestures may differ. A 'thumbs up,' for example, a sign of success in the West, may be seen by Muslims as a very lewd gesture! Making eye contact when communicating with a

[109]Paul G. Hiebert, 53-54.
[110]Yale Richmond and Phyllis Gestrin. *Into Africa: Intercultural Insights* (Boston, MA: Intercultural Press Inc., 1998), 88.

person who is older or of higher status is considered a sign of disrespect or even aggression in many parts of Africa where respect is shown by lowering the eyes. Occasional eye contact may be acceptable but not a stare…

In many African countries, the appropriate way to address a man is to call him by his family name. For example, John Brown should be appropriately addressed as: Mr. Brown and not John as is done in the West. You can call each other by the first name within one's peer group only. But even on special occasions you need to address your peer appropriately. Missionaries need to accommodate themselves to such cultural differences if they are to work successfully among Africans. An inappropriate address is seen as a sign of disrespect for the person and this can create tension. Richmond & Gestrin observe,[111]

> Variations on the traditional handshake will be encountered across the continent. In some parts of West Africa the handshake is concluded with a light tap with a clenched fist or a snap of the fingers. In Southern Africa, a handshake may be completed by locking thumbs with the other person – wrapping your fingers around their thumb – and then resuming the conventional handshake….When entering a room you must shake the hand of each, even if you may have greeted them somewhere else on the same day. The most senior or eldest person is usually greeted first, and then the others, including women, moving around the room in a circular direction. The same procedure is followed on leaving.

Hospitality and home: In the African traditional setting, it is impolite to refuse an offer if you visit a home or village. A man can offer you his last chicken because an African believes that a household that welcomes a guest does not die. Because of this concept one can just, without prior arrangement as it is done in West, walk into a village or town, and will have a place to stay. Also, in many African homes, they remove shoes in their homes, and so also is the visitor to do. African hosts will always give visitors a gift. It is impolite to refuse the gift. It is also offensive to carry anything when you are invited into an African home because

[111]Richmond & Gestrin, 92-93.

the visit itself is a gift. Taking a gift would imply to that household that they cannot feed you adequately.

The way to an African's heart is through his children. A wise missionary should make sure to touch their children as they come around to visit. Be careful, if Africans ask you for something from home, they expect that to be given as a gift to them. And if you ask them to reimburse you, they may reluctantly do it, but may show their disappointment by avoiding you in the future.

Tipping in Africa: Tipping is done differently in African society. In the Western world, it is done after the service. But in Africa, it is done before the service is rendered. Some Westerners demand tips if they serve you. I once was served at a Denny's restaurant. As I was leaving, the waitress reminded me about her tip. Some Africans will demand their tip before the service is given. Because of this, it is considered by the West as bribery. Another form of tipping done in Africa is called *dash.* It is a practice used in the Anglophone West Africa. It takes other forms in some African countries. Because government officials are poorly paid, a *dash* to push them to sign or implement something for you is required. A *dash* is something you give to grease the gears of the bureaucracy and to get things going. It is a way of life in Africa. These are just some of the dos and don'ts you may find in Africa.

In the next discussion, I will lead you into understanding the importance of African religion and secret societies. Understanding these will enable the missionaries to be effective in communicating the Gospel in that culture.

African Religions and Philosophy

Ministering within a particular country requires knowing the complexities of their tribal religions and secret societies. It is necessary for a missionary to study the religions and other secret societies of the host country.

African Traditional Religion: African Traditional Religion is complex because, in most cases, it is embedded with their cultures, witchcraft and other secret societies. The missionary may not be able to master the African religion and philosophy owing to its complexity. But he needs to understand the African worldviews, the African concept of God, His works, nature; the concepts of spiritual beings, spirits and

the living-dead. There are the concepts of creation and the original state of man, marriage and procreation, the concept of time, death and the hereafter, the concepts of evil, ethics and justice in African worldviews. Others to be considered are the concepts of ethnic groups, kinship and the individual. Understanding the African belief systems will help the missionary to be effective in Africa. Knowing where they are, will enable him to take them to where they should be. There are many books that are published on African Traditional Religion. One of the best, in this field of study, was written by Dr. John S. Mbiti, *African Religion and Philosophy, Second Edition.*

The effectiveness of a missionary is always based upon his obedience to God and his willingness to be a servant to the people. The apostle Paul was all things to all peoples just to win some to Christ (1 Cor. 9:20-22). Paul's address to the Athenians when he found them worshipping Pagan gods including an "Unknown God" (Acts 17:22ff) is worth mentioning here. Paul knew that the Athenians were zealous in their ignorant worship and could be more zealous in Christ. The Apostle told them that the "Unknown God" has been made known to him. He is Jesus Christ. Paul explains: *"The God who made the world and everything in it is the Lord of heaven and earth and does not live in temples built by hands. And he is not served by human hands, as if he needs anything, because he himself gives all men life and breath and everything else..."*(Acts 17:24 italic mine). He preached the Gospel, and at the end of his message, some people accepted Jesus Christ, "among them was Dionysius, a member of the Areopagus, also a woman named Damaris" (Acts 17:34).

I would like to emphasize that the secret societies in Liberia can be found in many African countries. The following is my summary discussion on some of the secret societies.

Secret Societies in Liberia and Other African Countries

Every country has some secret societies. Knowing about these, if possible, is important. Prior to a missionary's landing in an African country, he should realize that some of the people most likely have a hidden allegiance to some secret societies. Below is a sampling of some of the secret societies one may find in Liberia and other parts of Africa:

First: The United Brothers of Friendship Lodge (UBF): This secret lodge was originally organized in Louisville, Kentucky in 1861 by men of African descent—some slave, some free. Lodges thereafter were organized throughout the United States, Canada and the West Indies. UBF was also established in Liberia and in many parts of Africa. It is now a secret society and some of the lodges have taken on an *African flavor*[112] in term of their practices.

Second, the Masonic Craft: This lodge is also in Africa, and some of the lodges have also taken on an "African flavor." Many sources placed the official birth of Freemasonry at 1717 A.D. However, Masonic references clearly indicated that the organization's history went back much farther than this. This lodge is highly respected in some parts of Africa. One can do research on the Masonic Craft through many Internet cult-watching groups. During the civil war in Liberia, the first Masonic Center was destroyed and rebels found *stored human remains – bones, fresh human parts in the freezers and some blood. Then some human remains were also found in the* UBF *lodge Center.*

Third, the Negee Society in Liberia has no record of its origin. No one knows about its secret history or practices until one becomes a member. They have their own initiation ceremony. This secret society falls under the category of witchcraft. The Negee has a "box" called, "Negee Box". We are told that this box is kept under water. They can capture and murder one who is sold to them. It is a terrible society. Missionaries must understand that members of this wicked society may be some of the leaders of the people in the various villages, towns, and cities. They have no written records. One of my personal encounters with this secret society is as follows: I was travelling one day with over sixty-five persons in Liberia and the Negee society attacked us by conjuring up a storm. A tree broke as the result of the storm and killed one young man who was with us. We were told later that his family sold him to the Negee Society. His death through this storm was said to be an act of retaliation by the secret society.

Fourth, the *Poro* and *Sande* Societies: These societies have no published books, but they are the traditional training institutions for the boys and girls as they grow to a certain age. Over the centuries, these schools are usually located in the forest enclaves and called by

[112]A mixture of witchcraft and fetishism.

outsiders "bush schools." The schools have been a major source of perpetuating cultural history and practice orally as well as with special crafts and skills: The skills are tribal music, dance, acting, directing, linguistics, weaving, hunting, architecture, medicine, fishing and daily life skills.

The traditions of the *bush schools* differ from one ethnic group to another and from region to region. In some ethnic groups it takes seven years to graduate from the *bush school* but in another region it may take children from three to five years to graduate. But because of compulsory education launched in Liberia years ago, formal negotiations were made by government officials and the *bush schools* leadership to reduce the years of training. Training takes less than a year now in Liberia for the *bush school* and a little more than a year in other regions of the country. This special traditional training differs from country to country in Africa.

The *bush schools* (*Poro* and *Sande* societies) are under the direction of the Traditional Councils of Liberia or the Zoe, (as it is also called). This group has succeeded in grooming many past Liberian presidents for their *Poro* Society. The *Zoe* cult is also a strong political force in the country and they function like the electoral college in the United States. For major decisions affecting the country or the *Zoe* leadership, the *Poro* and *Sande* meet together. And because the majority of the men and women in Liberia were educated in these societies, one cannot stand against the decision of the Zoe. Even within the Mamba Zoe (a member of the *Poro* and *Sande*), if you were doing something that another Zoe member disliked, he can stop you by a special "sign." And if you refuse to listen to your fellow Zoe's member, he can report you to the Chief Zoe to be punished. Sadly, any death that occurs in the "*Poro* or *Sande* bush" cannot be investigated by the government.

There has been a constant fight among many Liberians, especially Liberians of the educated class and the Christian community, to disable this secret society, but it is an uphill battle against "principalities and powers."

Fifth, Witchcraft: this is the most complex secret society. It is made up of a combination of the Negee, the bush school, the medicine man, and some of the UBF and Masonic lodges. There are no written records of this movement but they function in all aspects of the African society.

As a missionary serves in Africa (or to be more specific in Liberia) he will constantly encounter these secret societies. The only solution to counteracting them is faith in Jesus Christ.

Conclusion

Because of the complexities of man in his culture, a missionary needs to study many areas of the culture in which he serves. This also includes secret societies that are traditional and/or foreign in the country. A missionary must be bicultural, that is, he is not only to study the culture to which he expects to serve, but he should also study his own culture to see how his beliefs and traditions "come across" to Africans. God in Christ is reconciling the world unto Himself in every culture. Elevating one's culture to being the norm of Christianity is unbiblical—no culture is perfect. Cultural study is essential for cross-cultural missionaries. Because not understanding the differences in the way others think, judge, and work may interfere with the effectiveness of the mission. For example, people from the Western world tend to be task oriented while people of Africa and other countries tend to be more person oriented. There will always be disagreements or confusion between the two if the missionary is not bicultural. There are also tensions about how different cultures view time. Punctuality is the hallmark of the West while Africans are only concerned about the event and camaraderie and not *when* they get there. Decision making in terms of crisis is another issue of major difference: The Western missionary may immediately calls for preventive measure while his African brothers and sisters may procrastinate or ignore his missionary brother. For him, it can only become an issue of concern when it occurs.

Missionaries are to be sensitive to the *dos* and *don'ts* of each culture. They should watch out for the dress code in the country where they serve and follow the rules of hospitality of the people they seek to serve. The more a missionary understands the culture, the more they will find acceptance of them and the Gospel message. There are some people that a missionary will meet who will be shocked by how well informed the missionary actually is. Studying about the secret societies will enable a missionary to preach the Gospel with appropriate illustrations and applications in that culture. *Being a bicultural missionary does not mean that a missionary should compromise the Gospel. It means by way of analogy that he*

is being like Jesus, who, though in the form of God became man (Jn. 1:1ff). Being man does not limit Him in preaching about His kingdom. Refusing to be a bicultural missionary is an indication that a missionary just wants to preach the Gospel through his own cultural lenses – because that's the way he has always done it!

In the next section of the book, I will focus on the Operational Perspective of Growing Missionaries. Gleaning from the discussions in the previous sections, Section Four proposes a comprehensive training program for short- and long-term missionaries. It also applies the agricultural systems discussed in chapter 2 as a foundation to the definition of "Growing Missionaries," to the proposed missionary training program.

Section Four
Operational Perspective of
Growing Missionaries

The blunder of the colonial and imperial approach to missions by missionaries cannot hold any longer in the twenty-first century. We need a bicultural missionary to bring every culture under the Lordship of Christ.

Chapter 6
Short- and Long-Term Missionary Training

Introduction

\mathbf{M}issionary training is indispensably essential in the fulfillment of the Great Commission. Jesus trained His disciples, not in the formal classroom setting, but while He went about doing good. A classic among the many books written on Jesus' approach to discipleship/missionary instruction is A. B. Bruce's, *The Training of the Twelve* (Grand Rapids, Michigan: Kregel Publications, 1980). He discusses and analyzes the disciples' call and the diverse lessons taught by Jesus for effective work in obedience to the Great Commission.

This chapter is divided into six main parts; Part A: Preparing Candidates for Short-term Missions; Part B: A Proposed Eleven-week Training course for short-term mission trips; Part C: Long-term Missionary Training with a proposed curriculum for "formal" and "informal" missionaries; Part D: Sources for recruiting Missionaries; Part E: Application of Agricultural Systems to Missionary Training; Part F: Fundraising Methodologies and Accountability of the Missionary.

Part A discusses the preparation of missionary candidates for short-term missions. It focuses on the building of mission teams. Prayer is the starting point in building a mission team. It will avoid Satan's creating loopholes in the objective of the mission trips. The church or mission organization is advised to provide an application form. The objective of the form is to ascertain some general facts about

the applicant. This will enable the church/mission organization to make a sound decision regarding each applicant. The spirituality of the applicant is measured by questions that are on the form; general information about health issues as well as personal information about the applicant is mentioned. Selection of qualified candidates is based upon the facts that are analyzed from the form. Accepted candidates are also required to sign a covenant agreement with the church or mission organization. This Covenant form specifies the dos and don'ts of the trip. Fundraising, cultural study, and the responsibilities of team leaders are also discussed.

Part B provides Eleven-week studies for qualified mission-trip candidates. These trainings are required for everyone.

Part C provides curriculum for formal and informal missionary training. By *formal*, I mean missionaries who have had seminary education and who are now ready for the mission field. *Informal* refers to those who do not have seminary education; some may even be a high school dropout, but God called them for missions. A curriculum was also proposed for them.

Part D identifies helpful sources for recruiting missionaries.

Part E applies the agricultural systems discussed in Chapter 2 to missionary training. Part F discusses and analyzes fundraising methodologies and accountability of missionaries. In discussing the importance of fundraising, I discovered that many missionary-sending organizations do provide excellent training for missionaries' fundraising. Therefore, I will recommend a few books instead of presenting a comprehensive proposal for fundraising.

Pivotal in this section is the importance of missionary accountability. I clarified that missionaries are accountable to God, their churches, their families, and those who are partnering with them through prayers and financial support. Therefore, missionaries are called upon to be biblical in their understanding of partnership. Some missionaries are erroneously using the political word "partisan" for partnership. A definition of each is provided so as to enable them to go back to the biblical meaning of a partner or partnership in ministry.

Let us begin with Part A: Preparing missionary candidates for short-term missions.

Preparing Candidates for Short-Term Missions

Building the Mission Team

Prayer is the Starting Point to Missions: Starting mission preparation without prayer is a major error in many churches and mission organizations. We need to begin with God in all that He has called us to do. People have different motives for wanting to go on a mission trip: Some love to travel. Others may travel for romantic reasons such as because a fiancé is going on the trip. Some want to travel just for the experience of seeing another country, and many participate in a mission trip hypocritically to prove their spirituality. Hence, beginning with fervent prayer may weed out those with wrong motives. Mission team leaders need to imitate Jesus who prayed for God's wisdom in everything. As the church prays, God will direct the entire process of where to go, when to go, how to go, and what to do on the mission trip. Some churches have previously worked in a particular country and want to do a follow-up mission trip or undertake or finish a project begun in that country. Building a mission team also requires an application process that should include surveying the candidates' background and a willingness to covenant with team members.

Application process: Every church or mission organization should have an application form given to those who are interested in participating in the trip. A sample of such a form is found in Appendix D. This form includes a survey of the person's personal information with regard to his faith, marital status, past mission experience, travelling documents and medical issues.

Selection of candidates: The church leaders should prayerfully consider the response of each applicant. Some areas of concern include (1) their general health condition: an applicant can be turned down if he has a serious medical issue. The screening committee may have to consult with the person's medical doctor in some cases; and (2) the person's Christian testimony and call to participate in the trip is essential to scrutinize. An application can be disapproved if the person has wrong motive(s) for the trip. For those applicants who are under eighteen years of age, the church must have parental or legal guardian permission if he or she is eligible to be selected.

Covenant with the Candidate: A release document must be signed by the selected candidates. This document should spell out the dos and

135

don'ts for the mission trip as well as stating any risk(s) involved in the trip. Also, the applicant's commitment to abide by the mission's covenant statement is clarified in this document. A sample of a covenant agreement is found in Appendix E.

Fundraising Activities: One of the most important areas for planning a successful mission trip is fundraising. Each approved team member is usually self-sponsored. But some churches are able to pay for the costs outright. Other churches are able to subsidize a portion of the cost, leaving the rest to be raised or provided by the team members. Scholarships can be awarded to some needy and qualified members of the team by either the church at large or by a member of the church. Pivotal to fundraising for a mission trip is providing an accurate cost estimate and providing strategies to help participants raise the needed funds. Fundraising can be accomplished in many ways and each strategy should require the participation of every team member. Such fundraising strategies include church-wide yard sales, breakfasts or bake sales, spaghetti dinners, craft fairs and Trivial Pursuit marathons. Additional suggestions include golf tournaments, car-washes, and letters written by team members indicating the purpose of the trip and its costs. The goal is to solicit support from church friends, relatives, neighbors, employers, and friends.

Mission team administrators and their responsibilities: Administrative structure is essential for every successful mission trip. David C. Forward affirms, "It works well to first select a core group, perhaps even before you publically announce the trip."[113] These administrators should be people of mission experience who are willing to run with the goal of the trip in mind and the proven ability to head up the project. Some suggested mission projects include: teach Vacation Bible School, building construction or repairs, medical or agricultural education, etc. The team administrator(s) also needs to prepare himself for conflict resolution that may affect the team's success in achieving its goal. The leaders are required to make advanced arrangements: David Forward suggests that they call: "(1) a local travel agent, (2) an airline, (3) a consolidator, or (4) a mission specialist."[114] The effectiveness of this mission administrator in finding out all the facts and figures about the

[113]David C. Forward. *The Essential Guide to the Short-Term Mission Trip* (Chicago, Illinois: Moody Publishers, 1998), 83.
[114]Ibid, 95.

proposed travel will help prevent disappointment in the process and conflict at home or on the field. The trip planners should take into account the readiness of all the travelling documents: the obtaining of international driver's license, passport, carrying medical supplies and pre-trip immunizations as well as insurance needs.

Missions and the Culture

Mission candidates should be required to study their own culture and the culture of the host country. Studying the culture of the host country will also preclude a lot of the cultural shock that happens to foreign visitors. Most importantly, the mission candidate will know the good things about African culture that can be assimilated with Christianity. This will also allow the Spirit of God to show the people what they must abstain from in that culture. Christ is Lord in every culture. Hiebert observes, "*Emic* and *etic* understanding of a culture complement each other. The former is needed to understand how the people see the world and why they respond to it as they do. The latter is needed to compare one culture with other cultures and test its understanding of the world against reality." [115]

Some Insights about Western and African Cultures

It is important to discuss below some generalized characteristics that Western missionaries may possess to some degree as part of their personalities, customs and viewpoints. This self-understanding culturally will help them to avoid imposing their ideologies and cultural mores on the host culture.

First, Western culture is time oriented: That is, the culture is time driven. An American is controlled by his calendar and watch whereas African countries are event oriented.

Second, Americans are task oriented: They believe in the job being done as scheduled. Westerners are achievement focused. Africans are fellowship oriented – although the job is important, it can be done the following day to give fellowship a chance.

Third, eye contact: Westerners consider eye contact in communication as a gesture of politeness, but it is a sign of disrespect in African cultures.

[115]Paul G. Hiebert, 97.

Fourth, crisis oriented: Westerners place high value on avoiding crises, but Africans will only act when there is an actual crisis.

Fifth, Americans are very open in self-disclosure: That is, they seemingly have nothing to hide. An African friend of mine once advised, "If you have any secrets, don't share them with your American friends, indeed, it will be in the air tomorrow."

Sixth, Americans are trained to behave as independent, self-reliant individuals. Hence, often elderly Americans would prefer living in a nursing home to avoid being a burden to their son and his family. This is perfectly acceptable with them; but in African cultures, it is a cultural mandate that children care for their elderly parents until death.

Seventh, Americans are pet oriented: Dogs, cats, and other animals are domesticated and treated like members of the family. Many Westerners can kiss their dogs, cats, etc. Such shows of affection are repulsive in Africa. Kissing a dog is considered very "nasty"! If you kiss a dog, no one would want to offer you water in a cup. Or if they do, just to avoid embarrassment, they would throw that same cup away when you leave. In fact, dogs and cats in other African cultures are not pets. It is believed, in other African cultures, that the hairs of a cat carry some diseases like colds or coughs, tuberculosis, skin rashes, etc. Cats are also seen as associated with witch-craft in some part of Africa.

Eighth, supremacy of culture: Americans have a reputation that they believe they have the greatest nation on earth and therefore are superior to all others. To be civilized is to embrace the American culture, and they have been taught to act accordingly. *Mission team members are to understand that no culture by definition is inferior.*

Ninth, competitiveness: Typically, Americans want to excel to the highest level of anything that they undertake. Gary Althen confirms, "Americans see as heroes those individuals who 'stand out from the crowd' by doing something first, longest, most often, or otherwise 'best'. Real-life examples are aviators Charles Lindbergh and Amelia Earhart, golfer Tiger Woods, and basketball player Michael Jordan."[116] Such expressions of a competitive spirit are not found in a communal society. Dr. Mbiti sums this up in his astute statement about the collectiveness of the African peoples thus: "I am because we are; and since we are,

[116]Gary Althen, 10.

therefore I am."[117] Due to Western education in Africa, Africans are gradually *becoming more* competitive. This, I believe, is one of the roots of many conflicts on the African continent.

Tenth, individualism: Americans see themselves as individualistic, self-reliant, independent persons. Gary Althen affirms, "They [Americans] are trained from very early in their lives to consider themselves as separate individuals who are responsible for their own situations in life and their own destinies. They are not trained to see themselves as members of a close-knit, interdependent family, religious group, tribe, nation or any other collectivity."[118]

Eleventh, freedom: Americans see freedom as one of its most important core values. Hence, the spirit of freedom begins with the family. It also gives birth to an emphasis on freedom of speech in American society. Americans dislike any country that takes advantage of another group of people that needs freedom. This spirit is carried by Americans wherever they travel. Mission team members need to understand that every country was built on an established culture and the citizens hold their traditions in high esteem. Missionaries must learn to respect the host culture and do their best to learn about their worldview. What is important on the mission field is that the Gospel of Jesus Christ and not the cultural baggage that a missionary may bring with him.

Twelfth, privacy: Americans find it difficult to understand people who always want to be with another person. They believe that most people need some time to be alone. Privacy is foreign in African countries. Missionaries will always have uninvited guests show up at their homes, so they should learn to smile and be patient with them.

Thirteenth, equality: Americans believe in the ideal stated in their Declaration of Independence that "all men are created equal."[119] Americans are generally quite uncomfortable when someone treats them with obvious *deference*. They dislike being the subjects of open displays of respect such as being bowed to. This is quite different in other cultures where there is a hierarchy of citizenship based upon one's family line, political affiliation and leadership within the society. Richmond and Gerstrin affirm, "Observe the hierarchical ranking in bureaucracies. Go through proper channels, and do not jump over

[117]John Mbiti. 123.
[118]Gary Althen, 5.
[119]Ibid, 14.

officials in rank. If you do, the official you jump over may do you in. If you should make a courtesy call on a higher official, for example, notify the lower-level official so that he will not be offended. Follow the established procedures."[120] Short-term missionaries should be aware that once you cross the societal border, you are out of your comfort zone of culture. You need to adapt to the new culture and be willing to be a learner. The old adage says rightly, "When in Rome, do as the Romans do."

Fourteenth, family: In the American culture, family refers to the father, a mother, and their children – a nuclear family; but in African countries grandparents, aunts, uncles, cousins and others are all included in the family. Some Americans do not display the degree of respect for their parents that people in more traditional or family-oriented societies commonly do.

Americans are proud of their culture and often invites foreigners, who come to visit or live in the United States, to respect it. In the same way, every country honors its own culture and thinks it is the best in the world. Disrespecting another country and culture, especially in the homeland, creates chaos and rejection of the message of the missionary or missions team members.

It is important for a mission pastor or mission team leader to research his own as well as the foreign culture to which he is going. It is important to note the differences as well as the similarities between the cultures. The key to success in mission work is learning to accept and work with people as they are with respect to their culture and then to preach the Gospel in culturally sensitive ways to them.

Below I have prepared eleven-week training sessions for short-term mission candidates. These sessions are indispensably essential, and required for every approved candidate. The lessons are my reflection on the orthodox doctrine of God's Creation, Man's Fall, God's redemptive act in Christ Jesus, and His promised re-creation of all things.

[120]Yale Richmond & Phytllis Gestrin, 165.

Proposed Eleventh Week Sessions for Short-Term Missions Candidates

Successful mission trips are in large part related to team members' active participation in the team meetings together. Excellent understanding of the theology of missions, the redemptive act of God and the message of the Gospel are important for mission candidates. Therefore, the candidates' regular and disciplined regimen of prayer, study and planning for the trip are vital:[121] Class sessions:

- Build team camaraderie and morale.
- Enhance their biblical understanding of mission work.
- Develop other language skills (if appropriate) and cultural understanding of the host community.
- Prepare for the physical skills and logistical arrangements required for the trip.

Each training session has its own objective and updates the team members on the on-going preparations for the trip. Let's begin with the first week missions training/meeting:

First Week: An Overview of the Mission Trip

The objective of the first meeting is to:

- Offer an overview of the mission trip.
- Introduce church pastor(s), mission administrator(s) and team members.
- Discuss the logistical aspects of the trip.

Opening prayer

Introduction: Church pastor(s), team administrator(s), and team members.

Scripture reading on the Great Commission of Jesus Christ, Mt. 28: 16-20.

[121]David C. Forward, 110.

Brief information on: (1) the host country, (2) the purpose of the trip, and (3) a challenge to every team member to achieve the mission goal.

Brief discussion of logistics and other matters: cost, dates, fundraising concepts, expectation of team members to participate in all the training and fundraising events, the dos and don'ts of the trip, language acquisition, journaling, health considerations, insurance, accommodations and meals, cultural sensitivity, preparation of personal testimony and preparation of Scripture reading, the biblical basis of Christian missions and assigned materials.

Q & A

Adjournment of meeting with prayer.

Second Week: The Foundation of Christian Missions

At the end of this meeting, every team member will be able to understand and believe:

- In the foundation of Christian missions
- In the biblical account of creation

Opening prayer

The foundation of Christian mission is *God's love*:

- God originally created the heavens and the earth: the heavens as the abode of God while the earth was the paradise for man (Gn. 1:1; chapters 1-3).
- Adam and Eve, the first couple, were to have dominion over all of creation (Gn. 1:28; 2:15).

The Biblical account of Creation is the only truth as opposed to evolutionism:

- God created the world in six literal days versus the evolutionary view of the world that teaches that the world has been in existence for billions of years.

- Evolution is a belief system, not true science. Note that science only deals with the present, not with the past, because the past is not observable, nor repeatable.
- Some evolutionists have attacked the foundation of Christianity. If there is no Creator, and sin and death existed (in the world) long before Adam and Eve, then the conclusion is Christ's death is in vain; there is no redemption in Him.

Language skills begin

Discussion of financial matters

Q&A

Assignments:

- Prayer partner selection
- Journal entry begins
- Further reading required: Ken Ham. *Creation Evangelism for the New Millennium* (Green Forest, AR: Master Books, Inc., 1999). Ken Ham & Paul Taylor. *The Genesis Solution* (Grand Rapids, Michigan: Baker Book House, 1988).

Adjourn with prayer

Third Week: The Biblical Basis of Christian Missions

The objective of this session is that the participants will be able to know, understand, and believe:

- In the source of Christian Mission
- That the promise of redemption began in the Garden of Eden
- The justice of God is implanted with His blessings

Opening prayer

Report on assigned readings, prayer partners and journaling.

Teaching on the Biblical Basis of Missions: the first Gospel in Genesis:

- Adam and Eve were sinless in their original state, living in the presence of God and administering His creation (Gn. 2).
- The serpent deceived them into disobeying God by eating the forbidden fruit (Gn. 3:6).
- Adam's disobedience gives birth to three major problems:
 - First, physical death. In man's original state, he was created sinless. Physical death did not occur instantaneously, but it does occur later.
 - Second, spiritual death occurred immediately as a result of their Fall - God's Spirit in Adam which enabled him to understand the things of God was impaired and corrupted. Dr. David Nicholas called this "the warping of our spiritual sensor"[122] which originally enabled man to relate to God spiritually. This sensitive spiritual gift of God was corrupted, thus man lost the ability to communicate with his Creator.
 - Third, eternal death takes place after the final judgment – total separation from God in Hell forever!
- The divine justice with the first Gospel:
 - The serpent was cursed to crawl perpetually, eat dust, and be at enmity with the seed of the woman. "He [the Messianic Seed of the Woman] shall crush your head, and you [serpent] shall bruise his heel" (Gn. 3:15). This curse upon the serpent was embedded within God's redemptive plan: here is the first Gospel – the seed of the woman will crush the serpent's head! That is, the very woman who was deceived will bring forth the Messianic deliverer!
 - This Gospel was also illustrated in the covering of our first parents with the coats of skins from the slain animals [perhaps lamb skins] (Gn. 3:21) and was culminated in Christ's death on the

[122]David Nicholas, in his Gospel presentation booklet: *Life: What's it all about?* N.d., 8.

Cross of Calvary (Mt. 27:35-44; Mk. 15:25-32; Jn. 19: 18-27). More will be discussed in week four.

o The ground was cursed including man: Man will now till the ground painfully and the ground, in turn, will produce thorns and thistles for him; he shall now eat the plants of his field until he returns to the ground from which he was formed (Gn. 3:17-19).

o The woman was cursed with an increased pain in childbirth and her frustrating desire to dominate her husband (Gn. 3:16; cp. 4:6-7).

Key points to remember:

- No sin goes unpunished. God is love, but He is also righteous and just.
- The justice of God contains His grace.
- The seed of the woman was among her many seeds.
- Man would now eat by tilling the ground which would now produce thorns and thistles.
- The desire of the woman would now be to dominate her husband. The battle of the sexes has begun!

Distribute list of team members with home and work addresses, telephone numbers, fax and e-mail contact information.

Language skills

Financial matters: fundraising ideas

Q&A

Journal assignment continues

Adjourn with prayer.

Fourth Week: God's Justice and Redemption– the First Gospel in Genesis

At the end of this meeting/lesson, the team members will be able to learn and believe that God's grace is embedded also in His justice.

Opening prayer

Teaching on the biblical foundation of mission continues. Demonstrating God's love even in exercising His justice and redemption symbolizes:

- The Promised Redeemer Symbolized:
 - o God promised Adam and Eve restoration (Gn. 3:15).
 - o It was demonstrated by providing clothing for them at the expense of the animal kingdom (Gn. 3:21).
- The skins used for their covering were probably from lambs. This act symbolizes:
 - o The covering of Adam's sin. This was also demonstrated through the sacrificial system instituted in the Old Testament, and
 - o Christ is the Lamb of God who takes away the sins of the world (Jn. 1:29, 36). Instead of being covered (Gen.3:21) like the first Adam, the Second Adam was uncovered on the cross; He shed his own blood for believing mankind.
- Adam and Eve were driven from their paradise (Gn. 3:24) with the hope of future reconciliation.

Discussion

Language skill

Q&A

Assignment: Research on the host country, their form of government, some of the laws of that country and beliefs and practices of their culture.

Adjourn with prayer

Fifth Week: The Covering of Adam and the Uncovering of Christ on the Cross

At the end of the training lesson the team members will understand that they are:
* missionaries sent by the Lord to the host country, and
* to implement the redemptive plan that God initiated in the Garden of Eden in reconciling man back to God (Gn. 3:15, 21; 2 Cor. 5:16-20).

The first Gospel in Genesis and the covering of Adam and Eve clarified:

* The first Gospel in Genesis (Gn. 3:15): The Seed of the woman. *This redemptive-historical thread can be traced from this text (Gn. 3:15) all the way to Calvary:* Some theologians warn against using this text for Messianic interpretation because the Hebrew word for seed used here was in a collective sense and the word seed refers to descendants. In refutation, what these theologians missed in their interpretation is the word "seed" can have both a collective and singular sense. They fail to understand that there were several descendants from Eve, but it was one "seed" that crushed the head of Satan on the Cross of Calvary. Hence, I conclude that this very "Seed" was within the seeds of the woman.

* The seed-bearers from Seth to David – the lineage of Christ:
 o The seed-bearer in the household of Adam was Seth, his third son, not Cain the firstborn son who, out of jealousy, killed his brother Abel (Gn. 4:1ff).
 o In Noah's household, the seed-bearer was Shem, his firstborn.
 o In Abraham's household, the seed-bearer was Isaac, not Ishmael.
 o In the house of Jacob, the seed-bearer was Judah, not Joseph. Though Joseph provided physical deliverance from some of the dire effects of the

147

Fall (famine) and his dreams were fulfilled, he was not the bearer of the Messianic lineage. In fact, Joseph's life paralleled the life of Christ in many respects, but at the death of Jacob, the Scepter was given to Judah (Gn. 49:8-9-12NIV).

- o From the household of Jesse, who hailed from the tribe of Judah, came the seed- bearer, David the great King of Israel, not his oldest brother Abinadab (1 Sm. 16:1-13).
- o Ultimately, from the lineage of David came the final Messianic "Seed," Jesus, born from the line of David by the Virgin Mary (Mt. 2:1-12).

Group discussion

Q&A

Assignment:

- • Write three pages reflecting on the lesson taught in week five.
- • Write out your personal testimony (salvation history) that you will use on the field.

Adjournment and prayer

Sixth Week: Christ is the Lamb of God

The objective of this lesson is to prove that the animal blood that was shed in the Garden of Eden was from a lamb; its skins were used for the covering of Adam and Eve. This sacrificial lamb covering was repeated, in various ways, throughout Scripture and culminated on the Cross of Calvary.

My premise is Christ is the Lamb of God that takes away the sin of the world (Jn. 1:29, 36):

- • *The Adamic covering:* the first punishment for man's sin was placed on the animal kingdom – the blood of a lamb was shed

for Adam's covering. This act of God symbolized a promised redemption assured to our first family.

- *The Noahic covering* of the Ark was a type of Christ (Gn. 6-7).
- *The Abrahamic covering.* The ram substituted for Isaac on Mount Moriah (Gn.22:1ff) was the reenactment of the paradisiacal "covering" and a type of the atoning death of Christ.
- *The Passover* (cover-over), in Egypt, symbolized a covering for the Israelites (Ex. 12:1ff) by marking of lamb's blood on the door post in every Israelite's home.
- *God instituted Temple sacrifices* as re-enactment of the Adamic covering (Lv.17:11) by sprinkling the blood of sacrificial animals to cover sin.
- *The coming of the Promised Messiah was foretold*:
 - the Messiah is to be born of a woman (Gn. 3:15);
 - He would come through the line of Shem (Gn. 9:6);
 - specifically through Abraham (Gn. 22:18);
 - Isaiah presents the Messiah as a suffering Anointed One (Is. 53:1ff);
 - He is pictured not only as a great king (Is. 52:13; 53:12), but also as a humble (53:2), humiliated (52:14), rejected servant (53:3), bearing the consequences of mankind's rebellion (53:5, 6).

Q & A

Assignment:

- Further reading on the culture.
- Serve in an area among people of similar culture of the host country.

Language skill

Sharing insights about the culture of the host country (by the team leader)

Financial matters: payment of second financial installment.

Journal assignment: give your written reflection on the lesson taught.

Adjourn with prayer

Seventh Week: The First Great Commission – The Call of Abraham

The objective of this lesson is to propose that:

- The first Great Commission started in the Old Testament with the call of Abraham (Gn. 12:1-3).
- Abraham was to grow in his greatness.
- Abraham was to re-create the world by making God's name known to every man.

Abraham's calling was the first Great Commission: (1) He was to grow in his greatness, and (2) to make God's name known to the world.

- The call of Abraham: The First Great Commission (Gn. 12:1-3, read):
 - ○ Key promises made to Abraham: "I will make you a great nation; I will bless you; I will make your name great; you will be a blessing; I will bless those who bless you; I will curse those who curse you; and all people on earth will be blessed through you."
 - ○ Promise of a great name and a great nation: the concept of making or re-creating is embedded in the text. The first Hebrew word translated as "great" is gadol. It denotes big, great or expanded. The second Hebrew word translated great has the same root as gadol but with a slightly different meaning: "I will make your name great." The Hebrew word for great here is agaddela(h). It means growing up as in developmental stages to be strong. That is, this promise would be achieved through a growing process.
 - ○ Abraham's "leaving" his household and people signified his spiritual birth into the new era of "re-creation." The era began with Abraham and shall end with Jesus Christ. He raised

up Abraham and gave him his first Great
Commission to "go" and re-create the world
through the Gospel of making God's name
known to the whole world.

- In fulfillment of the promise in Genesis 3:15,
 God the Son, Jesus came that through His blood,
 man, by faith in Christ, would have forgiveness
 of sin and be commissioned to preach the Gospel
 of reconciliation (2 Cor. 5:16-20).
- Sharing the culture (team members share
 an insight about the host country that they
 learned).

- Language skills: learn basic questions and practice personal
 introductions.

Q & A

Assignment: completion of personal testimony–spiritual
autobiography.

Adjourn with prayer.

Eighth Week: The Second Great Commission and its Message

At the end of this lesson the team members should be able to:

- Know and believe that the Great Commission of Jesus Christ
 in the New Testament is the second Great Commission (Mt.
 28:16-20).
- Believe that it is to be implemented with the Gospel of Jesus
 Christ (1 Cor. 15:3-8; 2 Cor. 5: 17-21).

The message of the Second Great Commission: Key message of the
Gospel:
- That Christ died for our sins – He was punished for our
 iniquities.

- He was buried in a tomb, and on the third day rose from the dead.
- Salvation is by faith in Christ alone (Eph. 2:8).
- The goal is to: reconcile sinners unto God (2 Cor. 5:17-21) and for them to become new creatures in Christ.

Sharing the culture (team members share additional insights about the host country learned from their personal research).

Presentation of testimonies by team members.

Q & A

Financial matters: collect final payments.

Get a copy of photo/personal details page of each member's passport.

Assignment: further reading about the Great Commission.

Adjourn with prayer.

Ninth Week: Understanding the Culture of the Host Country

The objective of this section is to focus on the host culture.

Guest speaker: a national from the host country is to be invited to talk about the culture, people, customs, etc., or invite a mission specialist to lecture about the host country.

Q & A

Language skill practice

Journal assignment: Write a reflection about the need for cultural sensitivity.

Adjournment with prayer

Tenth Week: Understanding Your Own Culture

At the end of this lesson, the team members will be able to:

- Know their own worldview – that is to understand how they are wired and behave the way they do.
- Compare and contrast their culture to the host culture.
- Think through the differences and find a common ground in Christ that will enable them to relate well to the host country with respect.
- Believe that the same esteem you have for your culture, so has the host culture with their worldview.
- Know the differences in the thought patterns between the two countries.

Discuss the following cultural differences between the West and Africa:

- Crisis and non-crisis orientations; identify the problem of these two orientations and decide how the mission team will relate to such issues in the host country.
- Most host countries would always select some of their leaders to help team members in ministering to their people. Define tasks and persons' orientations and raise the issue that may likely arise as a result of these opposite orientations. How will your members be prepared to handle such differences for the sake of the Gospel?
- How will you address the issue of dress code differences and what will your team do to effectively preach the Gospel in that culture?
- How will you prepare to present the Gospel in a culture that does not understand the Gospel rationalistically as is preached in the Western world? How will you prepare your people to present the "whole" and then later in part?
- If possible allow each person to present to the team members other problematic areas from his reading for discussion.

Assignment:

- Research further on the host culture reflecting on the class discussion to find other details and helpful solutions for one's personal enrichment.
- Reread chapter 5: The Man You Meet.

Adjournment with prayer

Eleventh Week: Summarizing the Lessons Learned and Final Business for Departure

The objective of this lesson is for the mission team members to:

- Prepare themselves for the day of departure.
- Important tips about the host culture.
- Logistics for the trip.

Key facts to remember about the trip:

- You are God's ambassador to reconcile people to the Lordship of Christ (2 Cor 5: 16-20).
- The center of your teaching or preaching is the death, burial, and resurrection of Jesus Christ and that salvation is not found in any other; remember that in Christ alone our sins can be forgiven.
- Respect the people and their culture.

Tips about the trip:

- Start a mission-trip journal – one that includes your reflections during preparation, while on the trip and after returning.
- Develop relationships with the people in your hometown who are from a background similar to that of the people you will be visiting.
- Attend a church service of a culture or language group that is similar to the one you will be visiting.
- Invite them to your home for dinner as well. They may reciprocate by inviting you to theirs.

- Seek to learn several common phrases in the dominant language of the people among whom you will serve.
- Learn as much as possible about the place where you are going before you leave.
- Logistics of the trip: team leaders to hand out checklists and itineraries (one to take with you and the other to leave with the family at home), and tickets.
- Other packing tips.
- Financial matters: should you bring cash, traveler's checks, or credit cards? How much spending money will you need?
- Obtain reports from team leader or leaders of each group.
- Announce arrangements for commissioning team members during worship service before departure.

Q&A

Adjourn with prayer.

The objective of short-term missions is to preach the Gospel of reconciliation to every man. I also believe the goal should aim at long-term missions. As Christians are introduced to short-term missions, God may be at work in them upon their return from the trip. Many missionaries can be raised up as a result of their short-term mission exposure. However, we shall now propose a plan of training for long-term missionary service. Missionaries can grow spiritually as they study to become cross-cultural ministers.

Long-Term Missions Training

Growing missionaries biblically is only possible when missionaries receive the required biblical, theological, and cross-cultural education. During the colonial and imperial periods of missions, some of the missionaries sent to Africa and in other parts of the world did not grow biblically in their own home setting. God may have used them mightily, but at the same time, they created some cultural problems by equating Christianity with Western civilization or culture. I have argued that every culture should be subjected to Christ. Some of the missionaries

became colonial representatives and they presented colonialism and Western culturalism as if it was a part of the Gospel.

However, I wish to propose a comprehensive missionary training program for the Continent of Africa and with some modifications, it can be used globally. In this proposal, I consider *formal* and *informal missionary training programs*. By "formal," I mean missionaries who are willing to grow in a formal theological training institution and "informal" refers to missionaries called by God without any theological training.

Growing Missionaries through "Formal" Training: A proposed Curriculum

Missionaries who are trained in Bible colleges or seminaries with Associate, Bachelor, Master's or Doctoral degrees are those who undergo formal training. Every institution has its own curriculum with some differences for denominational and doctrinal purposes. But they hold some courses in common, such as Old & New Testaments Survey, Systematic Theology, Christian Ethics, Church History, Christian Education, Homiletics, Evangelism, Pastoral Care, Counseling etc. However, in this proposal, it is not my intention to present a new curriculum from associate up to the doctoral level. I believe that courses offered by these institutions for pastoral and missionary training provide an excellent foundation for understanding and articulating biblical truth.

It is important that missionaries be prepared spiritually, psychologically, theologically, historically, culturally and missiologically. Also, missionaries must be prepared with the proper skills to relate to their own family members and others. It is mandatory that missionaries take some courses in cross-cultural ministry and how to stand fast in ministry in the midst of suffering and trouble. Therefore, the following courses should be required for missionary training for those who want to serve in Africa:

- Theology of Missions
- Cross-cultural Church Planting
- Cross-cultural Communication
- Cultural Anthropology based on a Christian perspective: how to do and record ethnographic research, culture analysis, critical

contextualization, language acquisition, a perfect understanding of one's own culture
- Creation vs. Evolution: its analysis based on Christian perspective – defending the authenticity of Genesis chapters 1-11
- Christian Ethics vs. Cultural Ethics and its analysis for Christian assimilation
- The By-laws and Constitution and an introduction to the laws of the host country
- Interpersonal relationship skill development (including marriage and family)
- Adult Education (disciplining and teaching pre-literates)
- Spiritual Formation: Biblical and theological foundation, Bible study tools and methods, holiness in Christ, self-discipline in spiritual life, compassion for the lost, spirit-led life, servant's life, effective prayer life and high ethical standards
- Training in African Traditional Religions and Philosophy
- Introduction to Islam with emphasis on Africa
- Fundraising, Biblical Interpretation, Discipleship and Spiritual Warfare
- Conflict Management – Cross-cultural Implications
- Church-Mission Relationships – Cross-cultural Implications
- Missions History and Trends, Biblical Counseling
- Leadership/Management/Administration – Cross-cultural Implications
- Biblical Prophecy: God's Plan for the Ages – a careful study of prophecies in Scripture
- Christian Apologetics

Practical Skill Courses Strongly Recommended:

- Community Development: agriculture, livestock, water, natural resources, sanitation, health, food handling and storage, small business, micro-enterprise, fish ponds, etc.
- Construction/building, motor mechanics, carpentry, healthcare.

- Motorcycle mechanics, water pump repair.
- Electrical engineering (an introduction).
- Computer skills and mass communication modules.

The above courses should be required for missionary training. Some of these courses can be done through independent study while the missionary is on the field.

There are many people called for ministry without college or seminary education. Yet they are called to also fulfill the Great Commission. I also propose a curriculum for them below.

Growing Missionaries through "Informal" Training: A Proposed Curriculum

Though theological education is generally best for effective ministry, God, in his divine providence does call others, either from different professions or who are just high-school dropouts, to become missionaries. I met a young man at a church raising his support for cross-cultural ministry. He was without any formal training. But I felt the anointing of God upon him which was manifested by his joy in the Lord. Such persons ideally need more training. I therefore propose the following curriculum:

- Old Testament Survey
- New Testament Survey
- Doctrine of the Church and doctrine of his sending church
- Church History
- Introduction to Preaching and Teaching
- Christian Ethics
- Evangelism
- Christian Counseling
- Introduction to Missions
- Holy Spirit and Its Works

The missionary should be required to take these courses either in a classroom setting or by independent study over the Internet. The majority of the courses suggested under "Formal Missionary Training Program" are available now via the Internet. The Missionary is also required to take the courses listed under the "Formal Missionary

Training" section above." Some online training institutions would offer some of these courses to missionaries for a Certificate and or a Diploma.

In my research, I discovered that many denominational missionary-sending organizations do train their missionaries formally. For example, the Christian and Missionary Alliance, the Southern Baptist Mission, the Assembly of God, etc. have training institutions both on and off the field. But it was very disheartening to see that some non-denominational missionary-sending organizations do not provide any theological education for missionaries sent out by them. For example, in my interview with one of them, I found out that they provide seminar training for eight-and half weeks in spiritual formation, life goal planning, support raising, financial stewardship, HIV/AIDS, and practical aspects of living cross-culturally. The assumption, I believe, is that the candidates have already had formal seminary training. This is not true in many cases. Sadly too, the complexity of the man a missionary meets on the field, if he is not properly understood, may create needless conflict with the Gospel in the host country. I call on such missionary-sending organizations to provide online theological training for their missionaries while they are on the mission field. The following points missionaries to the sources for recruiting missionaries.

Sources for Recruiting Missionaries

There are many sources for recruiting missionaries for cross-cultural ministry. The love of God as manifested by pastors and missiologists does influence other Christians touched by the Holy Spirit to step out in faith for the Great Commission. I have thought it wise to mention four of these sources:

First, missionaries are recruited from a local church in which he/she is a member. The issue I have with this is that some of the aspiring missionaries are not comfortable to commence the missionary work in their own Jerusalem (Acts 1:8). They would rather begin by going "to the ends of the earth" (Acts 1:8c). Churches should make sure that a missionary candidate is already a missionary to his next-door neighbor and the church at home before going to the ends of the earth.

Second, missionaries are raised up at denominational conferences through the power of the Holy Spirit.

Third, missionaries are recruited through the Urbana Missionary Conference. This conference brings together missiologists who usually share their testimony motivationally of what God is doing around the globe to the participants. This often contributes to some students becoming fired up for the Lord for missions.

Fourth, the World Evangelical Alliance Conference: This conference subscribes to the Lausanne Covenant. It brings prominent Evangelical speakers and Christians together globally. Cape Town, South Africa hosted its 2010 Conference.

My next connection is to apply the agricultural systems of farming discussed in chapter 2 to missionary training. What does shifting cultivation have to do with mission work? What can the missionary learn from the Biblical Agricultural systems? Why are there so many agricultural languages, parables, metaphors used in the Bible? Because God ordained it with the first Paradise He created for man—the Garden of Eden.

Application of Agricultural Systems to Missionary Training

The following four elements are descriptive of the recruitment and training processes of a missionary. They are also very insightful for the selection, the preparation, the sowing and the harvesting work on the field.

Shifting Cultivation

Selecting the Farmland

Finding a new farmland is essential to growing a successful crop. Metaphorically, this involves two major steps in the training process: (1) the selection of a good missionary-sending organization and (2) the selection of a mission field to which the missionary is sent to serve.

First, the selection of a sending organization: A missionary should prayerfully select his sending organization. The sending organization usually provides training and resources for its missionaries including advice on fundraising, and it helps to monitor and manage their finances and other temporal matters while they are serving on the field. Selecting a good missionary-sending organization is important

to the success of the missionary and his service. It is just like selecting the right piece of farmland is essential to insuring a good harvest in shifting cultivation. The umbrella organization should hold to orthodox doctrines and ethical practices, and should have a good reputation. Also, the sponsoring organization should have a strong emphasis on intercultural study and communication. An effective training program provides the necessary tools for the missionary, to prepare him for the selected field like a good farmer selects his field.

Second, the field: The missionary needs to pray fervently for and about his place of assignment. Christ commanded us to go into the world (Mt. 28:19-20); but note, He sent Peter as an apostle to the Jews and Paul to the Gentiles (Acts 9:15; Gal. 2:8). As the farmer carefully looks for a good plot of land for farming, the missionary should prayerfully listen to God for his place of assignment. The failure of many missionaries is due to their going into areas not assigned to them by Christ. Acts 16:6-10 tells us that the apostle Paul wanted to go into Asia when God overruled him and sent him instead to Europe. In traditional farming, the experienced farmer knows the kind of trees, rattans, mounds, etc. that would help him to determine whether the ground is good for farming or not. Christ knows where to send each missionary. Note that while the ultimate success of the missionary's work on the field depends on God. It also depends penultimately on support and counsel from the sponsoring mission organization. Missionary candidates should take advantage of the many courses that the sponsoring organization offers to prepare for and to enhance the mission work.

Clearing and Plowing

In shifting cultivation, plowing is necessary for the preparation of the ground for planting. But it is used here as a metaphor for an initial stage of missionary work on the field. Now that the missionary has been trained and prayerfully sent on to the field, he needs to do some clearing and plowing as is done in shifting cultivation. Mission service is like farming; it initially entails such activities as brushing, felling, burning and plowing. The land must be made ready for planting of seeds. Similarly, the host country is a field and needs clearing and plowing for the Gospel.

First, clearing the land metaphorically, the missionary needs to get all necessary travel documents from his country and also from the embassy of his host country. The laws regarding immigration in the host country must be obeyed. As the missionary arrives on the field, regularizing his immigration status should be his first priority or else he may be deported. The missionary needs to study and follow the laws of the land so as to be a law-abiding missionary. Immigration laws and policies often seem like a thick forest of red tape that needs to be cleared up and plowed through.

Second, plowing the land: Plowing the ground on the field is also used here as a metaphor for learning the language of the people and their cultural practices. I suggest that the first six months of a missionary's service should be devoted to language study from the people. This also includes learning about the host culture; missionary training is a continual process.

Another area of initial concentration is studying the tribal religion, secret societies, etc. of the host nation. As plowing is important for sowing of seeds, the language, culture, religion, etc. are to be studied by the missionary. With dependence upon the Holy Spirit, the missionary should pray that his Gospel seeds would fall on good ground. This important plowing process can be done with the power of the Holy Spirit and proper contextualization of the Gospel. The Gospel must have *meaning* to the people.

Missionaries need to learn from the example of athletes. They spend hours in rehearsing just for an hour-long event. Obeying the Great Commission of Jesus Christ is only possible when the missionary becomes a true channel of Christ to the world. This will enable him, with the blessing of God, to bring every culture under *the Lordship of Christ*. Hence, the courses suggested for formal and informal training are a great mechanism for plowing the ground in the host country for effective sowing of seeds cross-culturally.

One truth that missionaries need to understand is that the field is first and foremost actually within himself. What the people in the host country most need is the missionary's personal holiness in Christ. Adequate preparation of the missionary should give birth to the mission work in the mission field. Christ created the world yet the world was also on His heart. It was the focus of God for the redemption of man that

constrained Christ in His ministry. Missionaries should be imitators of Christ who became the perfect pattern of bicultural missionary work and made our redemption possible. Paul said that Christ "has given to us the ministry of reconciliation" (2 Cor. 5:16-20).

Planting

In shifting cultivation, the farmer plants his seeds after plowing the ground. Metaphorically, in this context, it is sowing the seeds of God's Word profusely on the field. The seed must be good (this is why missionary training is important) in order to germinate when planted so that it will sprout again. Jesus assured us in parable about the sower that some of the seeds will fall in different places: on the beaten path, on rocky places, among thorns, but other seeds will fall on good soil (Mt. 13:1-9). He advised the sower to sow everywhere. In spite of the many difficulties and different responses to his efforts, He promises that there will be a harvest.

There are many ways the missionary can sow his seeds:

- Church planting—a key task for a missionary is to plant churches in the area where he serves. It is important for a missionary to train nationals to take over the church when he moves on to additional fields.
- House-to-house evangelism, making evangelistic house calls to present the Gospel to families, is essential. The nationals will believe that the missionary does care for them and is not proud or aloof when he comes calling. They will see him as an ambassador for Christ.
- One-on-one evangelism – sharing the Gospel with people on a one-to-one basis should be expected of a missionary. Sharing the Gospel with friends and strangers should be a way of life. Sometimes evangelistic calling is done by making an appointment or spontaneously as the Lord leads him in public places, stores, restaurants, etc.
- Lifestyle evangelism – The Christian life that one lives before the watching community is also an effective tool of evangelism.

There are some people who can only be convinced by the extraordinary life and character of the missionary.

- Seminar evangelism – conducting seminars in churches on various topics is one of the best means for effective evangelism. The missionary can offer to teach in schools (both private and government schools). His Christian life, friendships and example in handling the courses may be used by God as another effective tool of evangelism.

- Prayer evangelism – the missionary's regular habit of prayer as well as his conducting of public prayer meetings is important. It may be used to bring people to faith and obedience to the Gospel. Jesus was a man of prayer. Luke 5:15f tells us: *"The news about him spread all the more, so that crowds of people came to hear him and to be healed of their sicknesses."* But Jesus often withdrew to lonely places and prayed.

- Community care evangelism - providing medical care for the community. Teaching about AIDS and other related diseases to the community may also be a bridge to help lead people to salvation.

The missionary should remember that Satan will plant weeds or tares in his field of service: the birds will come to take away the Gospel seeds he sows; the groundhogs will come to destroy the crops. But missionaries should be strong in the Lord. We are called to remember that He who calls us is able to see us through. God will lead His people through the difficulties that the enemy of the cross would put in front of us. God will protect His farm.

But we should notice that Christ commanded His disciples to allow the weeds (tares) to grow together with the wheat until the harvest. During the harvest, the angels will separate the wheat from the tares (Mt. 24:31).

A farmer diligently works for twenty-four hours, seven days a week. There is no time for complacency on the field. Missionaries should be reminded to keep trusting, keep praying, keep caring, keep preaching and teaching, keep finding new ground for the Gospel as the farmer does yearly. Missionaries should test the ground, pray and depend on God to do His work in and through them and other believers. But the

Bible also reminds us "not to put our confidence in man or in princes" (Ps. 118:8-9). What is so fascinating here is that Psalm 118 is the center of the entire Old and New Testaments. God is providentially saying that He should be kept at the center of everything – not man.

The farmer is concerned about his crops. He gets up in the night to go and see whether groundhogs or other varmints are attacking the farm. He prepares fences to keep out groundhogs and other destructive animals. But for the missionary, God often does the work for him. At other times God expects the missionary to be diligent, watchful, and prayerful in protecting His "crops." Failure on the part of the farmer to be diligent may endanger the good harvest. In the same way the missionary must be watchful and stand strong in the midst of satanic attacks while at work on God's mission harvest. Nehemiah instructed his wall builders to work with a sword in one hand and a material in the other, i.e., to work on and protect their project.

Harvesting

Harvesting the crops is the goal of a farmer. This is also the objective of a missionary on the field. The harvested crop is kept in the barn and does two things: (1) it is used to sustain his family and (2) some of the seeds are used for sowing during the new farming season. There is a parallel in this context – the harvested seeds provide both *present and future sustenance*. I also see the same parallel when Christ speaks about allowing the wheat and tares to grow together because one may damage the wheat while trying to take away the tares (Mt.13:30). The Lord's advice symbolizes the *parallel of present and future harvesting*. The present harvest from the standpoint of the missionary includes true believers but also mere professors who have heard the Gospel and claimed to be saved but in reality are not. This is why the missionary must continue to teach the uncompromising truth at all times and not assume that all who profess faith in Christ are genuine believers.

I vividly remember long ago my mother (Qualie-nyon-nun) cried bitterly when she discovered that some of the bundles of rice placed in her barn were destroyed by rats. The blame was on my father because it seems that he failed to build a secure enough storage area, and so the enemy infiltrated.

The parallel in mission work is that there are those who are saved and others who are not, but yet they are all professing Christians. St. Augustine aptly stated, "For, in that unspeakable foreknowledge of God, many who seem to be without are in reality within, and many who seem to be within yet really are without."[123] The harvest for the missionary in the present means his church or ministry has gathered more followers of Christ. But in the future, according to Jesus, the angels will separate the sheep from the goats or the wheat from the tares. This is the true end-time harvest. Until then the missionary must preach the uncompromising Word of God until Christ returns. As the seeds for the farmer gave temporary life in the present and the future, in the same way the seed of the Word of God gives life in the present and life in eternity to true believers.

Biblical Agricultural System

According to the Bible, God ordained agriculture (Gn. 2:15). Missionaries need to understand that the same God, who took a chosen Messianic seed from among the cursed seeds of Eve, also brings victory to man. He is also using the cursed ground to provide for mankind.

God uses agricultural metaphors to teach spiritual lessons in the Old Testament and practical heavenly lessons in the New Testament. Missionary needs to carefully deal with passages related to farming. The concept of sustainability in this life and its spiritual application to the Word of God as seeds needs to be emphasized.

Having carefully analyzed and applied the agricultural systems to missionary training, I will now focus on fundraising methodologies and accountability of missionaries.

Fundraising Methodologies and Accountability of Missionaries

The purpose of this section is not to provide a comprehensive training session for fundraising for missionaries. My objective is to show them some of the methods that churches, denominations and non-denominational missionary-sending organizations are using in raising

[123]Saint Augustine. *Works.* vol. 3. Edited by the Rev. Marcus Dods (Edinburgh, Scotland: T & T Clark, 1872), 147.

funds for missions. Also, because missionary-sending churches and organizations are providing excellent fundraising training programs for their missionaries, I will only recommend a few helpful books at the end of this section.

Biblically speaking, missionary support is akin to God's instructions for priestly support in the Old Testament. God ordained the support of those who work directly in the Temple. They were to be supported by the sacrifices/offerings of the people (Lv. 7:28-36; Nm. 18:8-21). God prohibited the Levites to own any land allotment, but "Everything in Israel that is devoted to the Lord is yours" (Nm. 18: 14). Indeed, God said to Aaron, "...you will have no inheritance in their land. Nor will you have any share among them; I am your share and your inheritance among the Israelites. I give to the Levites all the tithes in Israel as their inheritance in return for the work they do while serving at the Tent of Meeting" (Nm. 18: 20-21).

Reflecting on the priestly support, the New Testament saints were convinced that the apostles were also worthy of support. Paul collected support for the saints in Jerusalem (1 Cor. 16:1ff). He was also supported by the Church of Philippi (Phil.. 4:10ff). In fact Christ endorsed this Old Testament concept of support by allowing His disciples to accept support from His followers (Lk. 8:1-3). Because the New Testament teaches the priesthood of all believers (1 Pt. 2:5, 9: Rv. 1:6; 5:10), anyone God called for a specific work is qualified to live off the Gospel (1 Cor. 9:14). Believers in Jesus Christ become the typological fulfillment of the Old Testament people of God (Ex. 19:6). Christ's redemptive work on the cross has reconciled believing man back to God (2 Cor. 5:16-20; 1 Pt.3:18). And because of Christ's gracious work, every believer as a priest has access to God. He is our High Priest (Heb. 3:1). In the way the priests of the Old Testament had their share of provision in God, equally so, the believers in Christ have their share in the Lord Jesus Christ, and most importantly they are regarded as sons of God (Jn. 1:12-13).

I will discuss the three ways missionaries are supported and their accountabilities.

The Three Ways Missionaries are Supported

First, missionaries are supported through their local churches. Many mission-minded churches do mobilize their members to support their missionaries. Support of this kind can be found among the independent churches. By independent, I mean churches that are established and operated without being accountable to any denominational authority. They organize their own boards to direct the affairs of the church. Most of these churches can recommend their missionaries to other non-denominational missionary-sending organizations for training and also to be a co-sender. Usually, the local church comes up with between 25 to 60 percent of their missionary's support and the rest is raised through the "sending organization."

In his book, *A People for His Name: A church-based Missions Strategy*, Paul Beals discusses three ways a mission's budget can be funded. First, it is funded through percentage plans. Some churches use 10 percent of their total budget for missions, others take 15 to 25 percent for missions. Second, the separate mission budget plan. That is, two sets of books are kept - one for the church and the other for missions. The pastor would promote missiongiving and other churches have what they call "Mission Sunday" to raise funds for their missionaries. And third, the Faith Promise. The late A. B. Simpson founder of the Christian and Missionary Alliance denomination is credited for this. A Faith Promise card is distributed among church members either at the local church or at the end of an annual missionary conference. Believers will prayerfully promise what to give to missions for the year.[124] Affirming mission-giving, Roger Greenway believes that Philippians 4:10-20 sets some profound principles for mission- giving: First, mission support should be done in an organized way. Second, that support is collected from the churches and delivered in an efficient way to the missionaries on the field. The Christian and Missionary Alliance, the Southern Baptist Mission Board, and the Assembly of God Mission Board are examples of this method. The third lesson we learn from these passages is that giving to missions is a voluntary response of Christians who, out of gratitude to God for salvation, support the Gospel. And fourth, the missionary support was more than enough; Paul affirms, "I am

[124]Paul A. Beals. *A People for his Name: A Church-Based Missions Strategy*, Revised Edition (Pasadena, California: William Carey Library, 1988), 98-99.

amply supplied" (verse 18).[125] The apostle Paul makes this clear to the Philippians' believers that missionary support is an investment into the Kingdom of God and, using an accounting term, the givers' account will be credited (Phil. 4:17).

Missionaries are supported through their denomination's mission boards. A Mission Board is established by some denominations to oversee missionaries' activities globally. Such denomination provides formal training for their missionaries. They have set requirements for the approval of a missionary to serve inter-culturally. Some denominational-oriented mission boards lessen the burden of their approved missionaries by raising the support for them from their local churches. In this condition the missionaries do not have to worry about a drop in their support. These missionaries can come for a furlough to just visit the local churches and reunite with family members. I visited one of those churches and a missionary shared his testimony with one of the denominational local churches. The church offered him a special offering, but he told them to send the gift to the Mission Headquarters to support missionaries globally. There might be several denominations that do raise support for their missionaries, but, as I had already mentioned, the Christian and Missionary Alliance, the Southern Baptist Convention Mission Board, and the Assembly of God Mission Board are raising full support for their missionaries.

Like the independent churches, there are some denominations that encourage their missionaries to raise support in their churches. That is, besides their Mission Board's support which varies depending on the financial strength of the denomination; they also have their own training institutions for missionaries. After the training, missionaries are sent to their various churches across the nation to raise support with a letter from the Mission Headquarters. Missionaries in this category do have financial problems and have to be called to revisit churches and seek for new partners/sponsors.

Missionaries are also supported through their families, friends, and other Christians. There are missionaries called from smaller independent churches that are not financially able to support them. I met a couple in Fort Myers who came from such a background and wanted some

[125]Roger S. Greenway. *Go and make disciples! An Introduction to Christian Missions* (Phillipsburg, New Jersey: R&R Publishing, 1999), 141-143.

sort of covering to go on the mission field. The couple was searching for another bigger church to be their covering. I advised them to seek a non-denominational missionary-sending organization because leaving the home church for financial support purposes was not healthy. The sending organization would be their covering, provide some training and help them with their accounting back home.

Fundraising is biblical (Nm. 18:21-24; Mt. 10:5-15; Lk. 8:1-3; Acts 18:3-5; 1 Cor. 9). Missionaries are to make their needs known to others (1 Kgs. 17; Mt. 10:11; Rom. 15:24; 2 Cor. 1:16). In his book, *People Raising: A Practical Guide To Raising Support,* William Dillon writes, "Support-raising is a ministry. It is not begging people for money. Rather, it is an opportunity for you to share your vision [with Christ-loving people].…. People must be challenged to have a part in the Great Commission through you. Support-raising provides an opportunity for blessing those who give to you. And God gives them credit for your fruit."[126] A missionary in this category needs to begin his fundraising with church friends, relatives, neighbors, school contacts, employment, service contacts, friends, and contacts from your mission.[127] He discusses 12 steps to successful fundraising for missions. In my judgment, it is one of the best books available for missionary training in this regard.

The Accountabilities of Missionaries

Missionaries are Accountable to God

Missionaries are accountable to God, their churches, and other partners. Funds that are entrusted to the missionaries belong to the Lord; they should be accountable to God, their churches and other partners that are partnering with them in fulfilling the Great Commission.

Missionaries are first and foremost accountable to God. Because God is omnipresent and omnipotent they are to live a life in Christ that brings glory and honor to God. This includes the way they handle their financial resources for the mission. One Scripture that is so clear about this matter is, "Man looks at the outward appearance, but the Lord looks at the heart" (1 Sm. 16:7) and God inspects our motive in all that we do. If our motive is wrapped up with the call of God, then

[126]William P. Dillon. *People Raising: A Practical Guide To Raising Support* (Chicago, Illinois: Moody Press, 1993), 12.
[127]Ibid, 87.

the missionaries will work according to God's will. They need to be careful in the following areas, as God's resources are poured into their hands.

First, how do you determine your salary as a missionary in a foreign land? How do you handle project funds? What is the difference between the salary you made at home and your salary on the mission field? Does it make sense for a missionary to take a salary of $6,000 monthly on the mission field? Is it fair when the highest salary ever made at home was between $2,000 and $3,000? How do you justify such personal income? K. P. Yohannan writes about a Western missionary who was living like a king on the mission field; he was living a life that he could not afford to live in the United States: "As I walked into his mission compound I passed a man with a gun sitting at the gate. The compound was bordered by a number of buildings with at least half a dozen imported cars. The staff members were wearing Western clothes, and a servant was caring for one of the missionaries' children. The scene reminded me of a king living in a palace with his court of serfs caring for his every need."[128] I know that there are some missionaries that are facing financial problems, but equally so, there are hundreds who are good at fundraising and are living an upper-class life on the field. It is an abuse to missions for a missionary to live like a millionaire among the poor, when in fact he is unable to reach the people with the Gospel in the villages.

Second, funds raised for a particular project must not be used for a different project. God who provided the funds for a particular project will do the same for the rest of the projects no matter how long it takes.

Third, don't use donations for national leaders or certain Christians for the mission. This error was made by a mission organization in Liberia. Donations of clothes, shoes, sneakers and other staples of life belonging to some national leaders of the mission were found in the Missions' Thrift Store in Monrovia. This resulted in a split between the mission organization and the churches they planted. The indigenous people felt that the missionaries were not honest with them. Being

[128]K.P. Yohannah. *Revolution in World Missions* (Carrollton, Texas: gfa books, a division of Gospel for Asia, 2003), 185.

accountable to God is using one's life and His resources according to His divine plan and will.

Missionaries are accountable to Their Local churches

Because missionaries are accountable to their churches, a high degree of honesty is required of them. As servants of God, they are to be true representatives of God and of their local churches. They need to be a faithful representative of Jesus Christ in their host country. Note that a local church is also in partnership with the missionary, therefore a monthly financial report to your church is a necessity. This will strengthen your church's leadership to do more for the missionary's support knowing that his financial standing and the projects are carried out in an ethical manner. Every missionary should send out a monthly or a bimonthly prayerletter indicating progress on the field, specifying needs and providing a regular systematic accounting of the ministry's funds. The missionary's salary, housing and other items should be established in consultation with the sending pastor and with the approval of the church and the "sending organization."

One key error that local churches are guilty of (including missionaries) is focusing their report on new members joining the church and ignoring those that left the church. If we do not have any strategy to lock the back door, then those that come through the front door may likely go through the back door as well. Missionaries must be honest in their report: state their failure, progress, and areas where they are wondering what God would have them to do. Having listened to missionaries speaking in churches during their furlough, they seem to dwell on the progress and play down the failures of their work on the field. Also, missionaries can be guilty of misrepresenting their host countries. They would photograph or video-tape needy areas of their host countries just to attract new donors. I would not do justice to America if I video-taped the needy Americans who I feed every Thursday and report it in Africa that the Americans are all starving and needy people. Accountability also involves telling the whole truth.

Missionaries are accountable to Their Partners

A missionary who is supported by a variety of people is accountable to them. The apostle Paul calls such groups "partners" (Lk. 5:7; 2 Cor.

8:23; Phlm. 17). They are his core group and congregation. They also share in his ministry on the mission field. Note that God calls both the missionary and their partners for His work. Without their obedience to God's will in sponsoring their missionary prayerfully and financially, they would not be where they are. Erroneously, many missionaries believe that their mission partners have nothing to do with any major decision regarding the direction of the mission. Often a missionary's supporters are only to give the funds and the missionaries are to do what they believe is right. A spirit-filled missionary will prayerfully seek prayers and counsel from prominent team members prior to reaching a major decision. A major transition, let's say in establishing a new orphanage, may create a problem for those who would prefer their dollars be used only for the previous mission focus. It is very essential for us to understand the definition of partner.

To do justice to the word partner, it is important to look at the origin and its usage today. *Partner* originated from the "...late 13c.,... [meaning] "joint heir," ...[or] "part holder." Partnership in the commercial sense is attested from c.1700."[129] From a business perspective, partnership involves one, two, or more persons who legally bind themselves in a business deal. They provide a starting capital, and any profit is shared among the partners based upon the partnership agreement. There is a misuse of this word today within the body of Christ; therefore, it has lost its original meaning. In my judgment, many are using partisan for partner. These words have different meanings. A *partisan* is one who zealously supports someone for a cause that he believes in. On the other hand, a *partner* is one, two, or more persons united in a cause who both share in its outcome. If John is your partner in ministry, for example, he provides financial resources and you also give yourself. If this is the case, then John is a "joint heir" in the work and shares in the blessings – both receive directly from God. Therefore your partner should share in major decisions that may affect the direction of the mission.

In defining the word partner from a biblical perspective, I will begin the study of this word first from the Old Testament and then move to the New Testament by looking at its usage historically. The book of Proverbs is the only book that used the word partner in the Old Testament. The Hebrew word translated as partner is "holeq/chalaq"

[129]Online Dictionary of Etymology: Accessed, March 17, 2010.

which means to "split, divide, share, allot, distribute, portion out, to be divided…."[130] It also means: "to make smooth, to be smoothly, to shave, to be smooth, slippery, to use a smooth tongue, to flatter, to use smooth words."[131] The Enhanced Strong's Lexicon indicates that this very word occurred 65 times in the Authorized Version (AV): 40 times translated as "divide," six times as "flatter," five times as "part," four times as "distribute," twice as "dealt," twice as "smoother," once as "given," once as "imparted," once as "partner," once as "portion," once as "received," and once as "separate."[132] What is most important, semantically, in translation is the context. For example Proverbs 29:24 from the ESV reads: "The partner [holeq] of a thief hates his own life; he hears the curse, but discloses nothing." If you joined a thief, you automatically accepted the consequences of the act even if it is death. The question that comes to mind is how do you define partner as it relates to those on your mission team?

When partner is used in the New Testament, there are four Greek words used interchangeably.[133] Each word is unique in its definition: (1) *koinonos* is defined as one who takes part with someone, sharer, companion, and portion in business (Lk. 5:10; 2 Cor. 8:23; Phlm. 17; Heb. 10:333). (2) *Metoxos* comes from two Greek words *meta* meaning "with," and *exo*, "I have." It indicates a closer association, sharing in, partaker or partaking, a partner in a work, office, (Lk. 5:7). (3) *Summetoxos* – partaking in jointly, casting one's lot with, sharing with, partner (Eph. 5:7). And (4) *Sugkoinonos* means partaker with, partaker, participating with other in anything, joint partner (Rv. 1:9). We can deduce from these Greek New Testament usage of the Hebrew word holeq (partner) the same concept of split, divide, dividing, to be divided up in these New Testament words for partner. But there are slight changes in the meaning today: a man's wife can be called his partner. Others think of partnership in terms of friendship.

A paradigm shift to the biblical meaning of partnership is required by missionaries. Because of the complication or misuse of the word partner, it is important that missionaries redefine it biblically in relationship with those on their partnership team or mission team. It

[130]Enhanced Strong's Lexicon, 2505.
[131]The Hebrew & Aramaic Lexicon of the Old Testament, 322.
[132]Enhanced Strong's Lexicon, H2505.
[133]Logos Bible Software.

would be improper for a missionary to think of his partners as mere friends who give to God's work. Honestly, the business community captures the true meaning of partnership better than most Christian organizations. The only difference is that their partnership agreement in any joint venture cannot survive without legalizing it; it must pass through the required law of the land in order to be valid. The business world is adapting some Christian practices to win customers. For example, many major businesses have greeters with big smiles in welcoming their customers. But if you meet that very same person in the parking lot after his day's work, he may not even speak to you.

It is important to note that those who are prayerfully and financially supporting missionaries are partners in the biblical sense of the word and they are accountable to them. They also share in the blessing with the missionary. Therefore, regular updates of the mission's activities are required for the supporters. No major changes of the mission's direction should be undertaken without the prayerful consideration of your sending church/organization and key sponsors.

Conclusion

Recruiting and training of missionaries for cross-cultural ministries will certainly be effective in the twenty-first century if they are bicultural missionaries. The error of the colonial and imperial missionary approach to missions cannot hold any longer in this century. This revival for missions, I believe, is the work of God. The Lord had spoken to many Western authors, and some of them had written extensively to correct this blunder. Just to name a few, Dr. Donald Anderson McGavran (though he may have had some flaws in other areas of missions thought) became one of the prophetic voices. In his book, *The Bridges of God: A study in the strategy of Missions* first published in 1955, he called for missions' reformation during his generation. Jonathan J. Bonk wrote against the affluence of Western missionaries in his book, *Missions and Money: Affluence as a Western Missionary Problem* first published in 1991. In addition to this, Ronald J. Sider wrote convincingly in his book, *Rich Christians in an Age of Hunger: A Biblical Study*. Many more examples can be found.

How do we solve this problem? The answer to this age-old question is to begin with this proposed paradigm shift in the training

of missionaries: Every missionary must study his own culture and the culture with whom he wants to minister. I have discussed at length missionary preparation for short-and long-term missionaries. I provided curricula for "formal" and "informal" missionary training. In a short-term mission trip, the church or mission's organization needs to make sure that those sent are trained; documentations such as an application form and a covenant agreement are prayerfully considered. Those approved for the trip are required to take the Eleventh-Week course provided in this book.

Sources of recruiting missionaries were provided, and the agricultural systems discussed in chapter 2 were applied to missionary training in this chapter.

The concept of supporting missionaries is rooted in the Old Testament (Lv. 7: 28-36; Nm. 18:8-21) and New Testament (Phil. 4: 10ff). Basically, it is analogous to the arrangements for priestly support in the Old Testament which were then applied to the apostles in the New Testament. Missionaries need to know that they are accountable first to God, then to their churches, their sending organizations and their partners in ministry. Accountability means being transparent in the way you handle God's resources, finances, mission field, and projects. It also means living a life that brings glory to God in their financial reports, newsletters and prayerletters. They are to give a true picture of what is going on in the mission field without covering up the setbacks. It is taking into consideration the advice of all your supporters as partners and realizing that you alone are not the center for every major decision about the direction of the mission. Accountability is regularly keeping accurate books and reporting to your home church, sending organization, and other partners the true financial position of the mission. Accountability is also using funds entrusted to your hands to carry out designated projects.

Missionaries can do an independent study by using the following two books: Dillon William PL. *People Raising: A Practical Guide to Raising Support*. Chicago, Illinois: Moody Press, 1993; Barnett Betty. *Friends Raising: Building a Missionary Support Team that Lasts*. Seattle, Washington: YWAM Publishing, 1991.

I would conclude this section with a story of the testing of a candidate for missions work,[134]

One snowy morning at 5:00 A.M., a missionary candidate rang the bell at a missionary examiner's home. Ushered into the office, he sat three hours past his appointment time waiting for his interview. At 8:00 A.M., a retired missionary appeared and began his questioning. 'Can you spell?' Rather mystified, the candidate answered, 'Yes, sir' 'All right.' Spell 'baker.' 'B-A-K-E-R.' 'Fine. Now do you know anything about numbers?' The examiner continued. 'Yes, sir, something.' 'Please add two plus two.' 'Four.' Replied the candidate. 'That's fine,' said the examiner. 'I believe you have passed. I'll tell the board tomorrow.' At the board meeting, the examiner reported on the interview. 'He has all the qualifications for a fine missionary. First, I tested him on self-denial, making him arrive at my home at five in the morning. He left a warm bed on a snowy morning without any complaint. Second, I tested him on promptness. He arrived on time. Third, I examined him on patience. I made him wait three hours to see me. Fourth, I tested him on temper. He failed to show any anger or aggravation. Fifth, I tried his humility by asking him questions that a seven-year-old child could answer, and he showed no indignation. So you see, I believe the candidate meets the requirements. He will make the fine missionary, just the kind we need.'

This quote helps us to understand the condition of our effectiveness on the mission field. We may have all the PhDs, but without spiritual virtues of self-denial, promptness, patience, asking the Lord to take control of our anger, and humility toward God and our fellowman, we shall crucify Christ afresh daily, in and by our foolish deeds.

Now, it is time to wrap up all the discussions in this book as I lead you into the final conclusion. It summarizes each major section and challenges the Christian community to join forces for the fulfillment of the Great Commission.

[134]Michal P. Green. *Illustrations for Biblical Preaching: Over 1500 Sermon Illustrations Arranged by topic and Indexed Exhaustively.* Revised edition of: *The Expositor's illustration file* (Grand Rapids: Baker Book house, 1989), 354-355.

Conclusion

In this book, I address the issues of wholistic missionary education for effective cross-cultural ministry. I believe that the colonial and imperial missionary outreach philosophies that dominated global mission work in previous eras are unacceptable in the twenty-first century. Equating one's culture with that of Christianity is unbiblical because Christ is the Lord who is at work in every culture. I took a fresh look at the preparation of missionaries for both short- and long-term missions in an African context. It is my prayer and hope that the proposed missionary training will bring about an effective and wholistic leap forward in world evangelization.

I limited this research to the Continent of Africa, but the principles discussed herein could be modified and used for any country. Hence, as a solution to the problem stated above, i.e., recruiting and training missionaries for Africa, I propose a comprehensive training program for missionaries. It is a *comprehensive training program that is biblically, theologically, historically, philosophically, exegetically, cross-culturally, communicationally, anthropologically, and biculturally sensitive. I targeted the necessity of studying:*

- *African Traditional Religion and Philosophy,*
- *African Secret Societies,*
- *The Laws and Constitution of a host country,*
- *The ongoing battle between Creationism and Evolutionism, and*
- *Bible prophecy.*

This book is intended to explore and explain the challenges that missionaries encounter in foreign countries. This wholistic approach to missionary education, which I term "Growing Missionaries Biblically," is defined as *the development of God's missionary/sower to present the Gospel cross-culturally through biblical, theological, anthropological, religious, communicational and cross-cultural education.* Wholistic training will help the missionary avoid syncretism and cultural disharmony between a missionary and the people he/she serves. Also, understanding their worldview will foster and result in excellent contextualization of the Gospel.

Using a descriptive survey and case study method, I was able to achieve my goal: In the first section, I defined "growing" from an agriculture perspective as it relates to traditional farming – shifting cultivation, and from a biblical perspective. It was discovered that agriculture was ordained by God but it took on a different turn when Adam and Eve sinned against Him (Gn. 3:1ff). Instead of it being a joy to be carried out in the presence of God, the ground was cursed, including Adam. Agriculturalism in Scripture was used naturally and as a metaphor to address spiritual truths in the Old Testament. Building on this foundation, Jesus also used agricultural terms with heavenly meanings to describe the growth of His kingdom. *The lesson that missionaries need to learn from the agricultural perspectives is, man works hard to store up food in the barn for sustenance in this life. The world is also seen as God's farm and the sower is required to trust God in laboring in His field with sowing, and caring for the eternal harvest in the Kingdom of God.*

A careful study was done in Section Two on Theological Perspective of Missions with the objective of reconnecting our reader to the true Biblical Basis of Missions. Due to the attack on Christianity by atheistic evolution, even the Old Earth theory in Creationism, etc. denies the validity of Genesis 1:1. Many missiologists are avoiding this controversy about the doctrine of creation (Gn.-1-3) and the creation/evolution controversy. I argued that evolutionism is not true science, it is a religion. Science deals only with the present, the observable and the repeatable. And history shows that scientific conclusions are subject to change when new facts are discovered. If evolution is a true science, as evolutionists insist, then we would like to have the name(s) of the scientist(s) or evolutionist(s) who documented the occurrence of the "Big Bang." I also want to know those who observed scientifically the

dying and decaying of the creatures that resulted in the fossil record. Such phenomena are matters of philosophical speculation and not of proven scientific fact. Honestly, I appreciate the contributions of science, but replacing God with science and using evolutionary theories to explain the origin of all things is unacceptable.

Charles Darwin (1809-1882), a naturalist, is regarded as the father of the theory of evolution. The contradiction in Darwinism is that Darwin was not alive a billion years ago and thus was not around to be able to explain what he did not touch, observe or handle. So, his conclusions of supposed facts are merely philosophical notions. I note, in this context, that Darwin's theory of evolution is the reenactment of the serpent that deceived our first family in the Garden of Eden (Gn. 3:1ff). It is also argued that the acceptance of Atheistic Evolution or Old Earth Creationism undermine the entire redemptive work of Christ. Evolutionists believe that there had been death and *evil* billions of years ago before Adam and Eve, and there is no divine moral code. This also means to evolutionists that the laws of the Bible are meaningless and Christ's death on the cross was fabricated by some religious fanatics.

I reject atheistic evolutionism and other unbiblical theories of Old Earth Creationism and propose a Biblical Basis of Missions commencing in the Garden of Eden. That Adam and Eve were actual human beings who sinned against God and as a result they lost the Paradise that God created for them (Gn. 3:1ff). In God's divine justice, the curse pronounced on the serpent also contains the *first Gospel*: the seed of the woman will crush the head of the serpent, and in the process the serpent will strike the Messiah's heel (Gen. 3: 15). *The woman deceived will, in the fullness of time, bring forth a deliverer.* God demonstrated this Gospel when he killed an animal (I believe it was a lamb) to provide covering for Adam and Eve. This act symbolized the promised redemption for man (Gn. 3:21).

The Gospel begins in the Garden of Eden and culminates on the Cross of Calvary. In the redemptive process, God used His people, in many ways for restoration to no avail. But He finally came in the person of Christ and took our sins away on the Cross of Calvary (Jn. 1:29, 36). In the continuity of the redemptive process, I proposed a comprehensive Gospel presentation for the twenty-first century with three dimensions: Man's Fall, God's Redemption, and New Creation.

All these are demonstration of God's love in reconciling the world to Himself (2 Cor. 5:16-20).

In my effort to "Grow Missionaries Biblically," I proposed in Section Three that a man must study his own culture and missional context. This study should include his own religion, society, culture, laws governing his society as well as those of his targeted culture. In this endeavor, it is advised that missionaries who want to serve cross-culturally should be bicultural because Christ is Lord and is at work in every culture. Bicultural missionaries should effectively contextualize the Gospel without compromising it.

I proposed new curricula for "Formal" and "Informal" training for both short-term and long-term missionaries. Such training as suggested should consider the biblical foundation of missions.

All the discussions in this book have been leading to this one and final point: *the fulfillment of the Great Commission of Jesus Christ.* "All authority in heaven and on earth has been given to me. Therefore go and make disciples of all nations, baptizing them in the name of the Father and of the Son and of the Holy Spirit, and teaching them to obey everything I have commanded you. And surely I am with you always, to the very end of the age" (Mt. 28:18-20 *NIV*). It is my prayer that everyone who reads this book will discover this paradigm shift to missions, and to join forces with churches, missionary-sending organizations, seminaries, and missionaries around the world to walk in obedience to the Great Commission. "Now to him who is able to establish you by my gospel and the proclamation of Jesus Christ, according to the revelation of the mystery hidden for long ages past, but now revealed and made known through the prophetic writings by the command of the eternal God, so that all nations might believe and obey him to the only wise God be glory forever through Jesus Christ! Amen" (Rom. 16: 25-26 *NIV*).

About the Author

R. Zarwulugbo Liberty (B.Th., Liberia Baptist Seminary; M.Div., D. Min., Knox Theological Seminary) is president and founding church planter of an African independent church denomination, Church of the Believers, Inc. in Liberia, West Africa and the Africa International Christian Mission, Inc. with headquarters in Boynton Beach, Florida. Prior to his coming to serve as a missionary in the United States, he, along with his wife, Esther planted nineteen churches in Liberia, established the Liberty Theological Seminary, the Fellowship of Christian Churches of Africa, and a Christian high school.

Presently, Dr. Liberty serves as president of Africa International Christian Mission (AICM), a non-profit 501(c)(3) organization founded in 2000. The mission of AICM is to assist Christian churches in implementing the Great Commission of Christ in Africa and beyond by ministering to the spiritual and physical man. Its vision is to promote ministerial and missionary education in Africa, to be an agent of independent churches in Africa who want to partner with Western churches and missions, raise support for indigenous pastors and missionaries to enable them fulfill the Great Commission in their homeland. Also, it is to plan seminars, workshops, crusades and special Bible Conferences for church leaders in Africa and the United States, with regular mission trips to and from Africa, etc. The mission is planting churches in Africa, operating orphanages and schools, and supporting indigenous pastors and missionaries in their homeland. AICM is also operating a food bank in Boynton Beach, Florida

providing weekly food and other staples of life to the homeless, elderly, families, children, etc.

Because Dr. Liberty hailed from Liberia, he focuses on his homeland, which went through fifteen years of civil war, taking the precious lives of over 250,000 persons. Presently the unemployment rate in Liberia is 80 percent. AICM has been providing scholarships for hundreds of Liberians. Some of them have graduated from high school and college in that country.

The author is not just giving you a concept for Growing Missionaries Biblically as a trial. This method is very effective. He is a bicultural missionary and has been serving in the United States for twelve years working with American churches and individuals, both black and white, successfully. Through his effectiveness in evangelism and missions work in this country along with his outstanding work in the Department of Evangelism and Missions, the Knox Theological Seminary awarded him a certificate of honor in Evangelism and Missions during his graduation in 2008. A bicultural missionary is the answer for the twenty-first century intercultural ministry.

Dr. Liberty and his wife Esther live in Boynton Beach, Florida.

Appendices

Appendix A
Forty-eighty Facts a Missionary
Needs to Know

1. A missionary is called to imitate Christ the Eternal Son of God who became man (Jn. 1:14) to save man from sin.
2. He should be like the apostle Paul who became "all things to all men" (see 1 Cor. 9:19-23) in order to win some to Christ.
3. Growing disciples and churches is similar to growing crops; it is a continual process and requires caring.
4. Jesus used agricultural parables (Mt.13:3-9) to illustrate principles of the Kingdom of God and the Gospel; the missionary should also learn about the culture and religion of his host country for proper contextualization of the Gospel.
5. A missionary is called to work diligently like a farmer (2 Tm. 2:6-7) while ultimately trusting the Lord for the harvest.
6. As a spiritual priest in Christ, the missionary has direct access to God (Rom. 5:2; Eph; 2:18); as he offers spiritual sacrifices to Him; declaring the Gospel by word and deed (1 Pt. 2:12).
7. Their labor in Christ's service will face many obstacles and hindrances due to the dire effects of the Fall, and opposition from the devil, but victory is certain in Christ.
8. The remedy of the Adamic curse and God's blessing comes through faith in Jesus Christ, and only *then as the curse fell on Christ on His cross.*
9. The Great Commission is like commencing a shifting cultivation farming system. It requires finding the right

farmland, clearing it, plowing, sowing seeds, nurturing them, harvesting, and securing those crops in the barn through the power of the Holy Spirit. These principles can be applied to every area of life and ministry.

10. Man is being controlled by his own inventions. The truth is, any decision without God has always been detrimental to mankind. The only solution is to return to God and His principles.

11. God's "grace" started in the Garden of Eden with the *protevangelium* (Gn. 3:15) and was illustrated when God provided the *typical covering* for our first parents (Gn. 3:21).

12. Imitate Christ in understanding the languages, parables, metaphors, stories, religions and cultures of the men and countries to which you are sent.

13. The missionary's responsibility is to plant the seeds profusely and indiscriminately, and then *leave the results with God.*

14. Like farmers, missionaries must seek for God's wisdom (Is. 28:26), be diligent (Prv. 27:23-27; Eccl. 11:6, and be joyful in working hard for the Lord – toil (2 Tm. 2:6) and be patient in waiting.

15. Understanding cross-cultural communication is an important key to effectiveness in intercultural ministry – *the Good News must have meaning to the people with whom we minister.*

16. Here is the pertinent truth for missionaries: "… not by might nor by power, but by my Spirit, says the Lord Almighty" (Zec. 4:6).

17. As growing and harvesting are perpetual processes, likewise Growing Missionaries Biblically is a continual process for the world and the people to whom they minister.

18. God demands that the carrier of the promise give up any control or claim on the promise and leave the future of the promise with God.

19. The nature of Messianic prophecy is progressive; each prophecy casts more light on the subject. For example:

- The Messiah is to be born of a woman (Gn. 3:15),
- He would come through the line of Shem (Gn. 9:6);
- Specifically through Abraham (Gn. 22:18);

- Isaiah presents the Messiah as a suffering Anointed One (Is. 53:1ff), and
- The four great Servant Songs of Isaiah all present the servant as an individual who ministers to Israel and the nations (42:1-7-7; 49:1-6; 50:4-9; 52:13-53:12).

20. Biblically, it is evident that the Anointed One's terrible ordeal of suffering is but the necessary prelude to infinite glory.
21. The redemptive-historical progressive thread from the "covering" of our first parents was culminated in the "uncovering" of our Lord Jesus on the Cross of Calvary.
22. The unity of language that man had lost (Gn. 11:1), because of pride, will be restored in Christ when He returns. Until then, missionaries are to preach Christ as the center of every achievement and also learn the language of the people.
23. The key message for missionaries is to preach/teach faith in Jesus Christ alone as our atoning substitute and risen savior.
24. God has been reaching the world in many ways throughout history.
25. It is certainly not wrong for missionaries to have formal seminary education, but a sound knowledge of theology without implementation is useless.
26. The focus of missionaries should be on the going, the making disciples, baptizing and teaching people to obey Christ's commands as indicated in the Great Commission.
27. If God wants a person to "go" and he is holding back, God can send him into the field like He did with Jonah, or through some sort of persecution or problem.
28. God removed the covering of Adam in Christ on the cross and thereby is reconciling man and giving him the ministry of reconciliation (2 Cor. 5:17-20).
29. A missionary is one who is *sent* on God's Mission (*Missio Dei*); by definition, he is an *apostle*, called by God and affirmed by a local church for service globally.
30. A missionary is to be saturated and commissioned with the orthodox message of the Gospel; he is to be faithful both biblically and theologically. Like an ambassador of a foreign country who represents his king and country in theory and

practice, a missionary should be a true representative of Christ wherever he is sent.

31. Every country loves its own culture and practices; missionaries should respect them, who they are, with the objective of winning them to Christ, if they are to be effective cross-cultural ministers.

32. Christians are engaged in a spiritual battle – all believers find themselves subject to Satan's attacks because they are no longer on Satan's side. They are sent as sheep among wolves; hence, they should be wise as serpents and innocent like doves.

33. *A bicultural missionary will be able to discern and weed out by the Holy Spirit what is cultural bias and what is good for the Kingdom of God.*

34. African thought patterns are different from Western thought patterns. A man in the West is dichotomistic and his philosophical bent is pragmatic rationalism. Africans are holistic in their approach to life. Africans are not interested in dissecting truth and life and peering within. They tend to be more experiential in their worldview and relational in their outreach.

35. The communication style in Africa can vary considerably across the continent, depending on the language, culture, and tradition. Some issues are decided by men only, others by women only, and still others by men and women together. One thing is certain, however, no matter where you go in Africa, decisions are not made on the spot but rather take some time to reach through consensus.

36. The Western concept of "majority rule" is foreign to many parts of Africa. This may be one of the sources of much civil unrest in African countries that are now practicing democracy.

37. A bicultural missionary will be able to discern when and where to use a majority rule principle and where to choose consensus. Majority rule is best practiced among the Western educated classes and the consensus approach would work well among the indigenous people in African villages and towns.

38. Africans are also event oriented. In the time-oriented cultures, everyone is programmed by time in their daily activities.

39. There are two ways to handle crisis management: (1) crisis orientation and (2) non-crisis orientation. A crisis-oriented

culture (Western nations) would take proactive measures in anything while a noncrisis-oriented society (Africans and other developing countries) would just walk by faith.

40. The issue of goal setting and task-orientation versus person-orientation: Africans, Asians and other countries are person-oriented countries. Western nations are task-oriented. Note the major difference in their thought patterns and adjust yourself accordingly.

41. Adaptation to how each culture is wired in terms of thought patterns, time, judgment, handling crises, and goal setting is indispensably essential for effective cross-cultural ministry.

42. A bicultural missionary will not equate his culture with Christianity and will, with discernment, know the practices in the culture he serves that can easily be incorporated and assimilated into Christianity. Every culture is under the Lordship of Christ.

43. The way to an African's heart is through his children. A wise missionary should make sure to affectionately greet their children as they come around to visit.

44. There is a major warfare between creationism and evolutionism globally. A complete knowledge of this debate is important for the missionary to defend the truth of the Bible.

45. Be sensitive to the *dos* and *don'ts* of each culture. Watch out for the dress code in the country where you serve and follow the rules of hospitality of the people.

46. Privacy is foreign in many African countries. Missionaries will always have uninvited guests show up at their homes – so they should learn to be patient and smile at them.

47. Be aware that once you cross the societal border, you are out of your cultural comfort zone. The old adage says rightly, "When in Rome, do as the Romans do." Disrespecting the host culture creates chaos and rejection of the Gospel; *no culture is inferior.*

48. Growing Missionaries Biblically is only possible when the missionaries are filled with the Holy Spirit and receive the required biblical, theological, and cross-cultural education.

Appendix B
The Cape Town Commitment:
Lausanne Conference

The Almighty God is in control of history. In spite of Satan's attack in the Garden of Eden and throughout the ages, God continues to reign in the lives of believing saints globally. The city of Cape Town, South Africa hosted the World Evangelical Alliance Congress (WEA) in October 2010. This gathering of the saints brought together 4,000 leaders from 198 countries in this historic convocation. After many days of deliberations, teachings and praying the participants recommitted themselves to the Lordship of Christ and to the fulfillment of His Great Commission. They renewed their vision and goals of the Lausanne Movement by (1) remaining committed to the Great Commission of Jesus Christ and all His teachings and to the first Lausanne Congress (1974) and the second Congress, in Manila (1989); (2) they remain committed to the primary documents of the Movement: Lausanne Covenant (1974), and The Manila Manifesto (1989).

The Cape Town Declaration affirms the true orthodox doctrine of Evangelicalism. The declaration was divided into two parts: (1) WEA's belief and (2) its call to action. Part 1 was completed during the conference, and the action plan was also completed in December 2010. Hence, I would like to summarize the 17-page document which focuses on the belief of the World Evangelical Alliance (WEA). The conference notes the reality of the changing world, but they believe

that the truth about God cannot change. Therefore, they believe that:[135]

- *Human beings are lost.* The underlying human predicament remains as the Bible describes it; we stand under the just judgment of God in our sin and rebellion, and without Christ we are without hope.
- *The Gospel is good news.* The Gospel is not a concept that needs fresh ideas, but a story that needs fresh telling. It is the unchanged story of what God has done to save the world, supremely in the historical events of the life, death, resurrection, and reign of Jesus Christ. In Christ there is hope.
- *The Church's mission goes on.* The mission of God continues to the end of the earth and to the end of the world. The day will come when the kingdoms of the world will become the kingdom of our God and of His Christ and God will dwell with His redeemed humanity in the new creation. Until that day, the church's participation in God's mission continues, in joyful urgency, and with fresh and exciting opportunities in every generation including our own.

The Lausanne congress reaffirmed the passion of our love:[136]

This Statement is framed in the language of love. Love is the language of covenant. The biblical covenants, old and new, are the expression of God's redeeming love and grace reaching out to lost humanity and spoiled creation. They call for our love in return. Our love shows itself in trust, obedience and passionate commitment to our covenant Lord. The Lausanne Covenant defined evangelization as 'the whole church taking the whole Gospel to the whole world.'

[135]http://www.lausanne.org/cape-town-2010. The Cape Town Commitment 2010, South Africa (accessed November 25, 2010).
[136]http://www.lausanne.org/cape-town-2010. The Cape Town Commitment 2010, South Africa (accessed November 25, 2010).

Accordingly, the conference renewed their commitment:[137]

- Our love for the whole Gospel, as God's glorious good news in Christ, for every dimension of his creation, for it has all been ravaged by sin and evil.
- Our love for the whole church, as God's people, redeemed by Christ from every nation on earth and every age of history, to share God's mission in this age and glorify him forever in the age to come.
- Our love for the whole world, so far from God but so close to his heart, the world that God so loved that he gave his only son for its salvation.

"In the grip of that three-fold love," the Conference maintains, "We commit ourselves afresh to be the whole church, to believe, obey, and share the whole Gospel, and to go to the whole world to make disciples of all nations."

The Cape Town Commitment begins with this axiomatic statement of belief:[138]

1. WE LOVE BECAUSE GOD FIRST LOVED US: The mission of God flows from the love of God. The mission of God's people flows from our love for God and for all that God loves. World evangelization is the outflow of God's love to us and through us. We affirm the primacy of God's grace and we then respond to that grace by faith, demonstrated through the obedience of love. We love because God first loved us and sent his Son to be the propitiation for our sins.... We affirm that such comprehensive biblical love should be the defining identity and hallmark of disciples.... So we re-recommit ourselves afresh to make every effort to live, think, speak and behave in ways that express what it means to walk in love—love for God, love for one another and love for the world,

2. WE LOVE THE LIVING GOD: Our God whom we love reveals himself in the Bible as the one, eternal, living God

[137]Cape Town 2010.
[138]Cape Town 1010.

who governs all things according to His sovereign will and for His saving purpose. In the unity of Father, Son and Holy Spirit, God alone is the Creator, Ruler, Judge and Saviour of the world. So we love God with joyful thanks for our place in creation, with submission to his sovereign providence, with confidence in his justice, and with eternal praise for the salvation He accomplished for us…. Loving God in the midst of a world that rejects or distorts him, calls for bold but humble witness to our God; robust but gracious defense of the truth of the Gospel of Christ, God's Son; and prayerful trust in the convicting and convincing work of his Holy Spirit. We commit ourselves to such witness, for if we claim to love God we must share God's greatest priority, which is that his name and his world should be exalted above all things.

3. WE LOVE GOD THE FATHER: Through Jesus Christ, God's Son, and through him alone as the way, the truth and the life— we come to know and love God as Father. As the Holy Spirit testifies with our spirit that we are God's children, so we cry the words Jesus prayed, 'Abba, Father,' and we pray the prayer Jesus taught, 'Our Father.' Our love for Jesus, proved by obeying Him, is met by the Father's love for us as the Father and the Son make their home in us, in mutual giving and receiving of love….This intimate relationship has deep biblical foundations….We confess that we have often neglected the truth of the Fatherhood of God and deprived ourselves of the riches of our relationship with Him. We commit ourselves afresh to come to the Father through Jesus the Son; to receive and respond to His Fatherly love; to live in obedience under His Fatherly discipline; to reflect his Fatherly character in all our behavior and attitudes; and to trust in His Fatherly provision in whatever circumstances He leads us.

4. WE LOVE GOD THE SON: God commanded Israel to love the LORD God with exclusive loyalty. Likewise for us, loving the Lord Jesus Christ means that we steadfastly affirm that he alone is Saviour, Lord and God. The Bible Teaches that Jesus performs the same sovereign actions as God alone. Christ is Creator of the universe, Ruler of history, Judge of all nations and Saviour of all who turn to God…. He shares the identity of God in the divine equality and unity of Father,

Son and Holy Spirit. Just as God called Israel to love him in covenantal faith, obedience and servant-witness, we affirm our love for Jesus Christ by trusting in him, obeying him, and making him known…. We commit ourselves afresh to bear witness to Jesus Christ and all his teaching, in all the world, knowing that we can bear such witness only if we are living in obedience to his teaching ourselves.

5. WE LOVE GOD THE HOLY SPIRIT: We love the Holy Spirit within the unity of the Trinity, with God the Father who sends him, and with Jesus Christ to whom he bears witness. He is the missionary Spirit of the missionary Father and the missionary Son, breathing life and power into God's missionary church. We love and pray for the presence of the Holy Spirit because without the witness of the Spirit of Christ our own witness is futile. Without the convicting work of the Spirit our preaching is in vain. Without the power of the Spirit, our mission is mere human effort. And without the fruit of the Spirit, our unattractive lives cannot reflect the beauty of the Gospel…. There is no true or whole Gospel, and no authentic biblical mission, without the Person, work and power of the Holy Spirit. We pray for a greater awakening to this biblical truth and for its experience to be reality in all parts of the worldwide body of Christ. However, we are aware of the many abuses that masquerade under the name of the Holy Spirit, the many ways in which (as the New Testament also exemplifies) all kinds of phenomena are practiced and praised which bear the marks of other spirits, not the Holy Spirit. There is great need for more profound discernment, for clear warnings against delusion, for the exposure of fraudulent and self-serving manipulators who abuse spiritual power for their own ungodly enrichment. Above all there is a great need for sustained biblical teaching and preaching, soaked in humble prayer that will equip ordinary believers to understand and rejoice in the true Gospel and to recognize and recognize and reject false gospels.

6. WE LOVE GOD'S WORD: We love God's word in the Scriptures of the Old and New Testaments, echoing the joyful delight of the Psalmist in the Torah, 'I love your commands more than gold. Oh how I love your law.' We receive the whole

Bible as the word of God, inspired by God's Spirit, spoken and written through human authors. We testify to the power of God's word to accomplish His purpose of salvation. We affirm that the Bible is the final written word of God, not surpassed by any further revelation, but we also rejoice that the Holy Spirit illumines the minds of God's people so that the Bible continues to speak God's truth in fresh ways to people in every culture.... We confess that we easily claim to love the Bible without loving the life it teaches, the life of costly practical obedience to God through Christ. Yet nothing commends the Gospel more eloquently than a transformed life, and nothing brings it into disrepute so much as personal inconsistency. We are charged to behave in a manner that is worthy of the Gospel of Christ, and even to 'adorn' it, enhancing its beauty by holy lives.... For the sake of the Gospel of Christ, therefore, we recommit ourselves to prove our love for God's word by believing and obeying it. There is no biblical mission without biblical living.

7. WE LOVE GOD'S WORLD: We share God's passion for his world, loving all that God has made, rejoicing in God's providence and justice throughout his creation, proclaiming the good news to all creation and all nations, and longing for the day when the earth will be filled with the knowledge of the glory of God as the waters cover the sea....

a. We love the world of God's creation. This love is not mere sentimental affection for nature (which the Bible nowhere commands), still less is it pantheistic worship of nature (which the Bible expressly forbids). Rather it is the logical outworking of our love for God by caring for what belongs to him....

b. We love the world of nations and cultures. 'From one man, God made all nations of humanity, to live on the whole face of the earth.' Ethnic diversity is the gift of God in creation and will be preserved in the new creation, when it will be liberated from our fallen divisions and rivalry. Our love for all peoples reflects God's promise to bless all nations on earth and God's mission to create for himself a people drawn from every tribe, language, nation and people. We must love all that God has chosen to bless, which includes all cultures. Historically,

Christian missions has been instrumental in protecting and preserving indigenous cultures and their languages. Godly love, however, also includes critical discernment, for all cultures show not only positive evidence of the image of God in human lives, but also the negative fingerprints of Satan and sin. We long to see the Gospel embodied and embedded in all cultures, redeeming them from within so that they may display the glory of God and the radiant fullness of Christ. We look forward to the wealth, glory and splendour of all cultures being brought into the City of God, redeemed and purged of all sin, enriching the new creation... We renew the commitment that has inspired the Lausanne Movement from its beginning, to use every means possible to reach all peoples with the Gospel.

c. We love the world's poor and suffering. The Bible tells us that the Lord is loving toward all he has made, upholds the cause of the oppressed, loves the foreigner, feeds the hungry, sustains the fatherless and widow....

d. We love our neighbours as ourselves....We emphatically reject the way of violence in the spread of the Gospel, and renounce the temptation to retaliation and revenge against those who do us wrong. Such disobedience is incompatible with the example and teaching of Christ and the New Testament....

e. The world we do not love. The world of God's good creation has become the world of human and satanic rebellion against God. We are commanded not to love that world of sinful desire, greed, and human pride. We confess with sorrow that exactly those marks of worldliness so often disfigure our Christian presence and deny our Gospel witness.... We commit ourselves afresh not to flirt with the fallen world and its transient passions, but to love the whole world as God loves it. So we love the world in holy longing for the redemption and renewal of all creation and all cultures in Christ, the ingathering of God's people from all nations to the ends of the earth, and the ending of all destruction, poverty, and enmity.

8. WE LOVE THE GOSPEL OF GOD: As disciples of Jesus, we are Gospel people. The core of our identity is our passion for the biblical good news of the saving work of God through

Jesus Christ. We are united by our experience of the grace of God in the Gospel and by our motivation to make that Gospel of grace known to the ends of the earth by every possible means.

a. We love the good news in a world of bad news. The Gospel addresses the dire effects of human sin, failure and need. Human beings rebelled against God, rejected God's authority and disobeyed God's word....

b. We love the story the Gospel tells. The Gospel announces as good news the historical events of the life, death and resurrection of Jesus of Nazareth. As the son of David, the promised Messiah King, Jesus is the one through whom alone God established His kingdom and acted for the salvation of the world, enabling all nations on earth to be blessed, as He promised Abraham....

c. We love the assurance the Gospel brings. Solely through trusting in Christ alone, we are united with Christ through the Holy Spirit and are counted righteous in Christ before God. Being justified by faith we have peace with God and no longer face condemnation. We received the forgiveness of our sins...'Nothing in all creation will be able to separate us from the love of God that is in Christ Jesus our Lord....'

d. We love the transformation the Gospel produces. The Gospel is God's life-transforming power at work in the world.

9. WE LOVE THE PEOPLE OF GOD: The people of God are those from all ages and all nations whom God in Christ has loved, chosen, called, saved and sanctified as a people for his own possession, to share in the glory of Christ as citizens of the new creation. As those, then, whom God has loved from eternity to eternity and throughout all our turbulent and rebellious history, we are commanded to love one another. For 'since God so loved us, we also ought to love one another,' and thereby "be imitators of God, and live a life of love, just as Christ loved us and gave himself up for us." Love for one another in the family of God is not merely a desirable option but an inescapable command. Such love is the first evidence of obedience to the Gospel, and a potent engine of world mission....

a. Love calls for unity. Jesus' command that His disciples should love one another is linked to His prayer that they should be one. Both the command and the prayer are missional 'that the world may know you are my disciples', and that 'the world may know that you [the Father] sent me'. A most powerfully convincing mark of the truth of the Gospel is when Christian believers are united in love across the barriers of the world's inveterate divisions–barriers of race, colour, social class, economic privilege or political alignment. However, few things so destroy our testimony as when Christians mirror and amplify the very same divisions among themselves. We confess that we have not laid aside all that divides us. Among such barriers, we are deeply troubled by the scandalous extremes of material inequality within the global body of Christ....

b. Love calls for honesty. Love speaks truth with grace. No one loved God's people more than the prophets of Israel and Jesus Himself. Yet no one confronted them more honestly with the truth of their failure, idolatry and rebellion against their covenant Lord. And in doing so, they called God's people to repent, so that they could be forgiven and restored to the service of God's mission. The same voice of prophetic love must be heard today, for the same reason.

c. Love calls for solidarity. "Loving one another includes especially caring for those who are persecuted and in prison for their faith and witness. If one part of the body suffers, all parts suffer with it.... We commit ourselves to share in the suffering of members of the body of Christ throughout the world, through information, prayer, advocacy, and other means of support....

10. WE LOVE THE MISSION OF GOD: We are committed to world missions, because it is central to our understanding of God, the Bible, the church, human history and the ultimate future. The whole Bible reveals the mission of God to bring all things in heaven and earth into unity under Christ, reconciling them through the blood of his cross, to the praise of God's glory and grace. In fulfilling His mission, God will transform the creation broken by sin and evil into the new creation in which there is no more sin or curse. God will fulfill his promise to

Abraham to bless all nations on the earth, through the Gospel of Jesus, the Messiah, the seed of Abraham. God will transform the fractured world of nations that are scattered under the judgment of God into the new humanity that will be redeemed by the blood of Christ from every tribe, nation, tongue and language, and will be gathered to worship our God and Saviour. God will destroy the reign of death, corruption and violence when Christ returns to establish His eternal reign of life, justice and peace. Then God, Immanuel, will dwell with us, and the kingdom of the world will become the kingdom of our Lord and of His Christ and He will reign forever and ever....

a. Our participation in God's mission. God calls his people to share his mission. The church from all nations stands in continuity through the Messiah Jesus with God's people in the Old Testament. With them we have been called through Abraham and commissioned to be a blessing and a light to the nations. With them, we are to be shaped and taught through the law and the prophets to be a community of holiness, compassion and justice in a world of sin and suffering. We have been redeemed through the cross and resurrection of Jesus Christ, and empowered by the Holy Spirit to bear witness to what God has done in Christ....

b. The cost of our mission. Jesus modelled [sic] what he taught, that the greatest love is to lay down one's life for one's friends.... Being willing to suffer is an acid test for the genuineness of our mission. God can use suffering, persecution and martyrdom to advance his mission....

c. The integrity of our mission. The source of all our missions is what God has done in Christ for the redemption of the whole world, as revealed in the Bible. Our evangelistic task is to make that good news known to all nations. The context of all our mission is the world in which we live, the world of sin, suffering, injustice, and creational disorder, into which God sends us to love and serve for Christ's sake. Our entire mission must therefore reflect the integration of evangelism and committed engagement in the world, both being ordered and driven by the whole biblical revelation of the Gospel of God.... We commit ourselves to the integral and dynamic exercise of all dimensions of mission to which God calls His church. In

response to God's boundless love for us in Christ, and out of our overflowing love for him, we rededicate ourselves, with the help of the Holy Spirit, fully to obey all that God commands, with self-denying humility, joy and courage. We renew this covenant with the Lord we love because he first loved us.

As we carefully reflect on the Cape Town Declaration of Belief, Evangelicals are committed to their foundation, which is Christ the God-man and missions. He is the creator of the universe. A literal belief that Adam was a man who disobeyed God in the Garden of Eden which resulted in his expulsion from the Paradise of God was emphasized. The redemptive mission which commenced in the Garden culminated on the Cross of Calvary. Our commitment to reconcile every man unto God through the power of the Holy Spirit was recommitted to by the conference.

The conference recognizes God's love for mankind and the need for our response to His love and to one another. Also, the Trinity: God the Father, God the Son and God the Holy Spirit as the central belief was again affirmed by the conference. The Cape Town Assembly also notes:[139]

Ethnic diversity is a gift of God in creation and will be preserved in the new creation, when it will be liberated from our fallen divisions and rivalry....We must love all that God has chosen to bless, which includes all cultures. Historically, Christian mission has been instrumental in protecting and preserving indigenous cultures and their languages.... Such love for all peoples demands that we reject the evils of racism and ethnocentrism, and treat every ethnic and cultural group with dignity and respect, on the grounds of their value to God in creation and redemption.

The Cape Town Assembly believes that every culture is under the Lordship of Christ. This fact then suggests that a missionary be bicultural for effective ministry cross-culturally. In a special Communiqué, the Evangelical leaders renewed their commitment to "this covenant with the Lord we love because he first loved us."

[139]Cape-town-2010 (accessed November 25, 2010).

Appendix C
Glocalization: My Response

I intentionally place my response to glocalizaion right after the 2010 Cape Town Commitment because evangelicals (of 4,000 delegates from 198 countries) recommitted to missions in their communiqué. I understand that there are other opposing views about missions in the twenty-first century. Bob Roberts, Jr., one of the key proponents in this debate, argues in his book, *Glocalization: How Followers of Jesus Engage a Flat World*, that missions was only good through the eighteenth to twentieth centuries. "The twenty-first century is about glocalization. The old missions metaphor does not communicate because it only worked as a religious response to an unconnected world.[140]" Though Bob has some excellent concepts in how to reach the world of so much need, replacing missions with glocalization contradicts his principles about the Kingdom of God because missions is the furtherance of God's kingdom. In fact, the heart-beat of God is missions. As I had argued in this book, missions commenced in the Garden of Eden and culminated on the Cross of Calvary, not just a New Testament phenomenon.

Because of the importance of missions, God gave the first Great Commission to Abraham (Gn. 12:1-3) to make His name known to all men. And Jesus, who is both God and man, gave the second Great

[140]Bob Roberts, Jr. *Glocalization: How Followers of Jesus Engage a Flat World* (Grand Rapids Michigan: Zondervan, 2007), 34.

Commission to His disciples to reach the Gospel to the utmost parts of the earth (Mt. 28:16-20). The Kingdom of God is embedded in His Word. Incarnationally, God came down to man as a missionary; He took on human flesh (Jn.1-14). Because missions require special anointing and training, God revealed to Peter in a vision that what He had made clean, he must not call unclean (Acts 10:15). Hence, Peter encountered his first Gentile mission in the house of Cornelius (Acts 10:1ff). Because God understands the limitations of man, He commissioned Peter as the primary apostle (i.e. missionary) to the Jewish people and Paul to the Gentiles (Acts 9:15; Gal. 2:8). With all the advancement in technology, we cannot effectively reach the world without missions. Because of man's sin, the ten[141] top problems Bob listed in his book will always be with man. The solution to this is not humanitarian work globally alone, although it is important, but in my judgment, I think it is misleading to think that the churches in America or the West as a whole can eradicate these problems in the midst of the world of sin. It is not wrong for the church to help the suffering people globally. When a man is liberated from sin by faith in Christ, then Bob's top ten problems of the world—wickedness and suffering will be minimized.

What the church needs in our generation is discipleship, being a friend to every culture, and to serve because we have been converted/saved. I agree with Bob on these points. A well-discipled Christian will represent Christ everywhere. The church needs mobilization to disciple every member or believer, and to train bicultural missionaries who will effectively disciple those to whom they are sent. This will avoid the spectators in the pew waiting for some sort of program that would amuse them every Sunday. The church's connection to the world is for redemptive purposes. Glocalization that focuses on how the work of the church must shift from the pulpit to the pew, from the church building to the community and world at large for the Kingdom of God, sounds great. But everyone in church cannot reach the entire world. I understand that Bob has taken many of his parishioners in many countries partnering with the natives of that land to impact their cities with the Gospel. I

[141]Bob's ten top problems in the world today are communicable disease, hunger, water and sanitation, government/corruption, migration/refugees, climate change, education, armed conflict/war, economy, and subsidies/trade (Bob Roberts, 46).

believe this is missions by definition, but with strong discipleship and humanitarian emphases.

The glocalization approach sounds anti-Augustine. In his *City of God*, Saint Augustine discussed two cities in tension because of their opposite objectives: the City of Man favors the things of the flesh while the City of God concentrates on the things of God.[142] Where does the church land when we combine these? I believe glocalization, with its major emphases in disciple building, laymen-focused and humanitarian concepts in reaching the world, is all a part of missions outreach for the Kingdom of God.

[142]St. Augustine. *The City of God*. Translated by Marcus Dods (New York: Modern Library, 2000), xviii.

Appendix D
Missions Trip Application Form

I wish to be part of the short-term mission team going to:

General Information: (Please print)
Name (as printed on birth certificate or
passport)_____
Address_____

City_____State_____Zip Code_____

Home Phone_____Work Phone_____
Cell Phone_____ E-mail:_____

Age_____Male or Female?_____Nickname_____
Citizen of what country_____

Passport #_____
Expiration date of passport_____

Date of Birth_____

Marital Status_____

Spiritual Assessment:

1. Name of your Church: _____

Address_____

Name of your pastor_____Phone_____
E-mail:_____

2. Have you had Mission Trip experience? () Yes, () No. If yes,
 a. When?_____
 b. Where_____
 c. Name of group or church: _____
 d. Name of group Leader_____Phone#_____
 e. E-mail_____

3. Are you presently participating in any ministry within your church or with any para-church organization? If yes explain: _____

4. What are your spiritual gifts?_____

5. Please give two references with their phone numbers:_____

6. Briefly describe your spiritual autobiography: _____

 (use separate sheet if possible).
7. Have you been water baptized? If yes, where and when? _____

8. Why do you want to participate in this mission?_____

(use separate sheet if necessary)

Work experience:

1. Are you employed? If yes, where?_____

 What is your position? _____

 How long have you worked for this
 company?_____
2. Do you speak any foreign languages
 fluently?_____
3. Please explain your strongest and weakest quality why:_____

Health Information:

1. Do you have any condition which might affect your ability to
 fully function as a missionary on this mission trip? _____

2. Do you have any chronic illnesses or allergies? () Yes ()No.
 If yes, Please explain: _____

3. Are you presently under medication prescribed by a doctor?

4. Do you presently have health insurance? _____
 Company_____ If yes, does it cover you while you
 are overseas? _____
5. How would you describe your health and fitness? () Excellent
 () Good ()
6. () Average () Needs work.

Personal Information:

1. What do you hope to accomplish while on the Mission trip? _____

_____(use separate sheet if necessary)

2. If you are in a dating relationship, or engaged to someone, is this person applying to serve on the same Mission team? _____

3. How does your family feel about your going on the Mission trip?

5. Have you been convicted of committing a crime? () Yes () No
If yes, please explain: _____

_____(use separate sheet if necessary)

7. Emergency Numbers:
(1st.) Name:_____Relationship to you:____

Address: _____

Phone # Day _____Night: _____

E-mail:_____ Cell_____

(2nd) Name_____Relationship to you_____

Address_____

E-mail_____Phone # Day _____
Night: _____ _____

 Team members, leaders, and staff serve at their own risk, and the church is not liable in the event of sickness, accident, death, or terrorist acts or for transportation and any other expense beyond normal involvement. We require all participants to be in good physical condition, and we may require a doctor's reference and exam.

 I have read and understand the above information. The information I have given is accurate and true to the best of my knowledge. My signature signifies my approval of all requirements listed above.

Signature of Applicant:_____Date:_____

Appendix E
Personal Covenant Form Between
The Participant and the Church/
Mission Organization

This covenant which is entered into between the Church's Mission Ministry and participant is herein referred to as a team member. The Covenant between God and His people is quite different from the one signed by a team member and the church. The difference is that God is the covenant keeper, whereas in the Missions Team Covenant, both parties must keep the terms of the covenant. With this understanding the team member shall be aware that a Mission Trip is not tourism, instead you will be a guest of another country and face cultural differences. Be flexible and be willing to adjust yourself accordingly.

As a member of the team, I accept the following guidelines and conditions for the Missions Trip. I agree, if accepted, to:

- ✓ Be God's representative with His message of reconciliation to every man which was made possible through the death and resurrection of Jesus Christ.
- ✓ Develop an attitude of a learner in the host culture; knowing it is necessary to understand their worldview and to preach the Gospel to them appropriately. Also, being sure to avoid any involvement in anything political in the host culture.

✓ Have mutual respect for every team member and Christians in the host country and avoid a prideful attitude among the believers. Note that every member of the team is to share his talents freely, whether it is music, art, carpentry, or basic hard work. I shall accept each team member in the Lord as fellow soldiers of the cross.

✓ Be obedient to any policy that the church or mission organization has put in place for the trip – it is sometimes called the dos and don'ts list on the field.

✓ Understand that I am to attend all the classes for the mission training and do all my assignments. Failure to do so shall warrant my dismissal from the team.

✓ Accept and submit to the leadership role and authority of the team leader(s).

✓ Release and discharge the church of any claims arising from this trip for all personal injuries, known or unknown, and injuries to property, real or personal, caused by, or arising out of this journey.

✓ Understand that this journey is risky and I am subjecting myself to this willingly, voluntarily. The church will not be responsible for any sickness or mishap that may develop as a result of poor sanitation in the host country, or potential injury while working.

✓ In the event that my conduct is considered unsatisfactory, my services must be ended and I will be sent home immediately at my own expense.

✓ Be mindful of my dress code. From my training sections, I am aware of how to dress modestly in the host country so as not to offend them.

✓ Understand that I am over 21 years of age, and if below the 21- years limit, my parents or legal guardian needs to sign this covenant statement in order for it to be valid.

Participant's Signature:_____

Parents or Guardian's signature if participant is under 21 years:____

Phone # of Parents or Guardians:_____

Name of participant:_____

Address:_____

Daytime phone:_____ Night phone:_____

Bibliography

Adeyemo, Tokunboh, ed. *Africa Bible Commentary: A One-Volume Commentary Written by 70 African Scholars.* Nairobi, Kenya: WorldAlive Publisher, 2006.

Althen, Gary. *American Ways: A guide for foreigners in the United States,* 2nd.ed. Boston, MA: Intercultural Press, 2003.

Aristotle. *The Nicomachean Ethics.* New York, New York: Penguin Books, 2004.

Augustine, Saint, Bishop of Hippo. *Works.* vol. 3. Edited by the Rev. Marcus Dods Edinburgh, Scotland: T & T Clark, 1872.

Barnett, Betty. *Friends Raising: Building a Missionary Support Team that Lasts.* Seattle, Washington: YWAM Publishing, 1991.

Boice, James Montgomery. *Genesis Volume I: Creation and Fall* (Genesis 1-11). Grand Rapids, Michigan: Baker Books, 1998.

Bruce, A.B. *The Training of the Twelve.* Grand Rapids, Michigan: Kregel Publications, 1980.

Collins, Marjorie A. *Manual For Today's Missionary: From Recruitment to Retirement.* Pasadena, California: William Carey Library, 1986.

Conteh Prince Soire. *"Fundamental Concepts of Limba Traditional Religion, and Its Effects on Limba Christianity and Vice Versa in Sierra Leone in the Past Three Decades."* D.Th diss, University of South Africa, 2004.

Day, Collins A. *Collins Thesaurus of the Bible.* Bellingham, WA: Logos Research System, Inc., 2009.

Davies, W.D. and Allison Dale C. *Matthew: A Shorter Commentary.* New York, New York: T&T Clark International, 2004.

Dearborn, Tim. *Short-Term Missions Workbook*. Downers Grove, Illinois: Inter-Varsity Press, 2003.

_____. *Beyond Duty: A Passion for Christ, a Heart for Mission*. Monrovia, CA: World Vision, 1997.

Dillon, William P. *People Raising: A Practical Guide to Raising Support*. Chicago, Illinois: Moody Press, 1993.

Faw, C. E. *Acts: Believer Church Bible Commentary*. Scottsdale, PA: Herald Press, 1993.

Ferdinando, Keith. *The Triumph of Christ in African Perspective*. Carlisle, Cumbria CA 3 O QS U.K.: Paternoster Press, 1999.

Forward, David C. *The Essential Guide to the Short-Term Mission Trip*. Chicago, Illinois: Moody Publishers, 1998.

France, R. T. Matthew: *Tyndale New Testament Commentaries*, edited by Canon Leon Morris. Grand Rapids, Michigan: Inter-Varsity Press, 1988.

Gage, Warren Austin. *The Gospel of Genesis: Studies in Protology and Eschatology*. Eugene, OR: Carpenter Books, 1984.

Greidanus, Sidney. *Preaching Christ from the Old Testament: A Contemporary Hermeneutical Method*. Grand Rapids, Michigan: William B. Eerdmanns, 1999.

Harbach, Robert C. *Studies in the Book of Genesis*. Grandville, Michigan: Reformed Free Publishing Association, 2001.

Hale, Thomas. *On Being a Missionary*. Pasadena California: William Carey Library, 1995.

Hamilton, Victor P. *Handbook on the Pentateuch, 2rd ed*. Grand Rapids, Michigan: Baker Academic, 2005.

_____. *Handbook on the Pentateuch*. Grand Rapids, Michigan: Baker Book House, 1985.

Ham, Ken. *Creation Evangelism for the New Millennium*. Green Forest, AR: Master Books, Inc., 1999.

_____. *The Lie: Evolution*. El Cajon, California: Creation –Life Publishers, 1987.

Ham, Ken, Snelling, Andrew, Wield Carl. *The Answers Book: Answers to the 12 most asked questions on Genesis and creation/evolution*. Green Forest, AR: Master Books, Inc., 1998.

Hesselgrave, David J. *Communicating Christ Cross-Culturally. 2nd. ed.: An Introduction to Missionary Communication.* Grand Rapids, Michigan: Zondervan Publishing House, 1991.

Hiebert, Paul G. *Anthropological Insight for Missionaries.* Grand Rapids, Michigan: Baker Book House, 2001.

_____. *Paradigm in Conflict: 10 Key Questions in Christian Missions Today.* Grand Rapids, Michigan: Kregel Publications, 2005.

Kaiser, Walter C. Jr. *Mission in the Old Testament.* Michigan: Baker Books, 2000.

Kennedy, James D. *Evangelism Explosion, Fourth edition.* Wheaton, Illinois: Tyndale House Publishers, Inc., 1996.

Kidner, Derek. Genesis: *An Introduction & Commentary. The Tyndale Old Testament Commentaries.* Wiseman, D.J. gen. ed. Grand Rapids, Michigan: Inter-Varsity Press, 1967.

Kraft Charles H. *Worldview for Christian Witness.* Pasadena, California: William Carey Library, 2008.

Kubi, Kofi Appiah, Torres Sergio, eds. *African Theology En-route. Maryknoll, New York:* Orbis Books, 1979.

L. Morris. *The Gospel According to Matthew.* Grand Rapids, Michigan: W.B. Eerdmans Inter-Varsity Press, 1992.

Lingenfelter, Sherwood G., Mayers, Marvin K. *Ministering Cross-Culturally: An Incarnational Model for Personal Relationships.* Grand Rapids, Michigan: Baker Book House, 1986.

Lugira, Aloysius M. *African Religion: World Religions.* New York: Facts on File, Inc., 1999.

Magesa Laurenti. *Anatomy of Inculturation: Transforming the Church in Africa.* Maryknoll, New York: Orbis Books, 2004.

Mack J and Stiles Leeann. *Mack & Leeann's Guide to Short-Term Missions.* Downers Grove, Illinois: IVP Books, Inter-Varsity Press, 2000.

Mbiti, John S. *Introduction to African Religion.* 2nd ed. Norfolk, Great Britain: Biddles Ltd, King's Lynn, 1991.

_____. *African Religions and Philosophy.* 2nd ed. Norfolk, Great Britain: Biddles Ltd, King's Lynn. 2006.

Moreau, Scott, Neetland Harold and Engen Charles, Van, eds. *Evangelical Dictionary of World Missions.* Michigan: Baker Books, 2000.

Morris, Henry M. *The Genesis Record: A Scientific and Devotional Commentary on the Book of Beginnings.* Grand Rapids, Michigan: Baker Book House, 1981.

_____. ed. *Scientific Creationism (General Edition).* San Diego, California: Creation-Life Publishers, 1981.

Moreland J.P. and Reynolds John M. eds. Three Views on Creation and Evolution. Grand Rapids, Michigan: Zondervan Publishing House, 1999.

Nicholas, David. *Whatever Happened to the Gospel?* Bloomington, Indiana: CrossBooks, 2010.

Osborne, Grant R. *The Hermeneutical Spiral: A Comprehensive Introduction to Biblical Interpretation.* Downers Grove, Illinois: IVP Academic, 2006.

Parrinder, Geoffrey. *African Mythology.* United States of America, 1975.

Pearson, Judy C. and Nelson Paul E. *An introduction to Human Communication: Understanding and Sharing, 8th Edition.* The McGraw-Hill Companies: U.S.A, 2000.

Phillips, John. *The John Phillips Commentary Series: Exploring Genesis.* Grand Rapids, Michigan: Kregel Publications, 2001.

Pirolo, Neal. *Serving as Senders.* San Diego, CA: Emmaus Road, International, 1991.

Plato. *The Republic of Plato.* 2nd ed. United States of America: Basic Books, 1991.

Reymond L. Robert. *The Lamb of God: The Bible's Unfolding Revelation of Sacrifice.* Scotland, UK: Christian Focus.

Rheenen, Gailyn Van. *Missions: Biblical Foundations & Contemporary Strategies.* Grand Rapids, Michigan: Zondervan Publishing House, 1996.

Richmond, Yale and Gestrin Phyllis. *Into Africa: Intercultural Insights.* Boston, MA: Nicholas Brealey Publishing, 1998.

Roberts, Bob, Jr. *Glocalization: How Followers of Jesus Engage the New Flat World.* Grand Rapids, Michigan: Zondervan, 2007.

Saint Augustine. *The City of God.* Translated by Marcus Dods. New York: Modern Library, 2000.

Seamands, John T. *Harvest of Humanity: The Church's Mission in Changing Times.* Wheaton, Illinois: Victor Books, 1988.

Shorter, Aylward W.F. *African Christian Spirituality.* Maryknoll, New York: Orbis Books, 1980.

Stinton, Diane B. *Jesus of Africa: Voices of Contemporary African Christology.* Maryknoll, New York: Orbis Books, 2006.

Stewart, Edward C. and Bennett Milton J. *American Cultural Patterns: A Cross-Cultural Perspective.* Yarmouth, Maine: Intercultural Press, Inc., 1991.

Sugirtharajah R.S. *The Bible and the Third World: Precolonial, Colonial and Postcolonial Encounters.* Cambridge: University Press, 2004.

Taylor, David William, ed. *Internationalizing Missionary Training: A Global Perspective.* Grand Rapids, Michigan: Baker Book House, 1991.

Tippet, Alan. *Introduction to Missiology.* Pasadena, California: William Carey Library, 1995.

Urbana 87. *Should I Not Be Concerned?* Downers Grove, Illinois: Inter-Varsity Press, 1987.

Utley R. J. D. *How it All Began: Genesis 1-11. Study Guide Commentary Series, Vol. 1A.* Marshall, Texas: Bible Lessons International, 2001.

Wakatama, Pius. *The Third World Church: Independence for the Third World Church, An Africans' Perspective on Missionary Work.* Downers Grove, Illinois: Inter-Varsity Press, 1978.

Waltke, Bruce K. and Yu Charles. *An Old Testament Theology: An Exegetical, Canonical, and Thematic Approach.* Grand Rapids, Michigan: Zondervan, 2007.

Waltke, Bruce K. and Fredricks Cathi J. *Genesis: A commentary.* Grand Rapids, Michigan: Zondervan, 2001.

W. A. Well and B. Beitzel. *Baker Encyclopedia of the Bible.* Grand Rapids, MI: Baker House, 1988.

Wenham, Gordon J. *Word Biblical Commentary Volume 1: Genesis 1-15.* Waco, Texas: Word Books, Publisher, 1994.

Wiersbe, Warren W. *Be Obedient.* Wheaton, Ill.: Victor Books, 1996.

Yamamori, Tetsunao and Taber Charles R. eds. *Christopaganism or Indigenous Christianity.* Pasadena, California: William Carey Library, 1975.

Yohannan, K.P. *Revolution in World Missions.* Carrollton, Texas: gfa books, 2003.

Index